Cli-Fi

Genre Fiction and Film Companions

Volumes

The Gothic
Edited by Simon Bacon

Cli-Fi
Edited by Axel Goodbody and Adeline Johns-Putra

Forthcoming

Horror
Edited by Simon Bacon

Sci-Fi
Edited by Jack Fennell

Monsters
Edited by Simon Bacon

Transmedia
Edited by Simon Bacon

CLI-FI

A Companion

Edited by Axel Goodbody and Adeline Johns-Putra

PETER LANG

Oxford • Bern • Berlin • Bruxelles • New York • Wien

Bibliographic information published by Die Deutsche Nationalbibliothek. Die Deutsche Nationalbibliothek lists this publication in the Deutsche Nationalbibliografie; detailed bibliographic data is available on the Internet at http://dnb.d-nb.de.

A catalogue record for this book is available from the British Library.

Library of Congress Cataloging-in-Publication Data:
Names: Goodbody, Axel, 1950- editor. | Johns-Putra, Adeline, 1973- editor.
Title: Cli-fi : a companion / [edited by] Axel Goodbody and Adeline Johns-Putra.
Description: First edition. | Oxford ; New York : Peter Lang, 2019. |
 Includes bibliographical references and index.
Identifiers: LCCN 2018022659 | ISBN 9781788740722 (alk. paper)
Subjects: LCSH: Climatic changes in literature.
Classification: LCC PN56.C612 C53 2018 | DDC 809.3/936--dc23 LC record available at
https://lccn.loc.gov/2018022659

Cover design by Peter Lang Ltd.

ISSN 2631-8725
ISBN 978-1-78874-072-2 (print) • ISBN 978-1-78874-073-9 (ePDF)
ISBN 978-1-78874-074-6 (ePub) • ISBN 978-1-78874-075-3 (mobi)

© Peter Lang AG 2019
Published by Peter Lang Ltd, International Academic Publishers,
52 St Giles, Oxford, OX1 3LU, United Kingdom
oxford@peterlang.com, www.peterlang.com

Contents

Axel Goodbody and Adeline Johns-Putra

Introduction I

PART I Proto-Climate Change Fiction 19

Jim Clarke

J. G. Ballard's *The Drowned World* (1962) – Psycho-Geographical Cli-Fi 21

Thomas H. Ford

Max Frisch's *Man in the Holocene* (1980) – Geological Cli-Fi 27

Mark Anderson

Ignacio Brandão's *And Still the Earth* (1981) – Political Cli-Fi 35

PART II Speculative Future Fiction: Dystopian and Post-Apocalyptic Narratives 41

Thomas H. Ford

George Turner's *The Sea and Summer* (1987) – Urban Dystopian Cli-Fi 43

Dana Phillips

Margaret Atwood's *MaddAddam* Trilogy (2003–2013) – Post-Apocalyptic Cli-Fi 49

M. Isabel Pérez-Ramos

Paolo Bacigalupi's *The Windup Girl* (2009) – Biopunk Cli-Fi 55

Antonia Mehnert

Steven Amsterdam's *Things We Didn't See Coming* (2009) –
Riskscape Cli-Fi 61

Axel Goodbody

Ilija Trojanow's *The Lamentations of Zeno* (2011/2016) –
Prophetic Cli-Fi 67

Kiu-Wai Chu

Bong Joon-ho's *Snowpiercer* (2014) – Adventure Cli-Fi 73

Stef Craps

Jeff Nichols's *Take Shelter* (2011) – Psychic Cli-Fi 83

PART III Realist Narratives Set in the Present and Near Future 89

Adeline Johns-Putra

Maggie Gee's *The Ice People* (1998) and *The Flood* (2004) – State of
the Nation Cli-Fi 91

Adam Trexler

T. C. Boyle's *A Friend of the Earth* (2000) – Activism in Cli-Fi 97

Chris Pak

Kim Stanley Robinson's *Science in the Capitol* Trilogy
(2004–2007) – Science and Politics in Cli-Fi 103

Sylvia Mayer

Barbara Kingsolver's *Flight Behaviour* (2012) – Class and Religion
in Cli-Fi 111

Hannes Bergthaller

Nathaniel Rich's *Odds Against Tomorrow* (2013) – Risk and
Rationality in Cli-Fi 117

Alexa Weik von Mossner

Franny Armstrong's *The Age of Stupid* (2009) –
Documentary Cli-Fi 123

PART IV Thriller, Crime, Conspiracy and Social Satire 131

Alexa Weik von Mossner

Roland Emmerich's *The Day After Tomorrow* (2004) –
Apocalyptic Cli-Fi 133

Greg Garrard

Michael Crichton's *State of Fear* (2004) – Denialist Cli-Fi 139

Terry Gifford

Liz Jensen's *The Rapture* (2009) – Thriller Cli-Fi 147

Bradon Smith

Will Self's *The Book of Dave* (2006) – Satirical Cli-Fi 153

Richard Kerridge

Ian McEwan's *Solar* (2010) – British Comic Cli-Fi 159

Lieven Ameel

Antti Tuomainen's *The Healer* (2013) – Nordic Crime Cli-Fi 165

PART V Children's Film and Young Adult Novels 171

David Whitley

Chris Buck and Jennifer Lee's *Frozen* (2013) – Fantasy Cli-Fi 173

Reinhard Hennig

Jostein Gaarder's *The World According to Anna* (2013/2015) –
Didactic Cli-Fi 181

Sina Farzin

Saci Lloyd's *The Carbon Diaries 2015* (2008) – Coming-of-Age Cli-Fi 187

PART VI Literary Modernism 193

Ursula K. Heise

David Brin's *Earth* (1990) – Epic Cli-Fi 195

Bradon Smith

David Mitchell's *The Bone Clocks* (2014) – Genre Pluralism in Cli-Fi 203

Louise Squire

Jeanette Winterson's *The Stone Gods* (2007) – Postmodern Cli-Fi 211

Iva Polak

Alexis Wright's *The Swan Book* (2013) – Indigenous Cli-Fi 217

Bibliography 223

Notes on Contributors 227

Index 233

Axel Goodbody and Adeline Johns-Putra

Introduction

Since the late 1980s, when it first came to the attention of a wider public, global warming has been generally (although not universally) recognized as one of the greatest challenges facing humanity in the twenty-first century. Models of its future development, predictions of its likely political, social and cultural impact, and proposals for measures to limit the rise in temperature and mitigate its consequences have been hotly debated over the last thirty years, and they are likely to remain subjects of contention for the foreseeable future. This public concern has latterly been accompanied by a growing body of climate change fiction. The emergence of cli-fi (an abbreviation in analogy with 'sci-fi' apparently coined by the journalist Dan Bloom in 2007) as a new genre of fiction and film, reflecting but also to a degree informing views and shaping conversations on climate change, was greeted in a series of articles in the press in the USA and Britain in 2013.[1] Climate change fiction has become the subject of numerous blogs and reading forums on the Internet, and a focus of growing academic interest.

Defining cli-fi

Cli-fi is not a genre in the scholarly sense: it lacks the plot formulas and stylistic conventions that characterize genres such as sci-fi and the western. However, borrowing from and often embracing elements of different existing genres, it

[1] For example, Rodge Glass, 'Global warning: The rise of "cli-fi"', *The Guardian* (31 May 2013); Pilita Clark, 'Global literary circles warm to climate fiction', *Financial Times* (31 May 2013).

provides a convenient term for an already significant body of narrative work broadly defined by its thematic focus on climate change and the political, social, psychological and ethical issues associated with it. Given the absence of a precise definition, cli-fi may be best thought of as a distinctive body of cultural work which engages with anthropogenic climate change, exploring the phenomenon not just in terms of setting, but with regard to psychological and social issues, combining fictional plots with meteorological facts, speculation on the future and reflection on the human-nature relationship,[2] with an open border to the wider archive of related work on whose models it sometimes draws for the depiction of climatic crisis.[3]

There are, of course, some novels that do not explicitly mention climate change, but have been read as addressing it, such as Cormac McCarthy's *The Road* (2006). And there is a larger number of others – for example, Margaret Atwood's *The Year of the Flood* (2009) and *MaddAddam* (2013), Sarah Hall's *The Carhullan Army* (2007), and works translated from other languages such as Peter Verhelst's *Tonguecat* (2003), Michel Houellebecq's *The Possibility of an Island* (2005) and Rosa Montero's *Weight of the Heart* (2016) – in which global warming is just one of a series of ways in which human actions are irreparably changing the natural environment on a global scale, it does not play an important role in the plot, and its causes, consequences and ethical implications are not discussed. While our working definition leads us to exclude these, it would logically embrace representations of deliberate (but usually disastrous) human interventions into global climatic conditions which predate global warming, such as Jules Verne's novel *The Purchase of the North Pole* (1889) and Alexander Döblin's *Mountains Oceans Giants* (1924). We have chosen not to go down this route in this collection of essays. However, we do include examples of what Jim Clarke has called 'proto-climate-change fiction' in a study of the dystopian novels written by J. G. Ballard in the 1960s,[4] although these predate awareness of the effects of greenhouse gases, and either

2 Adam Trexler and Adeline Johns-Putra, 'Climate Change in Literature and Literary Criticism', *WIREs Climate Change* 2/2 (March/April 2011), 185–200; here 196.

3 Adam Trexler, *Anthropocene Fictions: The Novel in a Time of Climate Change* (Charlottesville: University of Virginia Press, 2015), 8.

4 Jim Clarke, 'Reading Climate Change in J. G. Ballard', *Critical Survey* 25/2 (2013), 7–21.

attribute climatic change to natural causes (Ballard), use it to reflect on the limitations of human control over the natural environment (Max Frisch), or invest it with other meaning as a metaphor for political developments (Ignácio de Loyola Brandão). The inconsequence of this choice is in our view justified by the themes, tropes and generic features of climate change fiction which are prefigured in these novels.

A brief overview of literary production

The warming effect of increased carbon dioxide and other greenhouse gases in the atmosphere was first identified and progressively understood by scientists such as Joseph Fourier, John Tyndall and Svante Arrhenius in the nineteenth century. However, the 'discovery' of climate change only came when renewed attention was paid to this in the 1960s and 1970s. Public concern about human impacts on climate emerged alongside widespread unease over other environmental impacts, over-population, pollution and acid rain – all concerns that led to the organization of the first Earth Day in the US in 1970. Paul and Anne Ehrlich mention the greenhouse effect in *The Population Bomb* (1968), for example. By the early 1980s, the cumulative work over the previous decades – by scientists such as Charles Keeling, Roger Revelle, Wally Broecker, Reid Bryson and Stephen Schneider, presented at forums including the World Climate Conference in Geneva in 1979 – was increasingly penetrating the public consciousness, as evidenced by high-profile news reports and popular science books, such as Howard Wilcox's *Hothouse Earth* (1975) and Schneider's *The Genesis Strategy: Climate and Global Survival* (1976).[5]

Literary engagement with the phenomenon appears to have started in 1971 with *Lathe of Heaven*, a short sci-fi novel by Ursula Le Guin, author of

5 For more on the modern history of climate change science, see Mike Hulme, *Why We Disagree about Climate Change* (Cambridge: Cambridge University Press, 2009), 42–60, and Spencer R. Weart, *The Discovery of Global Warming* (Cambridge, MA: Harvard University Press, 2008).

the young adult fantasy *Earthsea* novels and other works of sci-fi distinguished by their thoughtfulness. It picked up only gradually, with Arthur Herzog's thriller, *Heat* (1977), and the Australian critic and novelist George Turner's *The Sea and Summer* (1987), before experiencing a first flowering around 2000 with Maggie Gee's *The Ice People* (1998), Norman Spinrad's *Greenhouse Summer* (1999) and T. C. Boyle's *A Friend of the Earth* (2000). As these titles suggest, issues associated with climate change were, from the outset, commonly fictionalized within the framework of popular genres, namely sci-fi and, to a lesser extent, the thriller. We shall expand further on the question of generic influences and strategies below, but note here the role played by genre fiction in making early cli-fi marketable, appealing to a specific readership and serving as a resource helping readers think through complex issues. At the same time, it should be recognized that, in some cases, generic expectations of plot and character might distort or distract from the issue of climate change. For, where the appeal of a novel resides mainly in its status within a particular genre (or even within the *oeuvre* of a particularly popular writer of genre fiction), this can circumscribe readers' understanding of potential solutions to the problems it presents. Though sci-fi novelists from Le Guin and Turner to Kim Stanley Robinson and Paolo Bacigalupi have produced relatively sophisticated treatments of climate change, generic norms weigh heavily on thrillers such as Rock Brynner's *The Doomsday Report* (1998) and James Herbert's *Portent* (1992) (which, as a 'chiller', draws on both horror and thriller traditions), starting a trend that continued with Michael Crichton's *State of Fear* (2004) and Clive Cussler's *Arctic Drift* (2008). In contrast, the novels of Gee and Boyle are early examples of writing that draws on generic expectations (mainly from sci-fi) but seeks to avoid the limitations imposed by the popular genre templates. They do so, on the one hand, by complicating stereotypes, introducing ambivalent characters and ironically subverting expectations, and, on the other, by foregrounding the links between human handling of the natural environment and issues of social justice, gender and sexuality, and individual or collective agency.

Cli-fi took off in the first years of the new century, paralleling Al Gore's success in raising the profile of climate activism, initially with novels from Atwood, Jeanette Winterson and Liz Jensen, in addition to Robinson, Crichton and Cussler. In his survey of Anglophone literature, Adam Trexler writes of

over 150 novels,[6] and there are dozens of films in the category.[7] Imaginings of the future impact of climate change typically involve desertification, drought and water shortage, floods and violent storms, the spread of tropical diseases, climate refugeeism and the collapse of a society divided between rich and poor into lawlessness and armed conflict. Against this background, human dramas of hope and love, betrayal and despair play out in action-driven plots peopled by journalists and scientists, politicians and climate activists, and ordinary people struggling to live in the worsening circumstances. The changing climate is often one source of anxiety among others, alongside unsustainable levels of consumption and population growth, concerns over the role of science in society, genetically modified foods, genetic engineering and geoengineering, and more generally what is perceived as the slide into ever more individualistic, virtual and 'unnatural' forms of life.

After the 'Climategate' controversy of 2007 (when leaked emails from the University of East Anglia's Climatic Research Unit were interpreted as evidence that global warming was a scientific hoax) and the failure of world leaders to reach agreement at the UN's Copenhagen conference in 2009, concerns about climate change circulated in an atmosphere of distrust, not just of scientific expertise but also of the formal agencies tasked with dealing with it – from the Intergovernmental Panel on Climate Change (IPCC) to the UN and to domestic politicians. There was a desensitization, too, resulting from exposure to multiple apocalyptic scenarios. A second cluster of novels which appeared after 2010, including titles by Ian McEwan, Ilija Trojanow and Barbara Kingsolver, reflected and responded to this shift in public opinion, by seeking to understand the reasons for the seemingly irrational unwillingness of the public and politicians to take action in the face of the predictions of climate science, and beginning to explore the realities of living with climate change. Other titles published since 2010 in countries from Finland to Australia include: Antti Tuomainen's *The Healer*, Alexis Wright's

6 Trexler, *Anthropocene Fictions*, 7.
7 E. Ann Kaplan, *Climate Trauma: Foreseeing the Future in Dystopian Film and Fiction* (New Brunswick, NJ: Rutgers University Press, 2015). See also Michael Svoboda, 'Cli-Fi on the Screen(s): Patterns in the Representations of Climate Change in Fictional Films', *Wiley Interdisciplinary Reviews: Climate Change* 7/1 (2016), 43–64.

The Swan Book and Nathaniel Rich's *Odds Against Tomorrow* (all 2013); David Mitchell's *The Bone Clocks*, Simon Ings's *Wolves*, Paul Kingsnorth's *The Wake*, Jeff VanderMeer's *Annihilation*, Emmi Itäranta's *Memory of Water* and Johanna Sinisalo's *The Blood of Angels* (all 2014); Bacigalupi's *The Water Knife*, Clare Vaye Watkins's *Gold Fame Citrus*, James Bradley's *Clade*, Elina Hirvonen's *When Time Runs Out* and the Saga anthology of short climate fiction, *Loosed Upon the World* (ed. John Joseph Adams), all published in 2015. Cli-fi continues to evolve (publications in 2016–17 include Maja Lunde's *The History of Bees*, Robinson's *New York 2140*, Ashley Shelby's *South Pole Station* and David Williams's *When the English Fall*), with a small number of novelists (Robinson and Bacigalupi, in particular) focusing their production on depicting climate change, and poets and playwrights contributing work such as Frederick Turner's epic poem, *Apocalypse* (2016), and plays in the UK from Caryl Churchill's *The Skriker* (1994) via Steve Waters's *The Contingency Plan* (2009) to the multi-authored *Greenland* and Richard Bean's *The Heretic* in 2011, and Duncan MacMillan and Chris Rapley's *2071* (2014).[8]

While most cli-fi originates from North America, Britain and Australia, it is (unsurprisingly, given the global reach of climate change) a transcultural phenomenon, with films such as the Korean action movie *Snowpiercer* (2013) and a significant production of novels in Germany and Scandinavia.[9] The small number of non-Anglophone works presented here reflects the paucity of English translations of foreign climate change novels. The absence of translations ruled out practically all the French contenders (works by Antoine Bello, Julien Blanc-Gras, Jean-Marc Ligny, Jean-Christophe Rufin and Philippe Vasset), some thirty German novels, and influential Latin American writing by Homero Aridjis and Rafael Pinedo. Scandinavian novelists, who have fared better in translation, are represented with titles by Jostein Gaarder and Tuomainen. Not only in the English-speaking world, then, climate change

8 See Stephen Bottoms, 'Climate change "science" on the London stage', *Wires Climate Change* 3/4 (July/August 2012), 339–48.
9 See Axel Goodbody, 'Telling the Story of Climate Change: The German Novel in the Anthropocene', in Caroline Schaumann and Heather I. Sullivan, eds, *German Ecocriticism in the Anthropocene* (New York: Palgrave Macmillan, 2017), 293–314; and the essay by Reinhard Hennig in this volume.

stories have become popular vehicles for reflection on our values and way of life, on patterns of material consumption and the tensions between individual self-fulfilment and responsibilities towards others, giving expression to feelings of anxiety and guilt, and asking what sort of future we want ourselves and others to live in.

Fictionalizing climate change: Aims and challenges

Literature plays a part in helping us meet the challenges with which life confronts us, by interpreting the past, dramatizing the situations and choices of the present, and imagining possible futures. Like narratives of gender identity, the stories told about global warming participate in the organization of our social reality as 'regulatory fictions',[10] deploying metaphorical concepts to define and constitute classes of objects and identities, and thereby determining how the problem is framed. Stories are forms of collective sense-making with the capacity to motivate and mobilize readers. Building on neurophysiological research into the ability of engagement with storyworlds to trigger real-world emotions and neural responses, and on narratological scholarship on how storyworlds have the ability to initiate simulation of experience and catalyse a mental and emotional 'transportation' of readers, Erin James and Alexa Weik von Mossner have argued that literature and film can make new things matter to us, widen our sense of identity to embrace human and non-human others, and foster a sense of care. They do this above all through textual cues which invite readers to inhabit a particular point of view, such as the organization of space and time and the depiction of characters.[11] Scholars

10 See Donna Haraway, *Simians, Cyborgs, and Women. The Reinvention of Nature* (New York: Routledge, 1991), 135.
11 Erin James, *The Storyworld Accord: Econarratology and Postcolonial Narratives* (Lincoln and London: University of Nebraska Press, 2015); Alexa Weik von Mossner, *Affective Ecologies. Empathy, Emotion and Environmental Narrative* (Columbus: Ohio State University Press, 2017).

of moral philosophy have advanced a similar argument, the most prominent work in this area being that of Martha Nussbaum. Nussbaum proposes that literature, in calling on the reader to exercise empathy for characters, helps to widen an individual's 'circle of concern'.[12] For Nussbaum, ethical understanding and action require compassion; compassion in turn comprises a cognitive judgement of the scale of another's suffering, whether it was deserved or not, and, crucially, of whether the other is a significant part of our future goals and activities.[13] Fiction and poetry encourage us to enlarge this third point, and to include previously unknown others as important to us.[14]

Moreover, climate change novels and films might provide what one might think of as a therapeutic space, in which collective Anthropocene anxieties are aired, shared and worked through. E. Ann Kaplan argues that the Anthropocene has induced a global 'pretraumatic stress', a macrocosmic version of the PreTraumatic Stress Syndrome (PreTESS) that soldiers experience when assigned to combat. Environmental disaster films, Kaplan suggests, help deal with such trauma; they become 'intriguing, if desperate, attempts by humans to make sense of and find ways around the global catastrophes already in process'.[15]

With its potential for encouraging reflection and motivation, cli-fi might be seen as a vehicle for protest against climate inaction. But, for authors, the possibility of galvanizing readers into action must be balanced against the wish not to alienate them. Invited by the Cape Farewell project to write a climate change novel, McEwan ruminated in an interview in 2007 on the pitfalls of polemic: 'Fiction hates preachiness. [...] Nor do readers like to be hectored'.[16] In a similar vein, Gee, speaking at the 2014 Hay Festival of Literature, cautioned

12 Martha C. Nussbaum, *Upheavals of Thought: The Intelligence of Emotions* (Cambridge: Cambridge University Press, 2001), 319.
13 Nussbaum, *Upheavals of Thought*, 321.
14 Martha C. Nussbaum, *Cultivating Humanity: A Classical Defence of Reform in Liberal Education* (Cambridge, MA: Harvard University Press, 1997), 88.
15 E. Ann Kaplan, *Climate Trauma: Foreseeing the Future in Environmental Film and Fiction* (New Brunswick, NJ: Rutgers University Press, 2015), 1 and 12.
16 Boyd Tonkin, 'Ian McEwan: I Hang onto Hope in a Tide of Fear'. *The Independent*, 20 April 2007.

other environmentally minded authors against being too 'message-y'.[17] Such nervousness is not to be taken lightly. The social protest novel has a proud tradition, but environmentalist sentiments are widely associated with stridency, fear-mongering and dogma, risking accusations of what Frederick Buell calls the 'Chicken Little syndrome' and 'doomsterism'.[18] The mixed reception of Gaarder's *World According to Anna* (2013) and Trojanow's *Lamentations of Zeno* (2011) in Norway and Germany – both of which were seen to be marred by overt authorial intent to drive home the environmentalist message – reflects this dislike of 'preachy' novels.

If cli-fi must avoid what McEwan calls hectoring, it must also be wary of another kind of lecturing. Climate change, more than simply a cultural phenomenon, is, of course, a physical one, knowable through scientific measurement and reporting. Cli-fi is therefore characterized by a mix of factual research and speculative imagination. Although literary fiction is commonly regarded as a form of writing licensed to depart from the purely factual, one distinguished by 'depragmatisation',[19] climate novels often go to considerable lengths to integrate scientific information. In *Flight Behaviour*, for instance, Kingsolver draws on her specialist knowledge as a trained biologist to rehearse the different ways in which global warming might affect the migration routes of the monarch butterfly, and *The Rapture* relies on the short explanations offered by a small cast of scientists to convey the research insights Jensen gained from her interactions with geologists at the University of Bristol. That this handling of scientific content demands particular skill, if the action is not to be interrupted and the reader's attention lost, is shown by the impatience with 'info-dumping' expressed in many online comments on cli-fi.

17 Diana McCaulay, Michael Mendis and Maggie Gee, 'The Untold Story: The Environment in Fiction', Hay Festival, 29 May 2014.

18 Frederick Buell, *From Apocalypse to Way of Life: Environmental Crisis in the American Century* (London: Routledge, 2003), xvii, 244–6.

19 Hubert Zapf, *Literature as Cultural Ecology: Sustainable Texts* (London: Bloomsbury, 2016), 87.

Approaches and forms

Particular difficulties in representing climate change in literary or filmic narrative result from the complexity of its causes and manifestations, and the discrepancy between its enormous spatial and temporal scale and that of individual human experience. Anthropogenic climate change is a global ecological problem which impacts quite differently in different parts of the world, and is set to affect distant generations incomparably more than the present. The issue of scale has received much critical attention in recent years.[20] Several – more or less sophisticated – cli-fi responses to this problem might be sketched. Some texts telescope the time frame, sometimes with a liberal dose of apocalyptic spectacle (for example, in *The Day After Tomorrow* [2004], which presents a similar 'abrupt climate change' scenario as Robinson's trilogy). Others opt for a non-linear depiction of time that might be thought of as postmodern (for example, Winterson's *The Stone Gods*, Mitchell's *The Bone Clocks* and Wright's *The Swan Book*) or otherwise generically innovative (as in the 'futurist history' conceit and docufictional structure adopted in *The Age of Stupid* [2009], where short documentary films are placed within the fictitious frame of a narrator sharing archives from a posthuman future). Still others, grappling with the ecologically and spatially diffuse nature of climate change, focus on a single event or setting that stands in, by analogy, for the multiple and multi-scalar effects of global warming (the monarch butterflies of Kingsolver's novel, for instance). Then, there are novels that deploy a montage of different settings and an ensemble of characters (as in Robinson's *Science in the Capitol* trilogy and Gee's *The Flood*). This recalls Ursula K. Heise's argument that climate change might best be depicted through the fragmented narrative techniques of high modernist fiction: Heise cites David Brin's *Earth* (1990) as a narrative montage embracing a large number of characters and episodes, and inserting

20 Two prominent examples are Timothy Morton's concept of hyperobjects in *Hyperobjects: Philosophy and Ecology after the End of the World* (Minneapolis: University of Minnesota Press, 2013) and Timothy Clark's analysis of Anthropocene disorder and scale effects in *Ecocriticism on the Edge: The Anthropocene as a Threshold Concept* (London: Bloomsbury, 2015), 139–55.

fragments of 'authentic' discourse (quotations from news announcements, letters, legal texts, books and online newsgroup discussions) into the fictional story.[21] Frisch's *Man in the Holocene* (1980) anticipated this technique by integrating a collage of factual information and reflections on the position of humanity in the context of geological time, as an alternative way of organizing and recording knowledge, in the narrative of the protagonist's mental decline (which serves as a correlative of the long-term fate of humanity). Novelists have thus resorted to a range of techniques to render the vast spatial and temporal scale of global warming meaningful for readers.

Associated with questions of scale are the intractability and open-endedness of the 'wicked problem' of climate change.[22] Too often, the progress of narrative emphasizes dénouement; indeed, Frank Kermode's influential analysis suggests that narrative is defined by the drive towards closure.[23] The result can, however, be that the depiction of the human drama takes precedence over that of ecological process, that the latter becomes a mere symbolic representation of a turning point in the protagonist's life, and the intractability of climate change is subordinated to the requirement for resolution of the conflict in order to satisfy the reader. For example, disaster narratives almost inevitably involve master plots of guilt and punishment, the quest for redemption, or romance, implying a degree of resolution which sits ill with the open-endedness of climate change.

Overall, it could be said that cli-fi walks an uneasy line between, on the one hand, presenting the dimensions, processes and impacts of global warming in a way that awakens the reader's curiosity and appeals to her psychologically, intellectually and emotionally – as art generally strives to do – and, on the other, conveying the enormity, urgency and indeterminacy of climate change. Timothy Clark has gone so far as to propose that the conventions of

21 Ursula K. Heise, *Sense of Place and Sense of Planet: The Environmental Imagination of the Global* (Oxford: Oxford University Press, 2008), 205–10. See also Heise's essay in this volume.

22 On climate change as a 'wicked' problem, see Hulme, *Why We Disagree about Climate Change*, 334.

23 Frank Kermode, *The Sense of an Ending: Studies in the Theory of Fiction* (Oxford: Oxford University Press, 1966).

story-telling are inadequate to address climate change in all its complexity.[24] More positively, however, this tension might be framed as an opportunity for the novel to do what it has always done – innovate. Trexler's analysis in *Anthropocene Fictions* is based on the premise that climate change, as a phenomenon comprised of multiple and interlinked kinds of agency, has changed the very form of the novel. Ian Baucom proposes that, since the Anthropocene calls for an understanding of human history at the level of species rather than individual or even political relations, it concomitantly requires a different kind of historical novel.[25]

The sheer prevalence of cli-fi might suggest that literary and cinematic artists are continuing to grapple, in ever greater numbers, with the demands of climate change. Certainly, the growing corpus of texts provides plenty of evidence of authors' response to climate change as a matter of both *adopting* and strategically *adapting* existing generic conventions and approaches, in order to achieve what we have already outlined – alerting readers to the dangers of global warming, informing debates, motivating and empowering to think and act, and thereby facilitating attitudinal and behavioural change, without falling into various pitfalls. A particularly influential mode of writing has been apocalypse, which plays on fears and conveys a sense of the extreme urgency of radical action, but also prominent is its double, pastoral, which conjures up images of harmonious living and cultivates a nostalgic feeling of loss and potential restoration.[26] The plot pattern of transgression and redemption (to which we have already alluded), when set within a world where environmental plenitude gives way to disaster, echoes the biblical narratives of the Flood, the Tower of Babel and the Apocalypse. Other genre models include the detective story (which evaluates clues and exposes criminals), and, similarly to this, the thriller (which is driven by suspense and the progressive revelation of secrets as the narrative reaches a climactic end). There is also the *Bildungsroman*, in

24 Clark, *Ecocriticism on the Edge*, 187.
25 Ian Baucom, '"Moving Centers": Climate Change, Critical Method, and the Historical Novel', *Modern Language Quarterly* 76/2 (2015), 137–57.
26 For a discussion of the relationship between apocalypse and pastoral, see Greg Garrard, *Ecocriticism* (Abingdon: Routledge, 2012), 99 and Heise, *Sense of Place and Sense of Planet*, 141–2.

which the protagonist learns about the dangers of climate change as part of a wider process of self-discovery. Sub-genres including post-apocalyptic cli-fi (at times taking on Gothic features, at others adopting the form of the 'last man', castaway or desert island story), ecotopian narrative, techno-thriller and biopunk have emerged (this last exploring the dark side of biotechnology, while tracing the struggle of individuals for survival and self-realization in dystopian future worlds). Futurist history is a commonly encountered structural device borrowed from sci-fi. Found in purest form in Naomi Oreskes and Eric Conway's *The Collapse of Western Civilization* (2014), where a Chinese historian looks back from the year 2373 at how climate change brought civilization to an end in a great social collapse which decimated the population and forced the survivors to return to a simpler way of life, this framing of climate change is also present in Turner's *The Sea and Summer*, Boyle's *A Friend of the Earth* and, as we have already suggested, the film *The Age of Stupid*.

In such futurist histories, the potential for satire – certainly, self-satire – is evident in the element of self-critique and self-awareness that must inevitably result from the reader's encounter with those in the future who regret and resent humans' past mistakes. More generally, satire plays a role in novels and films which reveal the failings of contemporary society through juxtaposition with alternative realities or exposure of hypocrisies to ridicule. Will Self's *Book of Dave* (2006) and Ian McEwan's *Solar* (2010) are examples of cli-fi in which mockery or black humour plays a major role, serving to avoid heavy-handed stimulation of fear, hate and guilt.

As has already been suggested, the settings and scenarios of some cli-fi might be seen as analogies of the larger-scale patterns and effects of global warming. Going beyond simple analogy, some cli-fi texts explicitly present their stories as allegory. In McEwan's *Solar*, for instance, the protagonist serves as a modern everyman as well as a particular type of scientist and entrepreneur, and a transparently allegorical scene set in a boot room on a trip to the Arctic demonstrates the inability of individuals, however well-meaning, to support each other and organize themselves harmoniously for the common goal of contributing to public awareness of the ecological crisis. Use of symbols is an associated literary technique. In the post-apocalyptic future storyworld of Emmi Itäranta's *Memory of Water*, water has become a precious commodity which the military control access to and use to terrorize the population. The

association of water with life, sharing with others, ecological connectedness and the memory of a truth which the authorities seek to suppress enables the issue of climate change to be overlaid with exploration of personal development and gender issues, and beyond these with reflection on the meaning of life and the ability of art to provide a permanence which human life does not afford.

In other novels, departures from the human focalization and linear narrative structure traditionally associated with literary realism serve to undermine Cartesian exceptionalism and reveal the presence and agency of the non-human. Nature itself can become the narrator, as in Dale Pendell's novel, *The Great Bay* (2010), and anthropomorphism can be a powerful tool 'for questioning the complacency of dominant human self-conceptions'.[27] In *The Swan Book*, Wright draws on Indigenous Australian beliefs to blur the boundaries between human and non-human agency, aligning the ecological mistreatment of the black swans of her novel's title with the injustices visited on her people. The novel is an explicit critique of what Australian ecocritic Val Plumwood has called the 'androcentric, eurocentric, and ethnocentric, as well as anthropocentric' tendencies of dominant Western cultures.[28]

Teaching cli-fi

The plethora of websites marketing, recommending and reviewing climate change fiction is only one form of evidence of the considerable popular interest in the subject. In response to this interest, courses on cli-fi are now being offered at various universities. Perhaps the most obvious question calling for critical consideration is what part fiction and film can play in environmental education. Readings of cli-fi texts frequently focus on the potential

27 Timothy Clark, *The Cambridge Introduction to Literature and the Environment* (Cambridge: Cambridge University Press, 2011), 192.
28 Val Plumwood, *Environmental Culture: The Ecological Crisis of Reason* (London: Routledge, 2002), 101.

of narratives and narrative conventions to raise awareness of climate change and initiate a shift of attitude, thereby addressing what Clark has called 'Anthropocene disorder'.[29] Students might examine the use of role models and identification figures in young adult fiction, and investigate points of view and other literary techniques through which readers' and viewers' identification is cued and empathetic and ethical responses are invited.[30] They might study how literature's eye for detail and sensuous evocation of sights, sounds, smells, taste and feel make storyworlds real and authentic, thereby developing attentiveness to nature (in texts from *Frozen* [2013] to *The Lamentations of Zeno*) and countering the anaesthesizing of the senses that has blocked consciousness of the impact of global warming and our own implication in its causes in everyday life.

Examination of texts might focus on the extent and reliability of the factual information on climate change which they convey, how skilfully it is integrated in the narrative and how effectively it is related to readers' lived experience. Or it could focus on tensions between this dissemination of knowledge and interrogation of our ethical responsibility to future generations on the one hand, and aesthetics on the other. How, and how successfully, is crude didacticism avoided? (It is striking how many narratives adopt an indirect approach to climate change, featuring cooling rather than warming.) To what extent does the author seek to feed into public debates, either by providing information, presenting a particular perception of climate change and its possible resolution, or perhaps rather by promoting critical thinking?

A second possible approach is to explore the ability of 'speculative fiction' (Atwood's alternative term to 'science fiction') to extrapolate from current trends and imagine the future,[31] by comparing different texts as thought experiments, working through the consequences of different choices in differing circumstances and juxtaposing them with non-fiction scenarios such

29 See Clark, *Ecocriticism on the Edge*, Chapter 7.
30 See James, *The Storyworld Accord*; Weik von Mossner, *Affective Ecologies*; and Nussbaum, *Upheavals of Thought*.
31 Margaret Atwood, '*The Handmaid's Tale* and *Oryx and Crake* in Context', *PMLA* 119/3 (2004), 513–17.

as those of the IPCC.[32] It may be instructive to establish and critically assess what they identify as the root causes of climate change, and how they relate environmental degradation to social inequality or gender relations.

A third group of questions relates directly to aesthetics, and through this, returns us to questions of ethics. What role do genres such as thriller, disaster novel and sci-fi play in shaping the account of climate change, what limitations might these impose, and to what extent have given writers succeeded in circumventing these? How do narrative and temporal structure (and other mechanisms for relating the present with the future such as memories and dreams) bridge the gap between the spatial and temporal scale of global warming and that of the human subject? What work is done by framing through prologues and epilogues, ambivalent protagonists (as in *The Lamentations of Zeno*) and unreliable focalizers (as in *Take Shelter* [2011]) to complicate and critique common environmentalist tropes? What use is made of non-mimetic narrative forms such as fantasy and myth, and of religious and literary allusions? The wider symbolic significance of such diverse motifs as troubled parent/child relations, cannibalism, ice, floods and cyborgs similarly invites exploration through comparisons. A focus on reader/viewer identification and ethical response would also facilitate subaltern approaches informed by Marxist, postcolonial, feminist or queer theory, in order to interrogate what is included and what is left out in empathetic and ethical invitations, and affective cues.

The shape and aims of this volume

This collection of essays was conceived as a contribution to the the new Peter Lang (Oxford) series of readers/companions on genre fiction and film. Twenty-four novels and five films were selected (with some difficulty, given the number

32 Alexandra Nikoleris, Johannes Stripple and Paul Tenngart ask how five cli-fi novels relate to and complement the IPCC's latest scientific scenarios of alternative societal developments in 'Narrating Climate Futures: Shared Socioeconomic Pathways and Literary Fiction', *Climatic Change* 143 (2017), 307–19.

of titles to consider and their diversity), as representative of work in the genre. The volume opens with three contributions on proto-climate change fiction: these show that real and perceived changes in the climate were a matter of concern before knowledge of anthropogenic global warming, and that climate change has always been interpreted in the light of human actions, and invested with wider meanings relating to socio-political concerns. The remaining essays have been divided into five sections, on speculative future fiction (dystopian and apocalyptic narratives), realist narratives set in the present or near future, genre fiction (thriller, crime, conspiracy, social satire), children's film and young adult novels, and literary modernism. The essays, which were all written for this volume, were commissioned from an international team of scholars already known for their work in the field. The contributors were asked to offer ways of reading/understanding the text (in most cases a single novel, but in a few, focusing on one novel by the author in the wider context of their work), and to keep plot summaries as brief as possible, so as to leave space for an analysis capable of engaging general readers as well as students and teachers. They were invited to indicate the importance of the work and its reception, and to provide suggestions for teaching. The academic apparatus of references has been deliberately curtailed, but the volume closes with recommendations for further reading and an index. We hope that this publication will fill what we see as a gap between longer, theoretically driven academic studies and the brief descriptive accounts and subjective views expressed in most internet blogs.

Part I
Proto-Climate Change Fiction

Jim Clarke

J. G. Ballard's *The Drowned World* (1962)

In 1962, James Ballard was attempting to forge a career as a writer. The editor of a chemistry journal, and a former medical student and air force pilot, he was desperate to parlay his limited success as a short story writer of sci-fi into a career which could support his young family. During a two-week holiday, he wrote *The Wind From Nowhere*, a potboiler in the style of catastrophe fiction then current in British sci-fi. Looking back on this period from a decade on, fellow sci-fi writer Brian Aldiss dismissed this sub-genre as 'cosy catastrophe'. In these novels, an apocalyptic event triggers the end of civilization, which somehow proves a boon for the protagonist, who is now free from civilizational constraints to act as he chooses, leading to an unlikely comfortable existence. In this vein, Ballard's protagonist, the doctor Donald Maitland, is released from his failing marriage by his wife's death in a hurricane. Maitland embarks on an heroic attempt to preserve collapsing buildings in London. As the winds build inexplicably, humans gather in tunnels and bunkers, fearing the end. Equally inexplicably, the winds begin to die down just as Maitland's own death seems assured.

Ballard dismissed the novel in later life as a 'piece of hackwork', and disowned it, anointing *The Drowned World* as his first 'real' novel. Though *The Wind From Nowhere* is shockingly standard fare compared to Ballard's other work, nevertheless it is not possible to consider the impact of *The Drowned World*, nor what Ballard was trying to achieve, without some consideration of this first, lost climate change novel. It reveals Ballard operating from *within* the cosy catastrophe paradigm, a mode which Aldiss largely attributes to John Wyndham. Clearly, Ballard did not feel that the genre quite fitted his own concerns as a writer. Nevertheless, he persevered, generating four 'elemental' novels, in which the world's climate is destroyed by wind, flood, drought and crystallization in turn.

Ballard is considered one of the foremost practitioners of the 'New Wave' of sci-fi, a movement which emerged in response to the countercultural politics and postmodernist literary style of the 1960s. He saw a pressing need for sci-fi to move beyond hoary old stories of space heroes saving damsels while shooting aliens with laser guns. His novels were characterized by a shift in focus from outer space to 'inner space', which he defined as 'an imaginary realm in which on the one hand the outer world of reality, and on the other the inner world of the mind meet and merge'.[1] All of Ballard's early 'elemental' novels, especially *The Drowned World*, are firmly located as much in this 'interzone' between thought and external reality as they are in realist landscapes, no matter how well drawn or constructed.

For Ballard, 'Earth is the only truly alien planet', and he strives in his elemental novels to depict Earth as utterly alien, revolting against the life which infests it, especially human life. This requires a repurposing of familiar landscapes. In *The Drowned World*, London becomes a lagoon, its tower blocks and famous sights now shadows shimmering far beneath still tropical waters. What is strange for readers in the Anthropocene era is the absence of human responsibility. There is no blood on humanity's hands, as this climate catastrophe is the result not of human interference in atmospheric carbon levels, but of unspecified solar storms. However, in Ballard's disaster novels, the reasons for disaster are much less important than how people react to them.

Scientists exist, and go through the motions of measuring, calibrating and reporting. But there is none of the sense of scientist as hero or messiah one sometimes encounters in later cli-fi, such as that written by Kim Stanley Robinson or Paolo Bacigalupi. Nor is there any sense of Gaia's revenge. James Lovelock's Gaian hypothesis emerged over a decade later, and in any case, Kerans, the protagonist of *The Drowned World*, is wise enough to project forwards, meaning backwards in the distorted psychotemporality of the novel, to realize what is actually taking place: 'The genealogical tree of mankind was systematically pruning itself, apparently moving backwards in time, and a point

1 J. G. Ballard, '1968 Munich Round Up Interview', *Munich Round Up* 100, 1968. Repr. in Simon Sellars and Dan O'Hara, eds, *Extreme Metaphors* (London: HarperCollins, 2012), 10–13.

might ultimately be reached where a second Adam and Eve found themselves alone in a new Eden'.[2]

The Biblical flood is but one of many subtexts and allusions littering the novel. Also prominent to those familiar with Ballard's life story or his autobiography *Empire of the Sun* is the flooding of Shanghai in his youth. As an interned prisoner of war in colonial Shanghai, the teenage Jim Ballard was struck by the flooded paddy fields which separated his camp from the occupied city in which he had formerly lived, a city which itself often saw the streets drowned in silt-laden water after floods. With reference to this memory of Shanghai under water, Ballard asked in his essay 'Time, Memory and Inner Space', 'How far do the landscapes of one's childhood, as much as its emotional experiences, provide an inescapable background to all one's imaginative writing?'[3] The answer, as far as *The Drowned World* is concerned, is very far indeed.

All the practical trappings of climate fiction – the flooded cities, exotic flora and fauna thriving in human-abandoned locales, struggling human settlements in previously remote outcrops – remain intact, or rather, are initiated in *The Drowned World*. Yet everything is suffused with what Freud called *das Unheimliche*, or the uncanny. Ballard's interest in surrealist art comes to the fore in this novel as he portrays aspects of both the environment and what it is doing to its inhabitants via the staging and presentation of famous surrealist artworks, particularly those of Max Ernst.

This uncanniness is sustained in his later two 'elemental' novels, but what is particular to *The Drowned World* is the medium of destruction. Images of skyscrapers peeking above floodwater have become ubiquitous, even clichéd, in the presentation of anthropogenic climate change in fiction, but they commence here, in Ballard's psychogeographical study of devolution. For to be submerged in water is also to be returned to the womb, with its latent possibility of radical rebirth. As the planet returns to the Triassic period, mankind too, in keeping with Ballard's principle of inner space, begins to devolve to an earlier stage of evolution (Figure 1).

2　　J. G. Ballard, *The Drowned World* (London: Fourth Estate, 2012), 23 [1962].

3　　J. G. Ballard, 'Time, Memory and Inner Space', in J. G. Ballard, *A User's Guide to the Millennium: Essays and Reviews* (New York: Picador, 1996), 199.

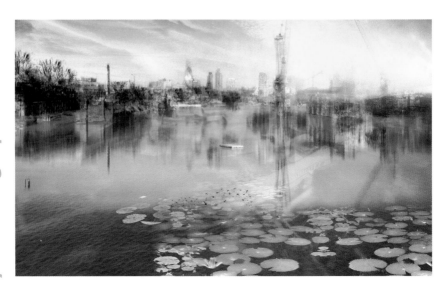

Figure 1. 'The expanding sun and rising temperatures are driving you back down to the spinal levels into the drowned seas of the lowest layers of your unconscious, into the entirely new zone of the neuronic psyche. This is the lumbar transfer, total psychic recall. We really remember these swamps and lagoons'. – from Chapter 5 of *The Drowned World* by J. G. Ballard © Landscape Futures Institute. Reproduced with kind permission.

This all stands disconcertingly in the context of what is, on the surface, a realist novel. Ballard's narrative unfolds in the third person, with extensive passages of description and dialogue, whose uncanny components are all the more striking for being embedded in a realist context. Throughout his career, Ballard was criticized for his character depiction. This began already with *The Drowned World*, whose characters seem either opaque or else perplexingly motivated. Oscillation between, on the one hand, a phantasmagoric landscape rendered realistic and, on the other, the psychic states of the protagonists emerging in Surrealist modes is one of the reasons why readers can find the characters in the novel difficult to grasp.

Kerans, along with his boss Colonel Riggs and his nemesis the looter Strangman, is a figure lifted from the Boys' Own stories of early twentieth-century pulp fiction, but the simple morality of such narratives is carefully subverted by Ballard. Strangman's venal desire for wealth, which he pursues

by draining the lagoon to better access its submerged riches, is read by the authorities as an act of restitution of the lost order, and hence welcomed. By contrast, Kerans's reflooding of the lagoon is not the destructive act it seems but a redemptive one, undertaken in honour of his colleague Bodkins' desire to leave the past in the past, but also out of a conviction that one must adapt to the new paradigm rather than fight it fruitlessly.

Ballard's novel explains what happens when climate change happens to us. Rather than exploring the issues of blood-guilt and collective responsibility for the disaster, Ballard unveils how some people will attempt futilely to fight it, some will attempt just as futilely to carry on as if nothing had changed, some will seek to exploit it for personal benefit, and some will simply aim to survive. It is this last motivation which most interests Ballard, as it leads to both the passive resignation of Beatrice and the radical individualism of Kerans. Even in the face of the apocalypse, Ballard argues, our own personal reactions are the most important component of existence.

The Drowned World is a complex novel which uses a range of literary and cultural allusions in order to convey the idea that inner space is a legitimate topic for literature. Its links with earlier sci-fi, pulp fiction, the Bible, surrealist art and the culture industry are all carefully nuanced to this end. This means that, for a novel featuring climate change, it says curiously little about climate change. Ballard's allegedly prophetic capacity is present in the text, in the images of urban landscapes submerged under steaming lagoons which now haunt so many cli-fi visions. But equally, those images are a commentary on the Shanghai of his childhood, and by extension, on the relationship between empire and colony. Like other supposedly one-directional phenomena, such as time, evolution and scientific progress, it is put into reverse by the catastrophe. In *The Drowned World*, the imperial hubs are sunken into decline. What little life there is exists on the margins.

It is easy to derive despair from *The Drowned World*. Ballard's closing image of a man walking to his death in the heat is not one inclined to inspire optimism, despite the clear Adamic parallels Ballard superimposes upon Kerans. His vision of a destroyed world is not one that can be repaired, restored or rebooted. Science, it is clear, will not save us from ourselves, and indeed may actively hinder us from understanding the circumstances we find ourselves in. Despite its downbeat note, the novel was an immediate hit, and led Ballard to

write his remaining two 'elemental' novels before embarking on a post-sci-fi career with *The Atrocity Exhibition* and *Crash*, which were both notably more experimental and transgressive texts. Yet his novel can still educate us about climate change. Though it eschews anthropogenism in favour of what David Paddy calls 'a primitive id-like nature taking its revenge on London'[4], it forces us to confront climate change in terms of impact rather than cause. In a world where, as Harlan Ellison notes, '[w]hat remains of civilization is fractured at best, and the birth rate has declined to a terminal degree,'[5] it does not matter who is to blame so much as what, if anything, may be salvaged from the submerged ruins. Unlike more recent approaches to the topic, such as Robinson's *Science in the Capitol* trilogy (2004–7), *The Drowned World* has little to say about systematic or institutional approaches to addressing climate disaster. Instead, Ballard zooms in on the individual response. Climate change affects us on the level of the individual, and he forces us to consider the effects of global warming as a 'neuronic odyssey', a journey that will take us far from the comforts of home into a dangerous, even fatal, exploration of the self.

Like its sister novel *The Crystal World*, Ballard's first 'proper' novel offers no sentimentality about our ravaged earth. Both novels reject simple expressions of loss of the past as opportunity costs. Critically, it does not matter in either novel how the catastrophe came about. Blame is not important and Ballard does not address the future, however limited or disastrous it may be. This offers the opportunity to teach Ballard's climate fiction by juxtaposing it with the novels addressing anthropogenic climate change which emerged later. Ballard's foregrounding of the agency of nature also contrasts with the optimistic depiction of human mastery over nature, not least in terraforming, which is found in some later fiction. Additionally, the surrealist imagery evoked in *The Drowned World* facilitates discussion and examination of flooded civilizations as a synecdochal trope of climate change. As I have noted elsewhere, Ballard's 'nightmare vision of abandoned buildings rising from steamy floodplains transcends literature and is now an iconic signifier of global warming itself'.[6]

4 David Ian Paddy, *The Empires of J. G. Ballard* (Canterbury: Gylphi Press, 2015), 52.
5 D. Harlan Ellison, *J. G. Ballard* (Urbana: University of Illinois Press, 2017), 60.
6 Jim Clarke, 'Reading Climate Change in J. G. Ballard', *Critical Survey* 25/2 (Summer 2013), 20.

Thomas H. Ford

Max Frisch's *Man in the Holocene* (1980)

First published in German in 1979 and appearing in English translation the following year, *Man in the Holocene* was written before climate change became a prominent subject of public concern. While the novel imagines climatic transformations, these cannot be related in any direct way to anthropogenic global warming. Nonetheless, Frisch's novel has attracted critical attention for its anticipations of climate change fiction, and has been read as 'a reflection on the Anthropocene *avant la lettre*'.[1] What has primarily motivated these readings is the novel's interweaving of the timescales of lived experience with those of earth history. That formal structure has been seen to offer a premonitory 'cryptogram of the complex and paradoxical human condition' in a time of climate change.[2]

Man in the Holocene tells the story of Geiser, an elderly widower who lives alone in a Swiss alpine village which has been cut off from the outside world, although the cause of this isolation is unclear. Perhaps it is a landslide caused by the incessant, unseasonal rains; perhaps a retaining wall has collapsed: the news in the village is contradictory. The village also loses power and lines of communication. Nonetheless, the villagers seem relatively untroubled. The post office remains open, selling stamps and receiving packages, although the mail truck is no longer running: 'Nobody in the village thinks that the day, or perhaps the night, will come when the whole mountain could begin to slide,

1 Berhard Malkmus, '"Man in the Anthropocene"; Max Frisch's Environmental History', *PMLA* 132 (2017), 71–85, 72.

2 Malkmus, 'Frisch's Environmental History', 74.

burying the village for all time'.[3] But Geiser is an outsider. He has retired to the village from Basel, and while the village cannot envisage its engulfment by the mountain, Geiser imagines great rocks and masses of earth sliding down into the valleys, cracks opening in the mountainside and water rising up to overwhelm the foothills. Geiser thinks this way because he is isolated and alone, and because he is a man losing his grasp on reality. And in thinking this way, Geiser understands his own personal situation – his life, existentially conceived – in geological terms. As Gilberto Perez noted in an early review, Geiser tries to make sense of the unceasing rain, for example, 'by seeing it as a continuation of geological processes inaccessible to the senses yet conceivable to the mind'.[4]

Today, this distinction between what can be perceived and what can be thought appears most urgently as the distinction between weather and climate. Weather is small talk, the everyday occurrence: it looks like rain, fine tomorrow, a change coming through, remember an umbrella. Climate is more abstract. It is *langue* to weather's *parole*, the system in which the conversational remarks of day-to-day weather are uttered. So Geiser is thinking climatically when he understands his personal physical and mental collapse in geological terms. For Perez, Geiser's response to the rain is pathological, and his geological terms are nothing more than symptoms of the faltering of his mind as he slides into dementia. But one could also view Geiser as a pioneer of a new climate change sensibility, a potential model for the cognitive negotiation of a changing geological order.

The German title of the book – *Der Mensch erscheint im Holozän* – could be translated more literally as 'Man appears in the Holocene'. That statement is true only if we understand 'man' here in terms not of species but of the humanist subject. Anatomically modern humans appeared in the Pleistocene. But it was the Holocene, the geological period of roughly the last 12,000 years, that provided the climatic stability within which agriculture, writing, civilization, history, philosophy and so on all developed. Rather than being a story of first appearance or of the ascent of 'man', Frisch's novella is one of disappearance

3 Max Frisch, *Man in the Holocene*, trans. Geoffrey Skelton (London: Eyre Methuen, 1980), 4.
4 Gilberto Perez, 'These Days in the Holocene', *The Hudson Review* 33 (1980), 575–88, 577.

– the disappearance of memory, order and knowledge, of history, writing and sense. The title then raises a question about the coming geological epoch, the age of man's decline. Now that the youth of humanist subjectivity has passed, what other geologies might it inhabit?

That question takes on considerable critical interest following the proposal, first dating from 2000, that the period of the Holocene has now ended and that our contemporary society has unwittingly crossed a geological threshold into the Anthropocene. This new epoch can be distinguished within the geological divisions of Earth history by the fact that human action is reshaping the environment on a planetary scale. Within the humanities, Dipesh Chakrabarty and others have argued that the concept of the Anthropocene radically challenges the way in which we have hitherto understood history, not least by undermining a set of distinctions traditionally drawn between natural history and human history.[5] Historical understanding of climate change requires drawing complex interrelations across what once appeared to be a fundamental discontinuity between the timescales of human collective action and the chronologies of the Earth's crust, 'thinking simultaneously on both registers' and so mixing 'together the immiscible chronologies of capital and species history'.[6]

Viewed in this context, Geiser might appear less as a solitary case of senility than as an example of someone who is beginning to sense the nature of our current predicament. Max Frisch's works often counterpose classical forms (including the forms of classical modernism) with modern technical rationality, and *Man in the Holocene* restages this collision of scientific knowledge and humanist values. Geiser, we learn, always preferred factual books to novels, 'the classics and others'; his personal library includes books on Hiroshima, gardening and encyclopedias, 'as well as maps and rambling guides that provide the geology, climate, history, etc., of the district'.[7] The friction between these two ways of seeing the world – Geiser's malfunctioning technical approach and the melancholy humanism of its narratorial framing – is the source of Frisch's

5 Dipesh Chakrabarty, 'The Climate of History: Four Theses', *Critical Inquiry* 35 (2009), 197–222.
6 Chakrabarty, 'The Climate of History', 220.
7 Frisch, *Man in the Holocene*, 9.

characteristic attitude of irony, and the historical meaning of the novel's tone of negative detachment. It is the source, too, of the novel's humour, often overlooked because the story it tells is so unremittingly bleak. But Geiser's decrepitude, his dithering and his obsessive routines, his constant worrying over his hat, glasses and umbrella, his petty humiliations and ludicrous failures are the stuff of gross physical comedy. There is slapstick in the darkness here, and pratfalls amidst the senescence and decay.

Reading the novel, then, requires holding two apparently irreconcilable interpretations together in the mind at one time. It involves understanding Geiser's geological vision as an idiosyncratic expression of this particular individual life, and also as the collective horizon in which the destiny of modern technological civilization will play out. The problem of how the existential moment of individuality might be reconciled with the time-dimensions of geological and evolutionary cycles is posed within the novel itself as one of novelistic form and purpose: 'Novels are no use at all on days like these, they deal with people and their relationships, with themselves and others, fathers and mothers and daughters or sons, lovers, etc., with individual souls, usually unhappy ones, with society, etc., as if the place for all these things were assured, the earth for all time earth, the sea level fixed for all time'.[8] But Geiser no longer trusts this bedrock of novelistic representation. Reporting from within a perceived climatic crisis, the conditions that once seemed to construct the untroubled and unremarkable background to human society no longer appear to him entirely stable: 'At no time within human memory has a village in this valley been overwhelmed'.[9] But Geiser, drifting free from the orders of human memory, senses the contingency of the ground we stand on, and remarks on the significance of this for literary fiction.

Man in the Holocene sets out to novelize the geology that makes the novel form itself seem redundant. Why read novels knowing that mountains slide into the sea, that the seas overwhelm the mountains, that life-forms mutate as the earth beneath them transforms? Frisch bases his novel on the paradoxical acknowledgement that the literary culture in which it participates depends on conditions over which that culture has no power, and which the novel itself

8 Frisch, *Man in the Holocene*, 8.
9 Frisch, *Man in the Holocene*, 33.

recognizes to have become uncertain and mutable. Moreover, it understands these conditions to include not just the social and economic contexts of writing, but now also the ecological, climatic and geological. *Man in the Holocene* then poses the question of how to write when our dominant narrative forms – the novel, above all – appear moribund, given that the schema of past, present and future through which our narratives have organized their focus on human change rest on an unspoken sense of continuity, of the solidity and fixity of the schema itself, that can no longer be taken for granted.

For Geiser, this problem, of how to write when the once tacit conventions of writing no longer hold, is quite concrete: 'It is idiotic to write out in one's own hand (in the evenings by candlelight) things already in print'.[10] Geiser's solution is to cut out items from his encyclopaedia and other texts that he judges to be worth remembering and to paste them on his walls. These cut-outs appear as text-boxes in *Man in the Holocene*, a collage technique that converts the text itself into something akin to a geological stratum. The excerpts – fragments of other texts which follow Geiser's reading of 'geology, climate, history, etc'. – resemble the distinctive glacial detritus that scientists use to identify geological formations, offering a peculiar cross-section of sedimented natural knowledge. By embedding natural histories of humanity and prehumanity within Geiser's own personal narrative, Frisch's cut-up method could be said to approximate the cross-hatching of discontinuous scales of knowledge that Chakrabarty and others have seen as required for an Anthropocene historical imagination.

Man in the Holocene offers further rhetorical resources for narrating the ecological present. Frisch's sentences in this novel often proceed by way of apophasis, a figure in which you say something by denying that you are saying it. (Gabriele Dürbeck notes that nearly half of the novel's sentences are negations.)[11] In Frisch, such sentences tend to introduce a thought by denying that anyone might think it: 'A lake, the color of brown clay, gradually filling the valley, a lake without a name, its water level rising day by day and also during the nights, joining up with the rising lakes in the other valleys

until the Alps become an archipelago, a group of rocky islands with glaciers overhanging the sea – impossible to imagine that'.[12] Apophasis is part of a family of rhetorical figures that flirt with the unsayable or unspeakable: apophatic speech communicates via an apparent refusal to communicate. So it is a peculiarly appropriate way to express what lies beyond expression: a way to convey an impossible experience, or even to suggest a more profound impossibility of all experience itself. It is a rhetoric that entwines denial with assertion to constitute the negative speech of unacknowledged knowledge. The novel inhabits this paradoxical space of apophasis. It novelizes a geology that makes the novel-form appear irrelevant, and narrates the contradictions of a time in which 'one cannot spend the whole day reading' but in which 'there is nothing to do but read'.[13] If we can now recognize that time as our own – the Anthropocene – then it could well be that the future historiography of our time will also need to invoke this apophatic register.

These formal properties of Frisch's novel – its disintegration of epistemic orders, its darkly comic treatment of mental decay, its collaging of an individual life with geological and evolutionary histories, and its apophatic insistence on what escapes expression – all offer valuable approaches for interpreting and teaching it in the context of climate change fiction. Beyond these particular anticipatory aspects, the novel also invites reflection on how reading more generally is being reconceived as a practice in which such moments of anticipatory coincidence have acquired new meaning in a time of climate change. Reading Frisch's novel today makes manifest what has been called the 'catachronism' of climate change criticism, a paradoxical looping of the temporality of interpretation that involves recharacterizing texts from the past in terms of a future that is not yet realized but which is nonetheless already climatically determined.[14] In other words, *Man in the Holocene* can be read for the manifold ways in which it anticipates later climate change novels and

12 Frisch, *Man in the Holocene*, 21.
13 Frisch, *Man in the Holocene*, 26–7.
14 Srinivas Aravamudan, 'The Catachronism of Climate Change', *Diacritics* 41 (2013); 6–30.

the structures of feeling they inscribe. But it also offers a vehicle for reflecting on this critical practice of climatically anticipatory reading – and so on the altered relation to the future that climate change will instantiate, is instantiating, has instantiated.

Geological Cli-Fi

Mark Anderson

Ignacio Brandão's *And Still the Earth* (1981)

Ignacio de Loyola Brandão's *And Still the Earth: An Archival Narration* represents an anomaly within the history of Brazilian fiction.[1] While Brazil has a rich satirical tradition dating back to the nineteenth century, it is better known for its utopian nationalism rooted in visions of exuberant tropical abundance than the kind of acerbic, dystopian sci-fi that Loyola Brandão deploys in *And Still the Earth*. For the unsuspecting reader, then, the first chapter title is quite shocking: 'The Sirens Wail Nonstop All Night Long. But Worse Than the Sirens Was the Ship Which Sank as the Children's Heads Exploded'.[2] This horroristic scene sets the tone for the novel, which contrasts the drudgery of daily survival under military dictatorship in post-apocalyptic environmental conditions with fragmented, indeterminate memories (such as the sinking ship, on which the narrator's two-year-old son may or may not have died) and the instability of constant crises of every kind and scale. Rather than responding to these intensifying crises proactively, Souza, the middle-class protagonist narrator, and Adelaide, his wife, prefer to maintain their daily routines, which are ordered almost entirely by the state, with a minimum of disruption. However, the crises eventually reach a breaking point and their domestic world slowly collapses. By the end of the novel, Adelaide has disappeared and Souza ends up homeless, packed with millions of others staving off almost certain death from lethal heat beneath the dictatorial regime's final public works project: a series of massive concrete canopies meant to provide shade from the sunlight,

1 Ignácio de Loyola Brandão, *And Still the Earth: A Novel*, trans. Ellen Watson (Champaign, IL: Dalkey, 1981). Portuguese original: *Não verás país nenhum: Memorial descritivo* (Rio de Janeiro: Codecri, 1981).
2 Brandão, *And Still the Earth*, 3.

whose rays have become powerful enough to incinerate the bodies of the multitudes who die each night of sickness, hunger and thirst. Viewed from outer space, these canopies spell out 'BRAZIL'.

Despite its dramatic depiction of irreversible, anthropogenic climate change and the near total annihilation of both human and nonhuman 'nature', Loyola Brandão's novel is not usually read as a serious reflection on the socio-ecological future of the planet. Due to its publication in the early 1980s, its explicitly political subject matter and this relative generic novelty within Brazilian letters, it is more often viewed as a satirical depiction of the military dictatorship that ruled Brazil from 1964 to 1985, forcibly implementing neo-liberal capitalism and extractive practices, militarizing governmental administration and repressing left-wing dissent and the socially marginalized with a mixture of institutional and extrajudicial violence. *And Still the Earth* is also clearly grounded in local and national geopolitical context through the representation of São Paulo's endemic water shortages, which began with the rapid expansion of the city from the 1950s onward. In part, this rapid growth was itself due to the massive influx of people displaced from north-eastern Brazil by poverty and recurring drought (Figure 2), a phenomenon which is also depicted in the novel in hyperbolic fashion. At the same time, however, the transparent intertextuality the novel establishes with Aldous Huxley's *Brave New World* (1932) and George Orwell's *1984* (1948), particularly regarding the biopolitical administration of human bodies by a globalized super state, expands the novel's geographical scope beyond the nation-state alluded to in the Portuguese title, which in a more literal translation would appear as 'There Will Be No Country [Brazil] Left to See: A Descriptive Memoir'.

The novel's English title, *And Still the Earth*, also guides the reader toward a planetary perspective, referring to an expression attributed to Galileo: 'E pur si muove' (and still it moves, to which the author adds 'the Earth' in parenthesis). This quotation serves as a chapter title and the postscript to the novel, almost an ironically hopeful epitaph to counter the novel's five epigraphs, which trace a nihilistic and foreboding progression from Christopher Columbus's and Pablo Neruda's descriptions of pre-Columbian natural abundance to

Figure 2. Air pollution in São Paulo © Thomas Hobbs. Reproduced under Creative Commons by-sa/2.0.

Fernando Pessoa's 'The Horror of Knowing', Clara Angélica's beautiful but contextually terrifying verses conveying that 'to breathe the land / is to want / to know nothing of limits' and, finally, a facsimile page of a decree issued by Portuguese Emperor Dom José I on 10 July 1760 that not only authorized the large-scale deforestation of Brazil's coastal mangrove forests, but also threatened those workers not participating in the deforestation with jail and a fine of 50,000 reals. Given the novel's trajectory toward the almost total annihilation of nature as well as that of Brazil as a sovereign nation, of its citizens and, most likely, of humanity as a whole, Galileo's postscript may in fact represent an epitaph for humanity: the Earth will keep on spinning with or without its human inhabitants. This interpretation is upheld by the fact that, awaiting almost certain death from heat or dehydration under the concrete slabs at the end of the novel, Souza sees a plant sprouting miraculously in the distant, cracked earth, the first authentic plant he has seen growing naturally in decades.

As well as expanding the novel's scope geographically through these planetary references, Loyola Brandão extends its chronology far beyond the historical bounds of the military dictatorship that ruled Brazil when the novel was published. Souza makes quite clear that he is narrating from the future, referring repeatedly back to the 'Open Eighties', which the novel presciently locates at the end of the historical dictatorship, as a key reference in a chronological progression that culminates in the novel's dystopian present, likely in the early 2000s. Tellingly, the descent into the particularly virulent form of capitalistic fascism that governs Souza's present, in which society is fully engineered, administered and policed toward maximum production and consumption with minimal individual rights and freedoms, results largely from the collapse of the democratic state due to the corrupt collusion of Brazilian politicians with multinational corporations. This initial political crisis is followed by a series of satirically named periods arising from the popular experience of social and political crises: the Great Epoch of the Decidedly Incompetent, the Era of Illicit Enrichment, the Great Fear of Leaving the House, the Era of Incredible Rationing, the Era of Notable Traffic Congestion and so on.

The study of history has been abolished by the regime, so these periods have no clear chronology or causal relationship between them; they simply refer to the passive experience of the effects of a series of crises. Indeed, the emphasis on the 'descriptive' nature of the narrator's memoir in the novel's Portuguese

subtitle accentuates the loss of historical agency: limited to documenting what is happening around him, neither the novel's narrator, himself a former history professor, nor any of the other characters are capable of individual or collective political acts due to the unbreakable hold *O Esquema* (the System) maintains on political power and, directly or indirectly, every aspect of its subjects' existence. In fact, they are unable to make even minimal sense of events, since the regime controls all schools and other information sources, limits movement to prescribed areas and routes, monitors all communications and even drugs the 'factitious', synthesized food that its subjects eat with tranquilizers.

Notably, the collapse of the democratic rule of law and civic life, rather than culminating in anarchy as is most common in the North American dystopian imaginary, leads to a retrenchment of state control, the militarization of civil society and this strange form of globalized fascism in which consumerism is enforced by the national state. This representation of the future of democracy under neoliberal capitalism, together with the incredible environmental destruction that results in the near-absolute 'end of nature' (Brazil has been entirely deforested, all of its rivers have run dry and Amazonia has become the world's largest desert), resonates powerfully with the present state of affairs, given: the current political, economic and environmental problems in Brazil as well as the resurgence of fascistic political activism in Western societies; the dictatorial implementation of neoliberal 'austerity' measures, privatization and the unfettered extraction of natural resources worldwide; and high anxieties about species extinctions and localized and global climate change due to anthropogenic activities. Nearly forty years after its publication, Loyola Brandão's novel seems more relevant than ever; its depiction of Brazilian dystopia has become universal as the exploitative models of development and social control that were engineered from the centres of world finance and international politics for the so-called Third World in the 1960s and 1970s have come home to roost in the USA and Europe.

The novel's heavy-handed style, its historical context and its prescience regarding current events and anxieties offer a wealth of possibilities for classroom discussion. On the one hand, the novel exemplifies the most deleterious effects of the anthropogenic modification of both local environments and the global climate; in this sense, it almost demands a reading within the geohistorical framework of the Anthropocene, a geological period first theorized by Eugene

Stoermer and Paul Crutzen, in which human industrial activities have altered the geological record in unprecedented ways. At the same time, the novel's emphasis on the correspondences between anthropogenic climate change and neoliberal capitalism provide an opening to critique Stoermer and Crutzen's formulation, which implicitly claims that all *Homo sapiens* are somehow equally responsible for the massive carbon emissions associated with modern forms of economic production, no matter how little they consume or how sustainable their lifestyles. In *And Still the Earth*, it is clearly the corrupt elite affiliated with the *Esquema* who are responsible for violently reorganizing both society and nature towards maximum production and consumption with no thought for long-term sustainability. The novel thus dismantles the common 'First-World' argument that 'Third-World' population growth is in fact at the heart of both the unsustainable exhaustion of resources and the social inequalities that place a majority of humans in precarious living conditions – in short, the belief that environmental degradation is a species, not an economic, problem.

This reading of *And Still the Earth* could be particularly fruitful when presented in tandem with environmental historian Jason W. Moore's reframing of the Anthropocene as the Capitalocene, which he theorizes as a 'capitalist world-ecology' – a 'capitalism-in-nature' that crystallized as capitalism expanded its frontiers beyond the borders of Europe and restructured human societies and environments around the globe for maximum commodification and accumulation, at the same time radically impoverishing their cultural and biological diversity.[3] The notion of the Capitalocene reinserts class structure and political history into Stoermer and Crutzen's reconceptualization of natural history, recognizing the realities of colonialism, modern North-South geopolitics and the economic history of exploitation of human and non-human nature.

For a more hopeful approach to *And Still the Earth*'s dystopia, one might consider addressing not only the roles that Western humanism's central tenet of human exceptionalism has played in systematic environmental degradation, but also posthumanist arguments for reconceiving humanity as part of a

3 Jason W. Moore, 'Ecology, Capital, and the Nature of Our Times: Accumulation and Crisis in the Capitalist World Ecology', *Journal of World Systems Research* 27/1 (2011), 107–46, 107–18.

community of species within an environment. Indeed, Loyola Brandão made this argument himself in an untranslated essay entitled *O presente é o futuro*: *Manifesto verde* (The Present is the Future: A Green Manifesto), which he published four years after *And Still the Earth*. Written in the form of an open letter to his children, he details a litany of senseless, real-life environmental destruction and political corruption in Brazil that will ostensibly lead to a situation akin to that represented in *And Still the Earth*. Unlike the novel, however, this manifesto aims to persuade its readers to unite in the construction of a viable future, before all human agency is annulled by the inexorable cultural logic of economic determinism under the Capitalocene. Instead, he argues for a revalorization of the economy on the basis of life – that is, ecological principles of ecosystemic health: 'Studying the ecosystem, one realizes that nothing is free in nature. Everything has a function, whether it is a mosquito, a snake, a rat, a cockroach, a swamp.'[4]

This argument for a revalorization of the economy of life has been taken up in several more recent Brazilian works, prominently among them Déborah Danowski and Eduardo Viveiros de Castro's *Ha um mundo por vir?* [Is There a World to Come?].[5] While this work has not been translated either, it expands posthumanist arguments that appear in several of the essays that Viveiros de Castro published in English. A good point of departure might be his essay on Amerindian perspectivism, 'Cosmological Deixis', in which he argues that native Amazonian cultures view many other species not as animals or even plants, but as people who live equivalent lives to humans.[6] He amplifies this point of view in *Ha um mundo por vir?*, arguing that the Anthropocene implies that humans can no longer consider themselves as existing in opposition to or beyond nature; all species are in this together and only by reconceiving of humanity as a multispecies society can we hope to have a future.

4 Loyola Brandão, *O presente é o futuro: Manifesto verde* (São Paulo: Ground, 1989), 8 (my translation).

5 Déborah Danowski and Eduardo Viveiros de Castro, *Há um mundo por vir? Ensaio sobre os medos e os fins* (Florianópolis: Cultura e Barbarie, 2014).

6 Eduardo Viveiros de Castro, 'Cosmological Deixis and Amerindian Perspectivism', *Journal of the Royal Anthropological Institute* 4/3 (1998), 469–88.

Part II

Speculative Future Fiction: Dystopian and Post-Apocalyptic Narratives

Thomas H. Ford

George Turner's *The Sea and Summer* (1987)

The core narrative of George Turner's 1987 novel *The Sea and Summer* – published in the USA as *Drowning Towers* – first appeared in print two years earlier as a short story, 'The Fittest', included in a sci-fi anthology from a small Australian genre press. The story is about survival, as its title suggests, in what for Turner was the not-too-distant future of Melbourne in the 2020s and 2030s. It concerns a family, the Conways, who have been precipitated down a yawning social chasm, falling from 'Sweet', the elite who live lives roughly comparable to those enjoyed in the 1980s by Turner's readers, down into the vast majority of 'the Swill', a workless lumpen multitude housed in crumbling tenement towers and supported by the state at subsistence levels approaching those of bare life, 'nearer to beastliness than most animals ever get'.[1]

The watery metaphors of 'Sweet' and 'Swill' in which this absolute class division is framed derive from the rising tides that are progressively inundating the city with polar meltwaters as part of a generalized ecological and economic collapse. While the Swill retreat upwards into the towers or navigate the streets only on home-made rafts, the Sweets are safe, for the moment, on higher ground. Turner envisions the state responding to the pressures of over-population and climatic catastrophe that have led to this starkly divided society with an exterminatory program of biomedical selection, 'the cull', a 'gene-penetrating virus' that is fluidly contagious, 'spread in sweat and spit and tears, maybe in the water'.[2] The insistently liquid terms of Turner's anticipatory imagination link themes of global warming with those of social class

1 George Turner, 'The Fittest', in *A Pursuit of Miracles* (North Adelaide: Aphelion, 1990), 173–207, 204.
2 Turner, 'The Fittest', 205–6.

and biological genocide, presenting a tale of what we might now call the bio-politics of climate change. The rising seas are both a contributing cause and a contagious vector for the social selection of 'the fittest' via the elimination of everyone else.

In the complex linkages it draws between social and environmental futures, the story implicitly poses a question: who will survive climate change? What will survival involve? Will a new humanity emerge from the Swill, amongst whom elements of love can still be identified, despite their degradation, and who might even potentially 'learn ecology as naturally as speech'?[3] Or will the world to come be constructed in the image of the individualist Sweet, 'the snatcher at advantage, the survivor, the truly fittest'?[4] But these questions are never finally resolved, and the story leaves it up to its readers to draw their own conclusions. And yet they are questions worth considering, Turner suggests, because they are ones his readers are effectively participating in deciding – whether or not they actively reflect on that fact. Indeed, for Turner, the practical demands of the immediate present conspire with complacency to prevent us from reflecting on the probable consequences of our current actions.

Turner personifies his two alternative answers in the characters of Francis Conway, who abandons his family to escape into Sweet corruption, and Teddy Conway, who although identified by the state as an 'Ultra' – one of the very fittest – returns to the Swill in a cross-class alliance with the local tower boss Billy Kovacs. The sibling rivalry of the two brothers, and their attractions and repulsions to the father-figure of Billy, then figure opposing social futures in a familial microcosm. The story employs a multivocal narrative structure to present those futures as equivocal and ambivalent, open to interpretation. It is narrated in first-person sections spoken by the two brothers and, briefly, by Mrs Parkes, a Sweet businesswoman whose black-market books are kept by Francis. In reworking the story into a novel, Turner retained this polyphonic narrative structure while augmenting and complicating it in two main ways that alter how we might understand and so answer its central questions.

The major thematic concerns of the story are left unchanged in the novel, as are the characters and main plot elements of the core narrative of Francis

3 Turner, 'The Fittest', 207.
4 Turner, 'The Fittest', 209.

and Teddy. In this regard, it remains a sci-fi novel on the biopolitics of climate change. But Turner interpolates additional voices that offer further perspectives on the central narrative. Significantly, alongside Francis, Teddy, Nola Parkes and a few others, we now also hear the boys' mother, Alison, who introduces in an opening retrospect the terms of the novel's title, noting the irony that 'the aging woman has what the child desired – the sea and eternal summer'.[5] Alison's words are given a further ironic turn when they are retrospectively revealed to be her last, reported second-hand by her son Francis in the novel's closing pages: she dies, exterminated in the cull, 'rambling about the past, about the summertime and the glistening sea'.[6] The unreconciled rivalry at the end of 'The Fittest' is then at least partly resolved in the novel, in which Francis rejoins his mother, Teddy and Billy amongst the Swill and commits to their collective project of community education that seeks to husband practical knowledge – 'stuff like farming, cloth-making, hygiene' – against the coming dark years.[7] To this extent, the novel can seem more hopeful than the downbeat dystopia that was its textual point of origin.

The second important structural change Turner made in the novel was the addition of a frame narrative, that of 'the Autumn people', who live on a now cooling planet as it enters a new ice age 1,000 years later. This frame narrative is played out between characters allegorically labelled the Scholar, the Artist and the Christian. The Scholar is a historian, author of a voluminous *Preliminary Survey of Factors Affecting the Collapse of the Greenhouse Culture in Australia*.[8] She shares the text we go on to read, the core narrative of Francis and Teddy, with the Artist, who wants to stage a play about 'the Greenhouse years'. It is 'a sort of novel', she explains, a 'historical reconstruction' of true events written to communicate to a broader public her revisionary thesis that the Sweet/Swill divide was not indeed absolute, but was instead mediated extensively through complex personal movements and relationships.[9]

5 George Turner, *The Sea and Summer* (London: Gollancz, 2013), 22.
6 Turner, *The Sea and Summer*, 357.
7 Turner, *The Sea and Summer*, 356.
8 Turner, *The Sea and Summer*, 15.
9 Turner, *The Sea and Summer*, 15, 17.

'The Fittest' had originally been commissioned by US sci-fi author and editor Harlan Ellison, who was visiting Australia in search of local content, but who rejected the story Turner produced as being insufficiently Australian – too distant from the expansive dystopian outback vistas offered, for instance, in the *Mad Max* franchise. In Turner's novel, the Artist similarly rejects the Scholar's text, '*The Sea and Summer*', although for opposite reasons. Because its characters are too entangled 'in the nets of local culture and their own personalities', he writes to the Scholar, they are unable to 'represent the collapsing world'.[10] Indeed, the Artist concludes, it 'might be impossible [...] to create a group that *could* represent it'.[11] Here and elsewhere, Turner's frame narrative stages moments of metafictional reflection on questions that have subsequently become central in critical accounts of climate change fiction, such as that of whether climate change can be accommodated within the scalar norms and other conventions of existing modes of novelistic representation.[12] In *The Sea and Summer*, climate change is figured globally by staging the failure of its local representation. Turner's enactment of that representative failure is linked metafictionally to Australia's liminal position within the international field of sci-fi, at once insufficiently distinguishable from American and British models and yet also overly enmeshed in nets of purely local culture and personality. Australia here is at once too close and too distant from the wider sci-fi world – which is why it can stand in for an uncanny climatic future.

Turner began writing sci-fi only late in his career. In his idiosyncratic memoir of 1984, *In the Heart or in the Head: An Essay in Time Travel*, he gives an account of how and why, in his sixties, this 'staidly respectable writer with half a dozen "mainstream" novels behind him' came to 'kick over his Australian-tradition traces and turn to science fiction, that most suspect of escapist genres'.[13] Turner's account runs on parallel tracks, one biographical, recounting his own childhood experience of abrupt *déclassement*, and the

10 Turner, *The Sea and Summer*, 361.
11 Turner, *The Sea and Summer*, 361.
12 Amitav Ghosh, *The Great Derangement: Climate Change and the Unthinkable* (Chicago: University of Chicago Press, 2016).
13 George Turner, *In the Heart or in the Head: An Essay in Time Travel* (Carlton: Nostrilla Press, 1984), 1.

other a history of the development of sci-fi as a literary system centred on the USA but global in reach. That history had culminated, in Turner's analysis, in the division of sci-fi into 'pop nonsense on the one hand and in more literary finesse than useful content on the other; pop writers are making money and the more literary types are breathing incense from ivory towers'.[14] In consequence, neither literary sci-fi nor genre sci-fi was capable of facing the 'constellation of crises' that Turner identified in his memoir as demanding urgent public attention.[15] Those crises will all reappear as central themes in *The Sea and Summer*: population, food, employment, finance, nuclear war and the Greenhouse effect.[16]

What was needed, Turner argued, was 'a new kind of science fiction writer' committed to creating a literature of ideas for 'the common reader', 'a popular fiction based on logical scenarios for the near future'.[17] In terms of its reception, sci-fi was to be reoriented towards a broad and general readership; in terms of its imaginative projections, it should focus on the nearer future and on the problems of the necessary transition from contemporary circumstances to potential new modes of social life. In *The Sea and Summer*, Turner's description of his divided contemporary literary field reappears allegorically in the social division of Sweet from Swill. The Scholar's historical interest in 'the Fringe' that lay between the two poles of the 'Greenhouse culture' recodes Turner's efforts to forge a path lying between the extremes of contemporary sci-fi as either elitely aestheticized or as mass produced. So too the novel's indication that a future 'Autumn people' might finally emerge if such social interactions were to take on a collective educative function is one that echoes his call for sci-fi to be reinvented as 'solid, tradesmanlike fiction with a purpose'.[18] In the novel, the story of Francis and Teddy ends with something like the revival of collective politics amidst conditions that would appear to have precluded it, those of the Greenhouse culture in which political agency had been effectively extinguished. Turner's metafictional frame allows that story to be read also as

14　Turner, *In the Heart or in the Head*, 203.
15　Turner, *In the Heart or in the Head*, 223.
16　Turner, *The Sea and Summer*, 364.
17　Turner, *In the Heart or in the Head*, 208, 214, 225.
18　Turner, *In the Heart or in the Head*, 226.

an account of the creation of Turner's new middlebrow literature of ideas. *The Sea and Summer* uses sci-fi 'techniques to write political fiction' with the aim of mobilizing reflection on a 'constellation of crises' that interlink the financial with the climatic, class with ecology.[19] But it also allegorizes the transformation of sci-fi into cli-fi that it seeks thereby to effect.

The Sea and Summer was Turner's most popular and critically successful novel – it won the Arthur C. Clarke prize in 1988 – suggesting that he was not alone in his sense that sci-fi could be reformulated into 'a useful tool for serious consideration, on the level of the non-specialist reader, of a future rushing on us at unstoppable speed'.[20] Over the last decade it has come to feature prominently in critical research on climate change fiction as a notably early and prescient instance of the genre. It has been discussed in terms of the sociology of climate change fiction;[21] from postcolonial perspectives;[22] comparatively, alongside scientific depictions of climate change in 1980s Australian culture;[23] and narratologically, as a novel of 'anticipatory memory' written in the future anterior tense of the Anthropocene.[24] These all represent valuable approaches for understanding and teaching Turner's novel, as does the novel's biopolitical dimension: its presentation, that is to say, of the complex relations that entangle contemporary reproductive sexuality with the state and with the rising seas. What I have argued here is that these thematic and formal approaches should also be extended through attention to the novel's metafictional reflections on its own thematic concerns and formal choices, for it is there that it most directly addresses the possible tasks and functions of literature in a time of climate change.

19 Turner, *In the Heart or in the Head*, 226.

20 Turner, *A Pursuit of Miracles*, 209.

21 Andrew Milner, *Locating Science Fiction* (Liverpool: Liverpool University Press, 2012).

22 Anne Maxwell, 'Postcolonial criticism, ecocriticism and climate change: a tale of Melbourne under water in 2035', *Journal of Postcolonial Writing* 45 (2009), 15–26.

23 Ruth A. Morgan, 'Imagining a Greenhouse Future: Scientific and Literary Depictions of Climate Change in 1980s Australia', *Australian Humanities Review* 57 (2014), 43–60.

24 Stef Craps, 'Climate Change and the Art of Anticipatory Memory', *Parallax* 23 (2017), 479–92.

Dana Phillips

Margaret Atwood's *MaddAddam* Trilogy (2003–2013)

In the *MaddAddam* trilogy, Margaret Atwood explores climate change, mass extinction, genetic engineering, globalization, cultural decadence, industrial modernity's failings and – in the face of all these things – the possibilities for environmental resistance. Despite its futuristic setting, much of the trilogy's content derives from familiar elements of the present-day world. This helps Atwood avoid the workmanlike exposition that often features in sci-fi set in alien terrain or a remote future. It also helps make her attitude to environmental calamity and its causes seem less censorious than darkly comic: she presents daring ideas and devastating images with satirical zest.

As the trilogy opens, the everyday reality of the post-climate change and post-industrial era is immediately apparent. Atwood details the failures of modernity throughout *Oryx and Crake* (2003), where the reader learns everything one needs to know to understand her fictional universe (see below). The second and the third novels in the trilogy revisit familiar scenes, and are devoted to backstory and further complications of plot. *The Year of the Flood* (2009) chronicles the activities of the God's Gardeners, an environmental resistance group and religious sect. The Gardeners raise food and keep bees on the rooftops of abandoned buildings, offer shelter to battered women, compose 'green' hymns and collude with corporate renegades, by means of the online game Extinctathon, to help counter the devastation of the natural world. *MaddAddam* (2013) follows the adventures of its titular character, a member of the God's Gardeners, the master of Extinctathon, and an environmental insurgent whose activities take him across a broad swath of North America. At the trilogy's conclusion (where Atwood's fiction seems to shift genres, and arguably becomes a work of fantasy), characters from each of the

three novels unite – with transgenic humans and telepathic hybrid pigs – to defeat a band of murderous ex-convicts.

In *Oryx and Crake*, Atwood treats climate change as if it were a matter of course. Early in the novel, she gives the subject a synoptic treatment: '[T]ime went on and the coastal aquifers turned salty and the northern permafrost melted and the vast tundra bubbled with methane, and the drought in the midcontinental plains regions went on and on, and the Asian steppes turned to sand dunes'.[1] This passage can scarcely be called a full account of climate change. However, it does reflect predictions current at the time of the novel's publication, some of which have begun to be confirmed less than two decades later; arguably, it is more or less realistic. But in *Oryx and Crake*, Atwood is more interested in the effects than in the causes and mechanisms of climate change. While these effects are certainly dramatic, what Atwood depicts may be characterized less as an apocalypse and more as an implosion, one marking the moment when the once-vital distinction between the cultural and the natural no longer affords a firm grasp of experience by serving as an epistemological lynchpin. The lack of epistemological clarity helps explain both the inept response to climate change on the part of a highly technocratic society and the confusion of more than one of Atwood's characters.

Oryx and Crake is the most surefooted of the three novels comprising the trilogy (and the best suited to classroom use) because of the original ways in which Atwood traces its interweaving of the business of gene-hacking and the exigencies of climate change. The two things relate as foreground and background, which exacerbates all the problems Atwood's characters confront. The novel is populated with flawed antiheroes like Snowman, the novel's focal character, and his boyhood friend Crake. Together, the two boys smoke pot, play violent video games, and watch pornography on the Internet. But Crake is no slacker: a brilliant student of evolution and extinction, he trains as a gene-hacker. He then designs and creates the Children of Crake – the Crakers – in his laboratory, intending them as a substitute for *Homo sapiens*, a species he views as flawed. They take their place alongside numerous other transgenic species, including giant neon butterflies and other gaudy creatures.

1 Margaret Atwood, *Oryx and Crake* (New York: Anchor, 2004), 24.

As *Oryx and Crake* opens, Snowman (whose real name is Jimmy) appears to be the only non-transgenic human to have survived a drastic alteration of the natural world and the collapse of civilization in the wake of a plague. He lives along the Atlantic coast of the USA, just where a major city lies in ruins offshore and where the climate, along with the vegetation and animal life, has become neotropical or has been genetically modified. Though they are affectionate creatures, and have been left in his care by Crake, the companionship of the Crakers is no comfort for Snowman. Their humanity is limited and their appearance is unnerving (they all have the same eerily green eyes).

Given the ruined city visible from the beach where Snowman and the Crakers forage and scavenge together, and considering the contents of the garbage they pick through, civil society and organized economic activity – and all those things that once helped to make people humane – appear to belong to an unrecoverable past. For Snowman, the world has become one vast midden. His disenchanted perspective is like the reader's, who grasps his predicament within a few chapters of the novel's beginning, and who soon realizes that Snowman is incoherent, a focal character who cannot focus. He grieves for lost friends and family, and has no one to talk to who can understand his loss. As a result, his grip on language and on meaning itself is slipping. He struggles to recall information (about recondite subjects like jute) and is sometimes unable to complete his thoughts: "'In view of the mitigating', he says. He finds himself standing with his mouth open, trying to remember the rest of the sentence.'[2] He is in equally bad shape physically: malnourished, covered with bites and scratches, and on occasion, drunk. But his precarious world is an emergent one we already have begun to know. Killer heatwaves and storm systems, like exclusive corporate enclaves, the unchecked power of capital and the erosion of intellect in the wake of the digital revolution, define our new normal, and the bestiary of genetically hybrid rakunks, pigoons, wolvogs and bobkittens that keeps Snowman awake at night has its corollary in present-day animals cloned or designed by genetic engineers. OncoMouse, Dolly the Sheep and glow-in-the-dark rabbits are among the most notorious.

2 Atwood, *Oryx and Crake*, 5.

Though many of its features are familiar, the world of the *MaddAddam* trilogy does present some novel cognitive challenges. The opening pages of *Oryx and Crake* are devoted to introducing the most important of these challenges. The first has to do with Snowman's sense of time. As the novel begins, he awakens before dawn and listens to the tide coming in, a sound which should be reassuring: the natural world still follows familiar cyclical and rhythmic patterns. But now the incoming tide passes over 'ersatz reefs of rusted car parts and jumbled bricks and assorted rubble', and Snowman is not reassured by the sound it makes, as something fundamental is lacking: 'Out of habit he looks at his watch – stainless-steel case, burnished aluminum band, still shiny although it no longer works. He wears it now as his only talisman. A blank face is what it shows him: zero hour. It causes a jolt of terror to run through him, this absence of official time. Nobody nowhere knows what time it is.'[3] 'Zero hour' is a phrase we use to mark what we think of as the end of history, as in the case of the doomsday clock that tells us how imminent nuclear annihilation appears to be. Atwood is hinting at a more dire meaning: here 'zero hour' marks not only the end of history but the end of time, too, as something measurable. But that fact alone – the 'absence of official time' – seems insufficiently alarming to explain the 'jolt of terror' Snowman feels as he consults his dead watch. The talismanic timepiece reveals not only the immeasurability of time after 'zero hour' but also its inconceivability, in a future no longer marked in increments of progress. That is what is suggested by Atwood's curious double negative at the conclusion of the paragraph: if 'nobody nowhere' can tell the time, then time itself appears to have been emptied of meaning.

Yet Atwood resists apocalyptic thinking even as she relishes the shock she delivers. Like so much else in the trilogy, Snowman's watch continues to signify the overlapping of culture and nature – the linkage of things like time and tide – despite the watch's presentation of the now blank face of time. It is no less 'talismanic' for having run down. So, far from presenting technology as somehow opposed to nature and attempting to master or obliterate it, Atwood treats it instead as one of the many ways humans have of knowing

3 Atwood, *Oryx and Crake*, 3.

nature reliably. For humans, technology and epistemology are intimately linked. Atwood suggests that this will not change.

The Crakers are perfectly suited to – have been designed for – this anomalous moment in time. They do not need clothes, since their variously pigmented skin – they come in shades of 'chocolate, rose, tea, butter, cream, honey'[4] – is resistant to the ultraviolet rays that flay Snowman. They enjoy a number of other physical adaptations (such as being able to digest grass and purring to heal injuries ultrasonically) that make climate change bearable. Their intellectual differences from Snowman are more noteworthy: for them, 'zero hour' was not especially significant, though they know the world has changed and are curious about the past. They are incapable, however, of articulating the nature of this change, and for them the natural and the cultural occupy a seamless continuum. They are at once the most natural (because they are perfectly adapted to their environment) and the most artificial (because they have been designed in a laboratory) of organisms. They are, literally, technology embodied, but are unaware of their genealogy – at first. Then they begin to evolve, to become more human. Before the trilogy ends, one young Craker has even learned how to read and write.

The Craker children are dedicated beachcombers and bring Snowman their findings for identification: 'They lift out the objects, hold them up as if offering them for sale: a hubcap, a piano key, a chunk of pale-green pop bottle smoothed by the ocean. A plastic BlyssPluss container, empty; a ChickieNobs Bucket O'Nubbins, ditto'. Snowman tells the children, 'Those are things from before'.[5] Snowman is saddened by these things and aware of their pathos. And even though at this point early on in the novel, the reader should have no better idea of what 'BlyssPluss' and a 'ChickieNobs Bucket O'Nubbins' might be than the Craker children have, such degraded, shop-worn commercial language is easily decoded. Atwood uses it throughout the trilogy to underscore how the world has been altered by climate change, gene-hacking and global capital.

The challenges of the post-climate change, post-industrial world are, of course, more than epistemological: they are moral as well. Crake is an extreme antihero, so much so that he also figures as the trilogy's arch-villain. In *Oryx*

4 Atwood, *Oryx and Crake*, 8.
5 Atwood, *Oryx and Crake*, 7.

and Crake, after he creates the Crakers he engineers a pathogen that, when concealed in capsules of the mood-altering drug BlyssPluss, causes a catastrophic global pandemic. Crake is a sociobiologist and a thoroughgoing post-Romantic thinker. He characterizes love as 'a hormonally induced delusional state' and sex as 'a deeply imperfect solution to the problem of intergenerational genetic transfer'.[6] That is why the Crakers do not fall in love and have sex, but instead come into heat and breed promiscuously. When Crake, who is still a student, says to Jimmy, 'I don't believe in Nature',[7] he means that he does not believe its order is immutable nor that there is anything sacred about genomes. The most daring thing about *Oryx and Crake* – and about the *MaddAddam* trilogy as a whole – is that Atwood never suggests that Crake's radically Darwinian worldview is *wrong*, however great the mishaps he causes.

6 Atwood, *Oryx and Crake*, 192.
7 Atwood, *Oryx and Crake*, 203.

M. Isabel Pérez-Ramos

Paolo Bacigalupi's *The Windup Girl* (2009)

The Windup Girl (2009), Paolo Bacigalupi's first novel, narrates life in Krung Thep, City of Divine Beings – commonly known as Bangkok – in the late twenty-third century. By this time, the world has gone from the 'Expansion' to the (petroleum) 'Contraction' period, in what Andrew Hageman terms 'a techno-industrial periodization'.[1] In a world that once had a global economy and a free market – a petroculture propelled by fossil fuels – this translates into an acute energy shortage (caused by the depletion of oil deposits and the scarcity of fossil fuels), as well as a severe environmental crisis. 'Calorie companies', that is, agri-corporations, have taken advantage of the resulting famines to expand the commercialization of their genetically engineered sterile seeds. Moreover, they have spread a series of bio-engineered plagues around the world in a struggle to monopolize food, seed production and distribution. By the twenty-third century, the ever-mutating plagues have already devastated most plant and animal life (including human life) across the planet; calorie companies have managed to control most of the food production worldwide; genetically engineered animals have supplanted their extinct or less advanced 'natural' counterparts; and the Japanese are creating sterile posthuman beings, as assistants, sexual toys and military personnel, to compensate for an aged and diminishing population. In this future world, Thailand is a starved country whose worth is counted in meagre calories. Notwithstanding this, it has prevailed as an independent, self-sufficient nation, thanks to the protectionist controls exercised by its Environment Ministry, and more specifically, thanks to a seed bank that provides it with new genetic material, and the work of the finest scientist specializing in genetic modification – a 'generipper'.

1 Andrew Hageman, 'The Challenge of Imagining Ecological Futures: Paolo Bacigalupi's *The Windup Girl*', *Science Fiction Studies* 39/2 (2012), 283–303; here 283.

The novel thus depicts a genetic tapestry of bio-engineered fruits and trees, cat and elephant-like animals and posthuman beings. In so doing, it questions the morality of GMOs (genetically modified organisms) and the traditional concepts of 'human' and 'nature', calling to mind Noel Castree's analysis and conceptual history of the latter.[2] It also asks what place such new life forms might have in theological perceptions of the soul and the afterlife, from several different religious perspectives, and challenges the notions of 'ecological niche' and 'alien species'. The novel's approach to the general issue of GMOs raises further questions about the limits of science and intellectual property, while deconstructing the human fallacy of being a god-like creator, calling to mind literary works such as Mary Shelley's *Frankenstein; or, The Modern Prometheus* (1818) and Philip K. Dick's *Do Androids Dream of Electric Sheep?* (1968). *The Windup Girl*, moreover, ends with the promise of a queer world populated by transgressive beings and 'the possibility for a new ecological paradigm to emerge'.[3]

These tensions around GMOs are played out in a starved world, decimated as a consequence of a global energy crisis and of climate change. The petroleum Contraction has slowed human development to such a point that carbon-propelled vehicles have become the extravagance of the wealthiest or the means of the military, wars are fought over coal deposits and most of the energy consumed is now produced by animal (including human) bodies. Moreover, the world suffers from environmental phenomena such as disrupted weather patterns and sea-level rise, leaving the Thais struggling to hold on to their doomed city. The centrality of the multifaceted environmental crisis to the plot shows how Bacigalupi is 'trying to find ways to tell compelling and engaging human stories within [the] futures [predicted by environmental science]'.[4] Environmental instability is combined in the novel with bigotry and religious

2 Noel Castree, 'Nature', in Joni Adamson, William A. Gleason and David N. Pellow, eds, *Keywords for Environmental Studies* (New York: New York University Press, 2016), 151–6.

3 Hageman, 'The Challenge of Imagining Ecological Futures', 300.

4 Patrick Wolohan, 'Interview: Paolo Bacigalupi', *SF Signal* (14 September 2009), <https://www.sfsignal.com/archives/2009/09/interview_paolo_bacigalupi/> accessed 21 March 2018.

fundamentalism, as social phenomena exacerbated by dire times.[5] Bacigalupi recounts several examples of religious fundamentalism previous to the time of the narrative, tensions deriving, for example, from the long-standing divisions between ethnic Malays (who are mainly Muslim) and ethnic Chinese in Malaysia, thereby relating the fictional story to real political difficulties in that country.[6]

Bacigalupi thus depicts a bleak future in light of the disturbing data and reports coming from environmental science, which prompt him to write about 'worlds which are often diminished versions of our own present [...] because [he is] worried that we as a society aren't particularly interested in changing our ways'.[7] In *The Windup Girl*, that translates into a dystopian future when most nation states have disintegrated, and the world exists in a quasi-state of apocalypse under the constant menace of fatal plagues and climate change at its worst.[8] Bacigalupi, who remaps the 'combined geopolitical and ecological imaginary' by setting a climate change plot in the Global South, in an Asian country generally regarded as a tourist paradise,[9] uses this devastating scenario

5 The interrelation of environmental disasters aggravated by climate change, and religious fundamentalism calls to mind the research of Kelley et al. on the Syrian drought and the Syrian war, which draws connections between climate change, environmental collapse and social instability – see Colin P. Kelley, Shahrzad Mohtadi, Mark A. Cane, Richard Seager and Yochanan Kushnir, 'Climate change in the Fertile Crescent and implications of the recent Syrian drought', *PNAS* 112/11 (2015), 3241–6.

6 The events in the plot recall the 13 May 1969 incident in Kuala Lumpur between Malay and Chinese citizens, and the subsequent implementation of economic measures such as the New Economic Policy, as an attempt to put in place affirmative action for Malays over ethnic Chinese and Indians in Malaysia. At the time of *The Windup Girl*'s publication, discussions about these policies were still ongoing; see Robin Brant, 'Malaysia questions ethnic preferences', *BBC* (23 July 2009) <http://news.bbc.co.uk/2/hi/asia-pacific/8165746.stm> accessed 31 January 2018.

7 Wolohan, 'Interview: Paolo Bacigalupi'.

8 Other critics, such as Matthew Schneider-Mayerson, describe the novel's world as 'diminished yet never desolate or stagnant – its inhabitants are familiarly restless, vibrant, and searching' – see Schneider-Mayerson, 'Climate Change Fiction', in Rachel Greenwald Smith, ed., *American Literature in Transition, 2000–10* (Cambridge: Cambridge University Press, 2017), 317.

9 Hageman, 'The Challenge of Imagining Ecological Futures', 285.

as a warning for the reader, cautioning about the risk of reaching a point of no return in the environmental crisis, and crossing what in scientific terms has been called too many 'planetary boundaries'.[10] He rebukes the readership by criticizing, from this ominous future perspective, current practices of wasting food and burning limitless amounts of fossil fuels.[11] He does so, ironically, from the perspective of a character who represents neo-colonial interests, exposing the human folly and cynicism – past, present and even future – behind the socio-environmental crisis.

The Windup Girl is therefore a work of extrapolative fiction. Because of the bio-engineered agricultural dystopia it depicts, it has also been labelled 'biopunk' and 'agripunk'.[12] Bacigalupi builds a 'fear fantasy', in an '"if this goes on" story' which reflects current anxieties (about GMOs, energy scarcity, climate change and fundamentalism) and speculates on how they might evolve in the future.[13] In order to achieve this successfully, he employs multi-perspectivity, narrating from the point of view of a range of native and foreign, female and male, human and posthuman characters, to show different experiences, exposures, understandings and ways to cope with the world and the crises he is depicting. Through these multiple voices, Bacigalupi is able to develop a complex plot in a vivid future, interweaving personal dreams and anxieties with the dramatic tension of an international complot and a civil war. His mastery as a storyteller of climate fiction lies in his ability to imagine not only the future of climate and energy, but also attendant socio-environmental and technological changes. He, moreover, provides enough background for the

10 See Johan Rockström, Will Steffen, Kevin Noone, Åsa Persson, F. Stuart Chapin III, Eric F. Lambin, Timothy M. Lenton, Marten Scheffer, Carl Folke, Hans Joachim Schellnhuber, Björn Nykvist, Cynthia A. de Wit, Terry Hughes, Sander van der Leeuw, Henning Rodhe, Sverker Sörlin, Peter K. Snyder, Robert Costanza, Uno Svedin, Malin Falkenmark, Louise Karlberg, Robert W. Corell, Victoria J. Fabry, James Hansen, Brian Walker, Diana Liverman, Katherine Richardson, Paul Crutzen and Jonathan A. Foley, 'A safe operating space for humanity', *Nature*, 461/7263 (24 September 2009), 472–5.

11 Bacigalupi, *The Windup Girl* (London: Orbit, 2010), 92–3.

12 James *Long, 'Interview with Paolo Bacigalupi – Part 2', Orbit, 5 May 2011* <https://www.orbitbooks.net/2011/05/05/interview-with-paolo-bacigalupi-part-2/> accessed 13 February 2018.

13 James *Long, 'Interview with Paolo Bacigalupi – Part 2'*.

reader to understand how the world as we know it could become the world he depicts, making the story much more real and plausible.

The complex, imaginative and well-written entanglement of topics and characters in *The Windup Girl* has led Matthew Schneider-Mayerson to describe it as 'one of the most innovative climate change novels to date'.[14] The book has, moreover, received prestigious awards including the Hugo, Nebula and John W. Campbell Memorial Awards, as well as the Locus Award for best first novel. *Time* magazine named it one of the 'Top 10 Books of the Year' in 2009, and it was selected as 'best science fiction book' by the American Library Association in 2010. Through its extrapolation of current concerns, *The Windup Girl* contributes to current debates, such as that on the production and repercussions of GMOs, by hypothesizing about how necessary they might be if climate change worsens, by questioning the power of multinational bio-technological companies and the agribusiness, and by warning about the risk of biological warfare, as well as about the monopolization of food production – particularly through patenting food sources such as seeds.[15] The novel, moreover, stresses the relevance of looking for sustainable and efficient energy alternatives to fossil fuels, by imagining a post-petroleum future. It is indeed its vivid imagining of a liveable (albeit not desirable) future that makes *The Windup Girl* such an engaging narrative dystopia.

The themes addressed in the novel, together with the extrapolative character of the narrative, make *The Windup Girl* a good text to use in the classroom. From literary or gender studies, to philosophy or bioethics courses, it is certainly capable of facilitating discussions and serving as an object of conceptual analysis. It can be approached ecocritically, for its depiction of a future world deeply affected by climate change, and allows a consideration of the extent to which literature can raise awareness and transmit environmental values and knowledge, as well as its capacity to depict the scale of climate

14 Schneider-Mayerson, 'Climate Change Fiction', 316.
15 For a critical journalistic review of the opinions about GMOs of scientists and environmental activists – particularly of Vandana Shiva – see Michael Specter, 'Seeds of Doubt: An Activist's Controversial Crusade against Genetically Modified Crops', *The New Yorker* (25 August 2014), <https://www.newyorker.com/magazine/2014/08/25/seeds-of-doubt> accessed 30 January 2018.

Biopunk Cli-Fi

change. Moreover, an environmental justice perspective can be applied to analyse how the narrative reflects on the unequal impact of climate change and the environmental refugeeism that might result. Furthermore, this multifaceted climate fiction, titled after the female posthuman character, is full of detailed accounts of rapes and sexual assaults, as well as of erotic descriptions of female bodies in daily contexts, and of patriarchal views, worthy of analysis from a gender perspective. *The Windup Girl* could also be studied through an economic lens or a political ecology approach, for the way it depicts how economic, political and social systems are entangled with ecological thought and practice. It could, moreover, be analysed in a philosophy or a bioethics course, as a contemporary revision of philosophical questions about human nature and posthumanism, and to consider different cultural interpretations of the ethics of genetic modification of plants and animals (including humans) in research and practice. It could serve, finally, to debate how the knowledge produced by the natural sciences challenges preconceived ideas of what is 'natural'. By combining all these critical approaches, the novel could also be analysed from the broader and composite perspective of the environmental humanities. All in all, *The Windup Girl* is a versatile narrative that might serve as a useful tool to engage students from any field in multiple discussions about socio-environmental issues, to foster self-reflection and a critical mind.

Antonia Mehnert

Steven Amsterdam's *Things We Didn't See Coming* (2009)

Steven Amsterdam's first novel, *Things We Didn't See Coming*, first published in 2009, offers glimpses into the life of a nameless protagonist and his struggle for survival in a world that is characterized by weather extremes fluctuating between heavy precipitation and severe periods of drought, battles over scarce resources and an increasing un-inhabitability of places. These changing climatic conditions, indicated to be anthropogenic in nature, force the protagonist as well as the other characters in the novel to continuously re-evaluate their living situations. Through nine individual stories, the reader travels in time, starting at the turn of the millennium when the homodiegetic narrator is still a young boy, as the chapter title indicates at 'What We Know Now', and ending with the closing of his eyes and thus presumably his death about forty years later.[1] Along the way, the protagonist faces not only extreme weather conditions, but also an increasingly disintegrating social order marked by violence, illness and the need for self-reliance.

An overarching theme in Amsterdam's novel is the transformation of places into 'riskscapes' by global climate change.[2] Already the title alludes to the idea of risk-determined landscapes, and this is reflected in the book's

1 Steven Amsterdam, *Things We Didn't See Coming* (London: Vintage Books, 2011).
2 The term 'riskscape' was first introduced by geographer Susan Cutter, who used it to describe the complex interaction between environment, technology and society in the production of specific hazardous landscapes – Susan L. Cutter, *Hazards, Vulnerability and Environmental Justice* (London: Earthscan, 2006). For Cutter, riskscapes are specific geographic areas with particular vulnerabilities. I read the term alongside globalization theory, in order to go beyond the specificities of place and show how climate change creates global riskscapes.

narrative structure and content alike. Amsterdam's landscapes are characterized by the anticipation and experience of a ubiquitous crisis, in which territorial distinctions decline in importance and socio-cultural practices are disembedded from place. The characters in his novel inhabit hazardous places, and, as a result, are forced into continuous movement. As any form of inhabitation becomes impossible, adaptability and constant renegotiation of the self are key to survival. Roots then become routes.[3] Amsterdam's work shows mobility and uprootedness to be the inevitable consequence of global climate change, which no longer allows for any risk-free spaces.[4] *Things We Didn't See Coming* represents the deterritorialized and global dimension of climate change risks without having to rely on digital networks or other means of disembodied, virtual communication. It provides an original narrative template for the representation of global risks, by refusing to focus on one particular locality or place. Amsterdam makes it painfully clear to the reader that if she or he were to zoom in on place in a climatically changed world of the future, that place would no longer be recognizable, because it would have become part of an ever-shifting global riskscape. Ultimately, everyone is thus affected by global climate change.

The dystopian future world depicted in *Things We Didn't See Coming* undoubtedly aims to draw attention to the urgency of environmental issues. However, Amsterdam's vision is not apocalyptic. As ecocritic Ursula K. Heise has explained, apocalyptic scenarios often posit a global disaster situation, in which destruction may be averted in the hope of restoring a pastoral ideal. Risk scenarios, on the other hand, emphasize 'uncertainties, unintended consequences, and necessary trade-offs'.[5] Amsterdam's climate change fiction does not conform to a binary of good vs bad, but rather suggests that the key to

3 The homophonous pun is Clifford's. James Clifford, *Routes: Travel and Translation in the Late 20th Century* (Cambridge, MA: Harvard University Press, 1997).

4 Parts of this analysis were first published in Antonia Mehnert, '*Things We Didn't See Coming* – Riskscapes', in *The Anticipation of Catastrophe: Environmental Risk in North American Literature and Culture*, ed. Sylvia Mayer and Alexa Weik von Mossner (Heidelberg: Winter, 2015), and Mehnert, *Climate Change Fictions* (New York: Palgrave Macmillan, 2016).

5 Ursula K. Heise, *Sense of Place and Sense of Planet: The Environmental Imagination of the Global* (New York: Oxford University Press, 2008), 141.

survival in a world of manifold risks is adaptability to a constantly changing environment involving possible sacrifices. The protagonist is aware that returning to a world without hazards has become impossible. A passage from the chapter 'Uses for Vinegar' illustrates effectively how Amsterdam's work portrays a world at risk rather than a world doomed to be completely destroyed. In this chapter, places are ranked in a 'Most Livable List'[6] after a series of increasingly extreme weather events. The narrator now works as a distributor of cash grants for relocation in places that have to be abandoned. Faced with extreme heat, drought and mosquito attacks, staff members are left with no choice but to take pills to cope with the situation. On several occasions the protagonist mocks the people around him, who still believe in the restoration of order in some other place on the planet:

> Most evacuees don't learn. They try to start over someplace exciting (a target) or temperate (subjects to floods, fires, or earthquakes). Or they identify the month's most thermopolitically neutral region. They assume they're not going to have to pack again. Even though it may be the third or fourth time for some of them, they're still completely tweaked with relocation fever [...]. They take their first steps around their new home and get confident; make friends, buy appliances, plant tomatoes. You want to shake them: *Do you really think this time it's going to be different?*[7]

This passage demonstrates that though there still remains a desire for reterritorialization and an urge to seek psychological comfort in socio-cultural attachment to place, this is ultimately futile. Riskscapes no longer allow for long-term inhabitation. Juxtaposing rootedness and mobility, the narrator clearly indicates that only the latter can serve as a 'route to survival'. Risk is ubiquitous. Approaching the issue of climate change by way of portraying risk-landscapes, Amsterdam shows that ultimately this crisis affects everyone. The book thereby calls for action. However, it does not indicate any concrete measures to be taken. Moreover, the author's ironic style – illustrated by the quoted passage above – diffuses the shock of the revelation of the state of the climatically changed world, and thereby softens the sense of urgency in the book. In the end, the message is, as in other risk narratives, the need to

6 Amsterdam, *Things We Didn't See Coming*, 93.
7 Amsterdam, *Things We Didn't See Coming*, 104.

acknowledge uncertainty. In the first chapter, the narrator's father tellingly explains: 'What we know now is that we didn't think enough'.[8]

The narrative technique which Amsterdam uses to render risk scenarios intelligible is interesting, as it relies on neither the dominant discourse models as defined by Lawrence Buell nor the genre models that Heise discusses for risk narratives, but rather blurs generic boundaries. Buell identifies four rhetorical templates in the representation of toxic risks: 'disrupted pastoral', 'total toxic dispersion', the 'David vs Goliath scenario' and the 'gothic'.[9] Heise furthermore elaborates that risk scenarios also often rely on genre models such as the detective story, tragedy and epic.[10] Yet, Amsterdam's book is not easily located in either of these sets of categories. Although it deploys elements of the coming-of-age story, romance and sci-fi, and resonates with characteristics of the picaresque novel, the narration of *Things We Didn't See Coming* is disrupted to such an extent that generic closure is never really provided. For example, unlike the picaresque novel, in which the picaro's heroic act ultimately lies in his resistance against the hypocrisies of the society he lives in, there are no clearly defined antagonists in Amsterdam's story which would allow for a 'good vs bad' interpretation. Also, unexpected turns in the story, the protagonist's continuous mobility and the fast pace of the narrative convey not only a sense of urgency but also one of disruption.

Amsterdam's narrative technique can be described as a 'stop-start' one, since the nine chapters of the novel are disconnected and could be read independently of one another.[11] Rather than weaving a linear storyline in Aristotelian fashion, presenting set-up, conflict and resolution in chronological order, each chapter elaborates a novel idea in a new setting, involving different characters. Through its fragmented story-telling, *Things We Didn't See Coming* puts characters and readers alike in a position where they cannot

8 Amsterdam, *Things We Didn't See Coming*, 23.

9 Lawrence Buell, 'Toxic Discourse'. *Critical Inquiry* 24/3 (1998), 639–65.

10 Heise, *Sense of Place*, 139.

11 The term 'stop-start pattern' is used for narrative techniques in nonlinear narratives, but lacks precise definition. In Amsterdam's case, stop-start emphasizes disruption, and the protagonist's mobility and multiple displacement.

know what is coming, which effectively illustrates that, although one cannot fully 'know' risks, one nevertheless has to make decisions in the face of them.

Amsterdam's *Things We Didn't See Coming* zooms in on personal experience and puts a human face on the otherwise 'disembodied'[12] idea of global climate change, while at the same time paying credit to its deterritorializing aspects. As the novel illustrates, deterritorialization does not mean that place is completely annihilated, because, as John Tomlinson points out, 'we are all, as human beings, embodied and physically located,'[13] and the need to reterritorialize continues to exercise significant power over our behaviour and psychology. However, what global risks such as climate change confront us with is that as places are continuously transformed, ties to them are significantly weakened. Amsterdam's work thus challenges our understanding of place-attachment, illustrating how, in the future climatically changed world, uprootedness will become the norm. Depicting this future scenario in detail, the book poses important questions about our ability to adjust to climate change: since crisis is inevitable, how can one best prepare for the volatility of riskscapes and changing environments – especially if crisis forces one to live without a 'home' or community of belonging? And are we psychologically and physically equipped to adapt to a life as eternal travellers? Finally, Amsterdam urges us to think beyond place-based routines and open up to global perspectives. He thereby makes an important contribution to debate on the ethical and social ramifications of the environmental crisis, although his message has so far only reached a limited readership – the novel has gained a certain visibility in Australia and the UK (it was nominated for the *Guardian* booklist and won the 'Book of the Year' award of the Melbourne-based newspaper *The Age*) but has not been on bestseller lists.

While the book's episodic structure may be confusing, Amsterdam's prose is an easy read. The text is suitable for readers outside of literature classes and can serve to illustrate some of the narrative strategies and templates used in environmental communication in general and climate change in particular.

12 Mike Hulme, 'Cosmopolitan Climates: Hybridity, Foresight and Meaning', *Theory, Culture & Society* 27/2–3 (2010), 267–76; here 273.

13 John Tomlinson, *Globalization and Culture* (Chicago: University of Chicago Press, 1999), 149.

Whereas environmental discourse has a tendency to draw on apocalypse as a moment of revelation at the end of the world, this fails to reflect the slow and 'unspectacular' character of climate change, which does not manifest in a singular moment but on multiple scales. Instead of playing out in one catastrophic event, global warming produces numerous, ongoing crises, which have no single cause, and a diversity of narrative frameworks is needed to convey them. *Things We Didn't See Coming* should be read as a risk – rather than an apocalyptic – narrative, because while it conveys a sense of great urgency, it still explores ways of adapting to climate change. Theories from the social sciences such as Ulrich Beck's risk theory[14] and Arjun Appadurai's works on deterriorialization and globalization[15] might also be read alongside the novel. The different genres on which Amsterdam's novel draws in depicting climate risk scenarios would also reward discussion in the context of a literature class. And as an example of genre hybridity, the book prompts questions about the ability of different narrative forms and of literature in general to enlighten readers, especially about global warming, and convey ideas compellingly.

14 Ulrich Beck, *Risk Society: Towards a New Modernity* (London: Sage, 1992).

15 Arjun Appadurai, 'Disjuncture and Difference in the Global Cultural Economy', *Theory, Culture & Society* 7/2 (1990), 295–310; Appadurai, *Modernity At Large: Cultural Dimensions of Globalization* (Minneapolis: University of Minnesota Press, 1996).

Axel Goodbody

Ilija Trojanow's *The Lamentations of Zeno* (2011/2016)

The Lamentations of Zeno (2016; originally published in German, 2011) portrays a man whose anger at the public's blindness to the consequences of climate change and desperation over the destruction of the environment lead him to commit suicide, in a dramatic act which he hopes will shake people out of their lethargy. The story unfolds through successive entries in the diary of Zeno Hintermeier, a glaciologist working as lecturer and expedition leader on board a cruise ship in the Southern Ocean. Eloquent in his indictment of the slaughter of animals, the disfiguring of landscape and above all the impact of global warming, which have all reached the last great untouched wilderness on the planet, Zeno also comments critically on the discrimination of indigenous peoples and the economic exploitation of the developing countries. At the same time, however, he reveals a degree of complicity in both respects, and voices views which are troublingly misanthropic. Zeno is therefore a flawed hero, and, we may suspect, a not entirely reliable narrator – for example, in the passages relating to his conveniently commitment-free, seasonally renewed relationship with Paulina, a Filipino waitress on board the cruise ship.

While he functions as a persona of the author, in a narrative drawing attention to the unsustainability of our way of life, Zeno simultaneously demonstrates the inadequacy of moralizing prophecies of doom as a way of responding to the crisis, since his actions are in the end ineffectual. His role is perhaps best understood as that of a holy fool: he is not a role model whose behaviour is presented for readers to copy, but a wildly impractical eccentric, whose madness commands our respect because it refuses to ignore, play down or rationalize away our treatment of the natural environment. Through tragicomic dramatization of the curmudgeonly Zeno's struggles with himself and his fellow men and women, and sympathetic depiction of his self-sacrificial

end, Trojanow calls on his readers to seek other, more effective ways of halting global warming and promoting social justice. The novel contains interludes of satirical humour, but it is essentially the tragic story of an individual who, wrapped up in his personal sorrow and anger, fails to recognize that others are also concerned about climate change, and to work with them. Zeno seeks to jolt humanity out of its equanimity over environmental destruction with his protest action. But his suicide can also be read as an attempt to expiate the sins of a species bent on destroying nature (he regards pollution, consumption and the extinction of species as something akin to original sin), and a search for personal redemption.

Among the more memorable aspects of this novel, which, originally published in 2011, remains the best-known work of German climate change fiction, and is the only one to date available in English translation, are poetic passages evoking the overwhelming spectacle of untouched nature at the outermost frontier of civilization, the majestic and mysterious scenery of the Antarctic. Interspersed in Zeno's account of the voyage from the port of Ushuaia in Argentina's far south, to the Falkland Islands, King George Island, South Georgia, Deception Island and the Antarctic mainland are recollections of how he became a glaciologist, and the events which led him to quit his university job in Munich and spend half the year in the Antarctic. He recalls how, on a hot summer day in his childhood, his father drove him from the city down to the Alps, and he first met a glacier (Figure 3). It seemed like a dragon in reverse, breathing cold instead of fire. Over the years he developed an intimate relationship with the great beast, initially as an object of wonder and a playground, later as a subject of scientific investigation, but always as a being for which he felt affection and reverence. Visiting it as a professional researcher to observe and record its gradual shrinkage, he greeted it like a beloved partner afflicted by a terminal illness. Its final meltdown, leaving behind 'lumps of darkened ice strewn over the cliff like rubble waiting to be removed from a building site', coincided with illness and the breakup of his marriage, precipitating an existential crisis.[1] Zeno has sought solace in the icy wastes of the *Terra Nullius*.

1 Ilija Trojanow, *The Lamentations of Zeno*, trans. Philip Boehm (London: Verso, 2016), 78.

Figure 3. Glacier melt in the Alps, as described in *The Lamentations of Zeno.*
Here the Pasterzen Glacier and Großglockner mountain, Austria © H. Raab.
From <http://flickr.com>.

At first, he derives satisfaction from his lecturing; he finds companion-
ship with like-minded colleagues, and happiness with Paulina. But everything
begins to fall apart when, in full sight of a group of tourists whom Zeno is
leading, a Chilean soldier blatantly breaks the internationally agreed codes
of behaviour on the continent. Zeno's overreaction nearly precipitates an
international incident, and almost loses him his job. His native Bavarian pen-
chant for taciturn stubbornness and contrarianism develops into disgust with
his fellow human beings, and his tirades estrange him from all but the most
sympathetic people around him. When a famous installation artist joins the
cruise with plans to assemble the ship's passengers standing in a giant SOS on
the ice and photograph it from the air to promote awareness of global warm-
ing, he is alienated by the man's showmanship. It prompts him to turn artistic
simulation into a genuine emergency.

Only at the end of the book do we learn from Zeno's diary exactly what
he does and why. However, the essentials have already been gradually revealed.

Set off by a section break composed of dot-and-dash Morse Code notation for the international distress signal, each chapter closes with a cacophonic collage of conversational fragments, advertising slogans, lines from popular songs and pornographic phrases, as if the reader were scanning radio stations or overhearing flippant chatter at a crowded bar. What unites the snippets of verbal material is an attitude of superiority and cynical indifference. Embedded in them are maritime distress calls and 'breaking news' announcements of an 'accident' on board the cruise ship which track the loss, hijacking and discovery of the *Hansen*, starting at the point in time of Zeno's last diary entry. As a structural device, these passages represent the clamour of human civilization, contrasting with the silence of the Antarctic, and build tension throughout the novel.

Trojanow's novel is distinguished from the thrillers and disaster novels which make up the bulk of climate change fiction by 'literary' qualities including aphorisms and historical and literary allusions. Zeno describes climate change as 'the blind spot of our calculated optimism', and progress as 'destroying the essential to create the superfluous', commenting: 'we're infesting now in our future'.[2] He is compared with Cassandra, the priestess in Greek mythology who was endowed with the gift of foreseeing coming disasters, but condemned never to be believed. His name references Zen Buddhism, but also the Greek founder of Stoicism, whose central tenet is that we should live in accord with nature and promote moral progress. He presents the Antarctic explorer Ernest Shackleton as a historical touchstone of moral probity, and quotes three poets in his diary. The most important of these is Samuel Taylor Coleridge, whose 'Rime of the Ancient Mariner' is cited at several points. Zeno resembles the ancient mariner, haranguing the public with his tale of ecological transgression, whose atonement demands reestablishment of a natural relationship with the natural world.[3]

Originally published with the title *EisTau* (literally 'ice thaw'),[4] Trojanow's novel met with a mixed reception. Read by leading German critics as a disappointing addition to the work of an established author with a reputation for

2 Trojanow, *The Lamentations of Zeno*, 80, 124.

3 See Kate Rigby, *Topographies of the Sacred: The Poetics of Place in European Romanticism* (Charlottesville and London: University of Virginia Press, 2004), 204–9.

4 Trojanow, *EisTau* (Munich: Carl Hanser Verlag, 2011).

espousing social and political causes, it was dismissed as a crude expression of environmentalist values, marred by maudlin sentiment. However, an extended reading tour, in which the author recited from Zeno's diary, accompanied by violin, saxophone and cello playing specially commissioned music, was enthusiastically received.[5] The book has also been adapted for the stage, in an ambitious production in Bremerhaven, home of Germany's climate museum, Klimahaus, which involved scientists working at the polar research institute which is based there. It has since come out in paperback and as an audio book. Philip Boehm's sensitive English translation was welcomed by reviewers in *The Times Literary Supplement*, *The Guardian* and *The New Yorker*.

There are several ways in which *The Lamentations of Zeno* might reward inclusion in the teaching syllabus. As a confessional narrative appealing openly to readers' environmental consciences, it illustrates the danger of putting off readers by preaching, and invites critical discussion of how successful Trojanow is in avoiding this pitfall.[6] Alternatively, it might be read alongside other environmental novels as an exposure of the latent misanthropy in deep ecology, and a critique of the apocalyptic pessimism which has characterized parts of the environmental movement.[7] Zeno might, for instance, be compared with the melancholic, contrarian environmentalist Walter Berglund in Jonathan Franzen's *Freedom* (2010).

Passages such as Trojanow's depiction of Grytviken as a site of butchery would support a reading of *The Lamentations of Zeno* as an example of 'toxic discourse,'[8] and of 'dark pastoral.'[9] The extent to which Trojanow seeks to inform

5 An excerpt can be seen at <https://www.youtube.com/watch?v=ELt6OHsZKdo>.

6 The long interview with Trojanow at <https://soundcloud.com/versobooks/the-lamentations-of-zeno-a-conversation-with-ilija-trojanow> provides information on the autofictional nature of the book.

7 See Steve Masover's entry, 'Desperate Books Aren't Suited to Desperate Times' on his blog, *One Finger Typing*, <http://stevemasover.blogspot.co.uk/2016/08/desperate-books-arent-suited-to.html>, which details how he was simultaneously engaged and repelled by the book.

8 Lawrence Buell, 'Toxic Discourse', *Critical Inquiry* 2/3 (1998), 639–65.

9 Heather I. Sullivan, 'The Dark Pastoral: A Trope for the Anthropocene', in Caroline Schaumann and Heather I. Sullivan, eds, *German Ecocriticism in the Anthropocene* (New York: Palgrave Macmillan, 2017), 25–44.

his readers as well as entertaining them, and the ways in which he integrates elements of climate science, are a further subject meriting comparative exploration. Finally, the novel might be read with profit as an example of writing on the Antarctic landscape, alongside travel diaries such as Apsley Cherry-Garrard's classic account of the tragic expedition led by Robert Scott, *The Worst Journey in the World* (1922), and novels such as Kim Stanley Robinson's *Antarctica* (1997).[10]

10 For the titles of further novels, see the blog 'Antarctica in Fiction: More than a blank page', <http://www.quixote-expeditions.com/antarctica-in-fiction/>.

Kiu-wai Chu

Bong Joon-ho's *Snowpiercer* (2014)

Loosely based on Jean Marc Rochette's graphic novel *Le Transperceneige* (1982),[1] South Korean director Bong Joon-ho's *Snowpiercer* (2014) is a cli-fi adventure movie that depicts human survival on the frozen planet Earth, in the near future of 2031. The movie deals with important issues in the age of climate change, such as the risks of geo-engineering, extinction and sustainability, social inequality and environmental injustice. The story begins in 2014 when governments all over the world start dispersing an artificial cooling substance, CW-7, into the upper layers of the atmosphere, in a collective effort to tackle climate change and bring down the global temperature to manageable levels. But the plan backfires catastrophically. Soon after the dispersal, the world begins to freeze. All life forms become extinct within a short time, except for some thousands of survivors, who are able to board a uniquely designed and engineered mega-train, the Snowpiercer, built by an engineer named Wilford. The train was originally designed for a luxurious locomotive cruise operating along a circular railway with a length of 438,000 km, encircling the Earth once a year.

Powered by an advanced 'perpetual-motion' engine, the train is a closed and self-sustaining ecosystem. Inside it, the passengers are separated into different carriages, which also divide them into distinct social classes. In the front section reside the god-like Wilford and the 'sacred engine' he invented that controls the entire train. Behind him, in the middle sections, are luxurious

[1] Published in English translation in 2014 as 'the graphic novel that inspired the film': Jean-Marc Rochette (illustrator) and Jacques Lob, Benjamin Legrand and Oliver Bocquet (authors), *Snowpiercer*, vols 1, 2, 3 (London: Titan Comics, 2014).

carriages which house wealthy people enjoying an extravagant lifestyle. A completely different world is seen in the carriages at the rear, where over a thousand passengers are packed into cramped and filthy spaces with hardly any food. Their conditions are so poor that, led by the protagonist Curtis, they start a rebellion and force their way to the front section, aiming to take over the engine and overthrow their oppressors. Class distinctions aside, the train is a multicultural, multiethnic melting pot where geographical and cultural boundaries are completely blurred and dismantled. However, far from depicting a positive and optimistic picture, the film is a post-apocalyptic dystopia that metaphorically reflects the socio-political problems experienced in our present world.

In the closed system of the train, air, water, food supply and population must all be kept in balance. On the surface, it appears that little goes to waste and everything can be fully utilized. However, the rich passengers are not interested in sustainability, and do not make any effort to create a fair environment for everyone on the train. Instead, they are obsessed with finding ways of obtaining the 'optimum balance', that is, guarding their privileges. The living conditions of the rich and the poor are strikingly contrasted in the film. While the elite in the front carriages have wine bars and dining places, a swimming pool and sauna rooms at their disposal, the lower classes are treated like refugees, cramped in the slum-like rear sections. Global environmental injustice is reflected in the front section passengers being served with sirloin steak and sushi, while the masses at the rear are forced into cannibalism. To regulate the population and prevent the train from becoming overpopulated, Wilford deliberately incites a riot in the tail section and allows the lower classes to fight their way to the front, in order to get a considerable number of 'disposable people' killed off.

The exploitation of the tail section passengers in the film is extended also to the young. After seventeen years of uninterrupted operation, Wilford's engine is finally wearing out. Without the resources to have it fixed, the people in charge begin abducting boys from the tail sections, as they are small enough to fit inside the malfunctioning engine and keep it operating. In an interview, director Bong Joon-ho has suggested that the child exploitation in the film is reflexive of real-life cases in Bangladesh, where for decades children have been hired in the shipyards for risky and hazardous jobs breaking up decommissioned

ships, where adults are too tall to fit inside the ships.[2] Scholars have pointed out how people in the underprivileged Global South, 'disposable people' in Kevin Bales's parlance, are coerced into hard manual labour.[3] They are also more prone to become victims of ecological crises such as earthquakes, floods and tsunamis triggered by climate change, due to their lack of resources that could keep them safe and protected. This prompts us to ask: what order and balance are we talking about here, when resources are far from evenly or fairly distributed among people on the train? Is overpopulation the real problem on the train that needs solving? Or are the resources on the train too unevenly distributed among the rich and the poor?

As a cli-fi movie, *Snowpiercer* makes use of various cinematic conventions to draw attention to thematic issues such as the possibility of human extinction in a dystopian future. The film has a linear, straightforward narrative to depict Curtis and his gang's fight from the very last section of the train to the front. It is the oppressed people's journey towards basic survival. At the same time, it is also a journey of rediscovery of things that once existed in the human world but are gradually disappearing. When Curtis and his people leave the rear section, they are delighted by the sight of glass windows, and the natural sunlight that enters through them from the outside world, as well as the skyscrapers outside, which are now lifeless and covered in snow, but offer people on the train a glimpse of human civilization in a bygone era (Figure 4). The tail section people are reintroduced to a number of things that they thought had become extinct – from cigarettes, guns and bullets to vegetables and meat. Through the eyes of a 17-year-old girl, Yona, who was born in the tail section and has no memory of the world as we know it, viewers are led to see ordinary things in everyday life from a new perspective. Entering the aquarium and the

2 David Gregory Lawson, 'Interview: Bong Joon Ho', *Film Comment* (27 June 2014). <https://www.filmcomment.com/blog/interview-bong-joon-ho/> accessed 28 March 2018.

3 Kevin Bales, *Disposable People: New Slavery in the Global Economy* (Berkeley: University of California Press, 2004); see also Rob Nixon, *Slow Violence and the Environmentalism of the Poor* (Cambridge, MA: Harvard University Press, 2011), and Ramachandra Guha and Juan Martinez-Alier, *Varieties of Environmentalism: Essays North and South* (London: Earthscan, 1997).

greenhouse sections, Yona sees marine life, soil, plants and living earthworms for the first time in her life (Figure 5). The film sets up a futuristic world where species have become extinct, but bit by bit it re-presents them in front of our eyes. Making use of Russian literary theorist Viktor Shklovsky's idea of 'defamiliarization' and 'making strange' (theorized in his 1916 essay 'Art as Technique'), *Snowpiercer* represents familiar things and environments as something new, and invites us to share the characters' pleasure in seeing everyday life from a fresher perspective.[4] The film points us to the importance of treasuring what we possess in our world today, before it becomes extinct in the near future.

Figure 4. Lifeless landscape outside the train with snow-covered skyscrapers. *Snowpiercer*, dir. Bong Joon-ho (Moho Film/Opus Pictures/Stillking Films, 2013).

Since almost all sequences in the film take place on a train, the filmmakers follow a strict rule in their camera positioning and movements, in order to give the audience a sense that the protagonists are constantly moving forward in a single direction, from the last to the first car. There are numerous shots in which the camera is set in front of Curtis and his gang, where the characters are framed facing and approaching the camera. It is as if we the viewers are

4 Viktor Shklovsky, 'Art as Technique (1917)', in K. M. Newton, ed., *Twentieth-Century Literary Theory: A Reader* (Basingstoke: Palgrave Macmillan, 1997), 3–5.

Figure 5. Yona and the tail section passengers, amazed by the aquarium on the train. *Snowpiercer*, dir. Bong Joon-ho (Moho Film/Opus Pictures/Stillking Films, 2013).

placed in the position of the ruling class, confronted by the angry, exploited protesters (Figure 6). With this framing of shots, the film pushes us to reflect upon our role and position as global citizens in a world characterized by human inequalities and environmental crises – whether we have been taking things for granted from the position of a privileged class, and are indulging in excessive consumption and misuse of the limited resources in our everyday life in ways that could, directly or indirectly, involve exploitation of the poor and underprivileged.

Having fought his way from the rear of the train to the front, in the process of which most of his followers have lost their lives, Curtis finally meets Wilford. To Curtis's surprise, the ageing engineer offers Curtis his place of the chief commander of the train, in order to keep it moving. Curtis is faced with the choice of whether to keep the flawed and exploitative system in operation, or to destroy it altogether. Metaphorically, this is also an invitation for us to rethink whether we should keep the exploitative capitalist system in place, and continue to consume excessive resources in the world, while letting the marginalized, underprivileged classes elsewhere in the world suffer, or whether we should be prepared to act and challenge the system, to come

Adventure Cli-Fi

Figure 6. Angry protesters confront the ruling class (and viewers of the film).
Snowpiercer, dir. Bong Joon-ho (Moho Film/Opus Pictures/Stillking Films, 2013).

up with alternative, collective ways of tackling the environmental challenges
that affect the entire human race.

In the end, the train is stopped and destroyed, by an explosion and an
unexpected avalanche. Only two of the younger characters walk away from
the scene alive. The first sight in front of them is a polar bear on the snowy
landscape (a contemporary icon for global warming), staring back at them
from a distance. This, Bong suggests, represents 'a hopeful ending' for human-
ity, as a new and different civilization can now be re-established by the two
young survivors (Figure 7).[5]

One major challenge for the cli-fi genre is to envision the future world
without being trapped in the constraints of dominant ideologies of the day.
As a cli-fi movie, *Snowpiercer* constructs an imaginative fictitious world for us
to reflect critically upon issues of global inequality when faced with massive

5 Simon Abrams, 'Director Bong Joon-ho Breaks Down Snowpiercer's Ending', *Vulture*
 (29 June 2014). <http://www.vulture.com/2014/06/director-bong-joon-ho-talks-snow-
 piercers-ending.html> accessed 28 March 2018.

Figure 7. A polar bear symbolizes hope for humanity. *Snowpiercer*, dir. Bong Joon-ho
(Moho Film/Opus Pictures/Stillking Films, 2013).

environmental crises. Its representation of food ethics, however, reflects the
filmmakers' limitations in envisioning a future where new, alternative kinds of
ethics and practices can be promoted. In the film, the production of protein
bars from huge processed and gelatinized bugs is used to evoke shock and
disgust in the viewers. In reality, insects have been increasingly recognized as
a sustainable food source. In this respect, *Snowpiercer* falls short of adopting a
more progressive thinking that promotes sustainable lifestyles not yet widely
accepted in today's world, as a way to further provoke viewers' minds to chal-
lenge dominant ideologies in the present world.

 With its focus on displaced environmental refugees, uprooted from their
home countries and cultures, *Snowpiercer* is an excellent text for teaching
about the social impact of climate change, and the injustices to which it can
lead. While extreme climate change has brought people of different national
and cultural backgrounds together in the film, the rich and powerful retain
their privileges. Students may be prompted to ask what aspects of the film
reflect real life situations, to consider whether the poor and minorities will
be able to preserve their cultures and ways of life, or they will struggle to just

keep alive, and to reflect on how environmental injustice and sociocultural injustice compound each other.

Apart from debates centring on social inequality and environmental injustice, discussion of the film might focus on the representation of geo-engineering/climate engineering. The film's imagination and representation of science, technology and sustainable living in a post-apocalyptic future has been a subject of criticism. One critic called it 'cli-fi with no science in it',[6] as no further scientific explanation is given as to why the cooling substances fail, and the film makes no attempt to explain how the train operates perpetually on the frozen planet.

However, is it important for cli-fi movies to get all the facts right? Scientists have for years explored the possibilities of pumping water-based sulphate spray or spraying nanometer-sized diamond dust into the atmosphere in order to reflect and scatter the sun's energy, but most of these proposed geo-engineering solutions are still just ideas waiting to be put into practice. It is also pointed out that most of them are 'fixated with getting the Earth's average temperature down and they miss the importance of the distribution of temperature with latitude, which is in fact what drives climate'.[7] Until we come up with better plans and regulations for geo-engineering technology, cli-fi movies like *Snowpiercer* will continue to be valuable in stimulating our imagination of climate change-related catastrophes.

6 Ted Alvarez, '*Snowpiercer* is cli-fi with no science in it. We need more films like it', *Grist* (11 July 2014) <https://grist.org/living/snowpiercer-is-cli-fi-with-no-science-in-it-we-need-more-films-like-it/> accessed 28 March 2018.

7 Mark Maslin, *Climate Change: A Very Short Introduction* (Oxford: Oxford University Press, 2014), 162–3.

Stef Craps

Jeff Nichols's *Take Shelter* (2011)

Released in 2011, *Take Shelter* is an American feature film written and directed by Jeff Nichols and starring Michael Shannon and Jessica Chastain.[1] Set in LaGrange, Ohio, it tells the story of a family man and construction worker, called Curtis LaForche (Shannon), who is plagued by a series of apocalyptic nightmares and visions. He starts to believe that he is developing paranoid schizophrenia, the illness with which his now-institutionalized mother was diagnosed when she was a similar age and which he has feared inheriting his whole life. At the same time, he becomes increasingly obsessed with the need to shelter his family – his wife Samantha (Chastain) and their hearing-impaired young daughter Hannah – from the coming storm that he cannot help thinking his terrifying dreams and hallucinations signal. Foremost among the protective measures he takes to keep his family safe is the renovation and expansion of the tornado shelter in his backyard, which he can ill afford and which causes him to lose his job and his health insurance, as a result of which Hannah cannot have the cochlear implant surgery she was scheduled to undergo. The question of whether Curtis is a prophet or mentally disturbed drives the film and remains unresolved until the epilogue, when his premonitions turn out to be true as an actual end-of-the-world storm is about to hit.

Take Shelter captures many of the anxieties of living in the post-9/11, post-Katrina and post-financial crisis USA, thanks to the 'flexible metaphor' of Curtis's apocalyptic visions.[2] Increasing in violence and intensity as the film progresses, they take the form of thunderstorms, twisters, flash floods,

1 *Take Shelter*, dir. Jeff Nichols (Hydraulx Entertainment, 2011).
2 Agnes Woolley, '"There's a Storm Coming!": Reading the Threat of Climate Change in Jeff Nichols's *Take Shelter*', *ISLE: Interdisciplinary Studies in Literature and Environment* 21/1 (2014), 174–91, 177.

Psychic Cli-Fi

Figure 8. Swarms of menacing birds. Michael Shannon in *Take Shelter*, dir. Jeff Nichols
(Hydraulx Entertainment, 2011).

motor-oil-like rain, swarms of menacing birds and attacks by the family dog
and zombie-like strangers as well as people close to him (Figure 8). They can
be interpreted as relating to pervasive fears about the threat of terrorism, eco-
nomic precarity, the implosion of the American dream and environmental
devastation caused by climate change. Like several of Nichols's other films,
Take Shelter can also be seen to explore the crisis of contemporary masculin-
ity through Curtis's gradual loss of control over his family's financial, physical
and emotional well-being, and his ever more desperate and self-destructive
actions in response to a world becoming unhinged. A tempting rationaliza-
tion that the film provides for Curtis's disturbing dreams and hallucinations,
by drawing attention to the history of mental illness in his family, is that they
are signs of an impending mental breakdown. Afraid that he is starting to lose
his grip on reality like his mother before him, Curtis seeks medical help and
counselling. *Take Shelter* spends considerable time depicting the realities of
mental illness, including the hold of fantasy, the stigma associated with mental
health problems, diagnostic difficulties, the dearth of providers and the high
cost of mental healthcare.

 Even so, the literal reading of Curtis's apocalyptic visions, as unsettling
portents of catastrophic climate change rather than symbols of mental distur-
bance, is the one that ultimately prevails. They prefigure the extreme and erratic
weather conditions of the climate-changed future in store for us if not already
upon us, such as severe hurricanes, torrential downpours and devastating

floods, as well as hinting at the collapse of human civilization that climate change could bring about (with society overrun by zombies). Reminiscent of a Cold War-era fallout shelter purporting to offer refuge from nuclear war, the state-of-the-art storm cellar that Curtis builds in his backyard scales up the significance of his visions beyond the local context of small-town Ohio, suggesting the planetary proportions of the terrifying storm that he believes to be coming, as well as its nuclear-level destructive force.

Figure 9. Protecting Hannah. Michael Shannon and Tova Stewart in *Take Shelter*, dir. Jeff Nichols (Hydraulx Entertainment, 2011).

Moreover, by putting Curtis's anxiety about Hannah at the centre of most of his hallucinations, where she is often in grave danger of attack or abduction, the film plays right into current fears about climate change: to the extent that they allow themselves to think about such matters at all, parents are painfully aware that their children will in all likelihood bear the brunt of climate change (Figure 9).[3] While *Take Shelter* does not include any explicit discussion of human activities' producing climate change, the phenomenon's anthropogenic nature is implied by the greasy, yellow rain that is repeatedly shown falling on Curtis's hands, which links the unusual weather he experiences to the world's addiction to oil (Figure 10). The film's focus on the drilling work Curtis does

3 E. Ann Kaplan, *Climate Trauma: Foreseeing the Future in Dystopian Film and Fiction* (New Brunswick, NJ: Rutgers University Press, 2016), 44.

Psychic Cli-Fi

for a living similarly ties the changes in the climate revealed in his dreams and hallucinations to human exploitation of the Earth's resources.[4]

Figure 10. Greasy, yellow rain falling. Michael Shannon in *Take Shelter*, dir. Jeff Nichols (Hydraulx Entertainment, 2011).

However, in marked contrast to most cli-fi films (and novels, for that matter), *Take Shelter* is set in the present rather than in a future world ravaged by climate change. Unlike Roland Emmerich's *The Day After Tomorrow* (2004) and many of the mainstream films dealing with climate change that have followed in its wake, Nichols's film steers clear of the prevalent post-apocalyptic or dystopian mode – or, at least, evokes it only in the dream and hallucinatory sequences. Instead, it opts to dramatize the pervasive culture of denial that refuses to acknowledge, let alone take action against, the impending environmental disaster. *Take Shelter* can be seen to denounce contemporary society's failure to register the threat of climate change and address it effectively by turning the tables on the community around Curtis and suggesting that in reality it, rather than he, is afflicted with a kind of madness: the insanity of denial, apathy and inaction in the face of climate catastrophe. His friends' and family's imperviousness to Curtis's visions, which are outside the realm of everyday life, and their bemused, embarrassed and dismissive reactions to his experiences and prophecies intimate that they are unable or unwilling to face the 'inconvenient truth' that Curtis

4 Woolley, 'There's a Storm Coming!', 184.

senses and whose messenger he becomes. Thus, without preaching, the film delivers a wake-up call to audiences to open their minds to the reality of climate change and the urgent need for effective action to avert its worst impacts.

Take Shelter achieves this effect through its clever play with genre. With a two-hour-plus running time, the film is a slow-moving psychological thriller that skilfully incorporates elements of horror, disaster film and family drama. It has a brooding, Hitchcockian atmosphere, creating persistent feelings of unease, foreboding and dread that intensify as the plot progresses. Sharing Curtis's viewpoint throughout the film, the viewer participates in his struggle to distinguish between vision and reality. *Take Shelter* deliberately blurs the boundaries between Curtis's dream-world and his waking life. The film's narrative present slides into Curtis's fantasies so subtly and slyly that the viewer is unsure, at first, as to the ontological status of the storms, zombies, etc. with which the protagonist is confronted there. Sounds and visuals are often maintained across Curtis's visions and the film's diegetic reality, thus confusing the dividing line between them. Sometimes his dreams also leave a physical mark that carries over into his waking life, as when he continues to feel the pain of a dog bite that happened in one of his dreams throughout the rest of the day, or when he discovers that he has wet his bed on waking up from a diluvial dream.

Figure 11. Taking shelter. Jessica Chastain, Tova Stewart and Michael Shannon in *Take Shelter*, dir. Jeff Nichols (Hydraulx Entertainment, 2011).

The viewer is denied the satisfaction of domesticating the film by interpreting it as a conventional psychological drama, an exploration of one man's personal journey towards acceptance of his mental issues. While it seems to invite such a reassuring interpretation, *Take Shelter* eventually cuts the ground from under it. The film uses the device of the false ending to that effect. At a social function that Samantha insists they attend in an attempt to restore a sense of normalcy to their lives, Curtis gets into a fight with a former co-worker and unleashes a verbal tirade on everyone present. He announces that a devastating storm is coming and insists that none of them are prepared for it. His words are met with an embarrassed silence, as the community evidently regards them as the ranting of a madman. As if to vindicate Curtis's warning, this dramatic scene is followed by an episode in which a powerful storm sweeps through the town, sending Curtis and his family into the shelter (Figure 11). However, they emerge the next morning to a bright and sunny day with only some branches to clear up: the apocalypse has not happened, suggesting that Curtis was deluded after all and needs help. This ending, which 'places the film firmly in the realm of psychological drama', with 'the family find[ing] renewed strength in Curtis's acknowledgment of his problems', is subverted, though, in the final scene, which adds yet another twist.[5] During the subsequent family vacation in Myrtle Beach, recommended by a psychiatrist, a massive storm is seen gathering over the ocean: not another of Curtis's hallucinations – it is shown from Hannah's and Samantha's viewpoints as well – but a genuine apocalyptic climate event, just as he had prophesied.[6] In the final instance, then, the film is revealed to have been a 'supernatural thriller' all along.[7]

Take Shelter enjoyed widespread critical acclaim and won numerous awards, including several at the Cannes Film Festival. However, these plaudits did not translate into equivalent commercial success, as the film, made at a production cost of $5 million, brought in only a modest $1.7 million at the US box office and $3.1 million worldwide.[8] Reviewers were effusive in their praise for the acting performances, particularly that of Michael Shannon, with

5 Woolley, 'There's a Storm Coming!', 188.
6 Kaplan, *Climate Trauma*, 53.
7 Woolley, 'There's a Storm Coming!', 188.
8 These figures are derived from IMDb.com.

whom Nichols frequently collaborates. While the film's environmental theme was widely noted, it is mostly academic critics who give it pride of place in their analyses. In fact, reviewers and regular viewers often express puzzlement at the ending, which, as we have seen, is crucial to the meaning of the film. Extensive and in-depth ecocritical readings are provided by Agnes Woolley and E. Ann Kaplan, who emphasize the originality of the film's way of engaging with climate change. Woolley contrasts *Take Shelter* favourably with cli-fi films of the post-apocalyptic variety, which she criticizes for their 'lack of transformative value'.[9] Kaplan worries, though, that what she (mis)perceives as the film's silence on the human causation of climate change might hamper its ability to act as a 'wake-up call' and raise public awareness of the issue.[10]

As Kaplan demonstrates, *Take Shelter* can be fruitfully analysed through the lens of her concept of 'Pretraumatic Stress Syndrome', by which she means the traumatizing impact of future (rather than past) catastrophic events and which she sees as a defining condition of human beings living in the current era of climate change.[11] The same idea, of a psychic wounding produced by the anticipation of violence, has been put forward by Paul Saint-Amour, albeit in relation to an interwar period haunted by the prospect of a second world war even more devastating than the first one.[12] Nichols's film also lends itself to a reading through Timothy Clark's recent work on the need for the creative and critical imagination to rise to the challenge posed by the vast scale and complexity of climate change.[13] His notion of 'Anthropocene disorder', for example, can be productively applied to the self-enclosed community in *Take Shelter*, which exemplifies the 'alarming and pervasive "denialism"' that passes for 'normal life' these days.[14] In fact, the film's fictional community invites comparison with 'Bygdaby', a pseudonym for the actual rural community in

9 Woolley, 'There's a Storm Coming!', 181.

10 Kaplan, *Climate Trauma*, 56.

11 Kaplan, *Climate Trauma*, xix.

12 Paul Saint-Amour, *Tense Future: Modernism, Encyclopedic Form, Total War* (New York: Oxford University Press, 2015), 7–8.

13 Timothy Clark, *Ecocriticism on the Edge: The Anthropocene as a Threshold Concept* (London: Bloomsbury, 2015).

14 Clark, *Ecocriticism on the Edge*, 139–73, 160.

western Norway that Kari Norgaard took as the subject of her sociological study of climate change denial.[15] This, in turn, could lead to wider discussions on how citizens in industrialized countries are (not) responding to alarming predictions from climate scientists, and on the role that aesthetic practices can play in breaking through the prevailing paralysis and motivating people to take meaningful action on climate change.

15 Kari Marie Norgaard, *Living in Denial: Climate Change, Emotions, and Everyday Life* (Cambridge, MA: MIT Press, 2011).

Part III

Realist Narratives Set in the Present and Near Future

Adeline Johns-Putra

Maggie Gee's *The Ice People* (1998) and *The Flood* (2004)

The Ice People (1998)[1] and *The Flood* (2004)[2] are set in near futures domi-
nated by climate change (though, in the latter novel, this is never named as
such). Both, therefore, might easily be labelled dystopian: certainly, each novel
adopts a conventional dystopian motif – icescape and flood respectively – to
depict the effect of climate change on the landscape.[3] In *The Flood*, the novel's
narrative climax in a devastating diluvial event might also be termed apoca-
lyptic. In the case of *The Ice People*, the dystopianism possesses sci-fi and post-
apocalyptic elements; the novel depicts futuristic technological innovations,
such as domestic robots and mini-copters, as well as, in the course of events,
a complete social and environmental collapse, with humanity reverting to
Palaeolithic living conditions.

Yet, although they adhere to dystopian, apocalyptic and post-apocalyptic
conventions, the novels resist the notion that environmental disaster can be
rendered straightforwardly, maintaining a focus on the social complexities that
underlie it. In their detailed analyses of the personal and political, they might
be described, as with Gee's fiction in general, as 'condition-of-England' novels.[4]
They offer, first, a detailed explication of the ties that bind the political and
public with the personal and private, and, second, a critique of the extent to

1 Maggie Gee, *The Ice People* (London: Telegram, 2008).
2 Maggie Gee, *The Flood* (London: Saqi, 2005) [2004].
3 Adam Trexler, *Anthropocene Fictions: The Novel in a Time of Climate Change*
 (Charlottesville: University of Virginia Press, 2015), 82, 108–18.
4 Mine Özyurt Kılıç, *Maggie Gee: Writing the Condition-of-England Novel* (London:
 Bloomsbury, 2013).

which socio-political lives, understood in these terms, are imbricated with the nonhuman environment. That is, they not only depict worlds devastated by climate change; they also reveal how the anthropocentric mismanagement of the environment is exacerbated by – and in turn exacerbates – various forms of social inequity. *The Ice People* aligns anthropocentrism with masculinist and heteronormative impulses, while *The Flood* shows both how it tends to be exercised along with white, capitalistic privilege and how it shores up that privilege, since environmental crisis disproportionately affects those marginalized by racial and socio-economic power structures.

Related to this is the novels' critique of common environmental tropes. *The Ice People* questions the idea that an ethic of care – especially where this is oversimplified – offers an easy solution to environmental problems. Meanwhile, as already suggested, *The Flood* employs apocalypticism, but does so ironically, in order to show the unevenness with which ecological damage, such as that inflicted by climate change, occurs. In doing so, Gee takes a deconstructive approach to contemporary attitudes to climate change, in terms of both how we understand it and how we respond to it.

The Ice People is set in London, over the course of the life of its narrator, Saul, from the early to mid-twenty-first century. It depicts the onset of two planetary climatic changes, as anthropogenic global warming is reversed by global glaciation. Both are accompanied by social upheaval: while the initial climate change causes pandemics and civil disorder, the Ice Age brings on complete collapse. Meanwhile, heterosexual norms give way to gender segregation and conflict. However, Saul, like many dystopian protagonists, is something of a dissenter; he maintains an old-fashioned attitude to love and romance, settling down with the like-minded Sarah. Their relationship, however, proves turbulent, and the novel charts its deterioration alongside society's slide into gendered culture wars and environmental chaos. Saul and Sarah engage in a bitter custody battle over their son, Luke. Sarah retreats with him to an all-female commune, run by a powerful women's movement, but Saul abducts him, taking him to the relative warmth and safety of Africa. The reader's view of this relationship is complicated by Saul's position as first-person narrator. This, along with his outsider status, makes him a sympathetic figure; however, as the novel unfolds, he proves to be an unreliable narrator. His increasingly irrational anger towards Sarah and other women enables an ironic critique of

his behaviour. The result is that the reader's loyalties are split between Saul and Sarah, with both proving to be ambivalent characters.

Luke is a crucial figure in any reading of the novel. To understand and to critique Luke's role, it is necessary to consider the centrality of 'the figure of the child' in the discourse of what has been labelled 'reproductive futurism'.[5] In this discourse, the child, as a sign of hope, is available to be adopted by various political agendas to exploit our desire for absolute wholeness. Thus, while the child appears as a positive symbol of the future and the object of selfless care, he or she is also the projection of individual and collective desires for fulfilment, desires set by external, socio-political agendas. As Sarah Dillon argues, Saul's parental concern for Luke replays this dynamic.[6] While this concern looks like – and, some might say, *is* – love, it is also allied to self-interest; it is, after all, framed in the language of genetic survivalism, for Saul seeks to save Luke in order to preserve his lineage. Caught in a tug-of-war, Luke comes to represent the nonhuman environment so mismanaged by humans entrenched in cultural – in this case, gender – politics. Thus, the novel reveals the risks of some ecological care ethics, particularly those that advocate environmental stewardship for the sake of future generations; such positions tend to gloss over heterosexist or masculinist expectations and priorities, and to invest in an anthropocentric view of the nonhuman environment as a human good.[7] Crucially, Luke ultimately refuses his assigned role as a symbol of promise for the future, running away to join a gang of wild children. Gangs such as these come to dominate as society collapses.

The Flood revolves around an ensemble of characters in an unnamed city, which resembles London, threatened by constant rain and floods. The focus is on May White, coming to terms with her husband's death and her son, Dirk's,

5 Lee Edelman, *No Future: Queer Theory and the Death Drive* (Durham, NC: Duke University Press, 2004), 2.

6 Sarah Dillon, 'Literary Equivocation: Reproductive Futurism and *The Ice People*', in Dillon and Caroline Edwards, eds, *Maggie Gee: Critical Essays* (Canterbury: Gylphi, 2015), 101–32.

7 Adeline Johns-Putra, 'Care, Gender, and the Climate-Changed Future: Maggie Gee's *The Ice People*', in Gerry Canavan and Kim Stanley Robinson, eds, *Green Planets: Ecology and Science Fiction* (Middletown, CT: Wesleyan University Press, 2014), 127–42.

imprisonment for the manslaughter of his sister's brother-in-law – a race crime related in Gee's earlier novel, *The White Family* (2002).[8] Newly released, Dirk joins One Way, a millenarian cult that welcomes the floods as an apocalyptic cull. His sister, Shirley, married to Elroy Edwards, juggles motherhood with university studies, helped by her former cleaner Faith, who lives in the flood-stricken Towers, where Elroy's sister Viola also lives. Elroy's other sister, Delorice, has a successful career in publishing, and is in a relationship with celebrity scientist Davey Lucas. Davey's mother, Lottie, is a fur heiress, and his pampered half-sister, Lola, indulges in anti-capitalist protest despite enjoying her life of leisure and luxury. The Lucas family provide a counterpoint to the less privileged Edwardses and Whites; their desirable neighbourhood is on higher ground, geographically and figuratively. Yet, unknown to them, the families are linked, not just by Delorice but by Faith, who used to work for Shirley and now cleans for Lottie, and by Faith's daughter Kilda, who babysits for Shirley and is part of the One Way cult. Other characters fill myriad other gaps.

Meanwhile, the rising waters coincide with two other harbingers of apocalypse – the spectres of war and a runaway comet. The president, Mr Bliss, is going to war in order to distract the electorate from the dire economic and environmental situation. He plans a further distraction in the form of a celebratory public gala. What is more, Bliss, when informed of the impending impact event, refuses to alert and alarm the public. The novel ends with a tsunami brought on by the comet strike; this unfolds in a slow montage, as humans, urban foxes and birds flee the impending wave. In a dreamlike epilogue, they emerge from the water to a kind of Elysian realm.

This final disaster is a combination of astronomical bad luck (the comet) and anthropogenic ecological failure (the floods caused by freak rains in turn wrought by climate change). The cosmological cause of the collision, combined with the millenarian prophecies of the One Way cult, might seem to drive the narrative to an apocalyptic finale; yet, this disaster is ultimately rendered in lyrical, pointedly un-apocalyptic terms. This ironizes the conventional treatment of climate change as a matter of sudden catastrophe and cautions against any equally simplistic understanding of climate change mitigation as a single, quick-fix response. Irony is also detectable in the frame of the novel – a

8 Maggie Gee, *The White Family* (London: Saqi, 2002).

prologue in which an unnamed narrator promises 'to tell you how it happened' and the concluding paradisiacal setting of 'a place of perpetual summer.'⁹ The fairy-tale tones of this framing device are out of keeping with the everyday relationships and incidents so meticulously detailed in the rest of the novel, which show the varied and accretive social injustices that amplify both the causes and effects of climate change.

Although both novels deal with climatic change, they were published before widespread recognition of cli-fi as a literary category. An early scholarly critique treats *The Flood* as a response to the events of 9/11, rather than to climate change.¹⁰ The reception of *The Ice People* was further muted because it was released by a relatively small press, a move forced on Gee when HarperCollins withdrew as her publisher, refusing to take on the racially charged *White Family* (which was composed before *The Ice People*).¹¹ It is only belatedly that Gee has been recognized as an author with environmental interests, and both novels have come to be read as engaging with climate change.¹²

Certainly, the novels would repay teaching in the context of climate change and literature. They provide a foil against texts that employ more conventional environmental rhetoric. Using Marxist and postcolonial theories, *The Flood* might reveal how the thin and tired motif of environmental apocalypse is often matched, equally, by business-as-usual solutions backed by hegemonic economic and political interests. Meanwhile, Marxist insights in combination with feminist and queer theory could be usefully brought to bear upon *The Ice People*, to interrogate the conservative cultural norms that might underpin ostensibly laudable ethics of care, where these are linked to parental and intergenerational interests.

9 Maggie Gee, *The Flood* (2004; London: Saqi, 2005), 7, 322.
10 Dillon, 'Imagining Apocalypse: Maggie Gee's *The Flood*', *Contemporary Literature* 48/3 (2007), 374–97.
11 Maya Jaggi, 'Maya Jaggi in Conversation with Maggie Gee: *The White Family*', *Wasafiri* 17/39 (2002), 5–6.
12 See Trexler, *Anthropocene Fictions*, 108–18; Johns-Putra, 'Care, Gender, and the Climate-Changed Future', 127–42; Chris Maughan, '"One and Indivisible, a Seamless Web": Climate Change as Historical Process in *The Flood*', in Dillon and Edwards, eds, *Maggie Gee: Critical Essays* (Canterbury: Glyphi, 2015), 131–57; Roman Bartosch, 'The Climate of Literature: English Studies in the Anthropocene', *Anglistik* 26/2 (2015), 59–70.

Adam Trexler

T. C. Boyle's *A Friend of the Earth* (2000)

A Friend of the Earth (2000) was published at a key moment in American public consciousness of climate change. The Kyoto Protocol was adopted in December 1997, providing a shortlived window of hope to many for a true, international response to climate change. Al Gore's presidential campaign in 1999 brought new visibility to the issue, and raised hopes that the world's largest economy would take resolute actions to reduce greenhouse gas emissions. In the Pacific Northwest, arsons and other acts of ecotage by Earth First! and the Earth Liberation Front were attracting national headlines and widespread condemnation. In December 1999, the Seattle World Trade Organization protests mobilized over 40,000 activists in an alliance of labour, anti-globalization and environmental commitments. Boyle's novel is primarily set in two time periods. Much of the action takes place in 2025, when the collapse of both environmentalism and the relatively stable climate of the Pacific Northwest affords a perspective for biting satire of late twentieth-century activism. In retrospective sections set primarily in 1989–90, the novel makes this critical approach to climate action present, exploring the moment when radical environmentalism first peaked in public consciousness, from the vantage point of its greater visibility ten years later.

Critics generally noted a growing concern with climate change amongst the American public, but treated the sections of the novel set in the early 1990s as transparent, dark satire. More attention was paid to the dense, odd, mordant depiction of environmentally inflicted poverty by 2025. Boyle's detailed, strange evocation of that future was very new in literary fiction at that time, and the novel's descriptions of an impoverished future economy, caused by biosystem collapse, were treated with curious bemusement. Thematically, critics tended to understand the book as an expression of hopelessness, that not just

the general public but also greens are doomed because of their consumerist tendencies.[1] (This rather missed the point that, unlike consumer society, Deep Ecology was not particularly focused on personal salvation.) Examining the novel's account of the recent past can help readers understand how climate change was difficult to apprehend in the late twentieth century, and reflect on the evolving tactics of climate activism.

The retrospective sections of *A Friend of the Earth*, which describe the actions of Ty Tierwater as he becomes radicalized in an environmental group called Earth Forever!, are closely modelled on the lived experience of real-life Earth First! activists. Earth First! emerged on a backpacking trip amongst five conservationists in 1980. The movement would emphasize the radical, no-compromise voices of impassioned amateurs, rather than the 'professional, bureaucratic hierarchy' exemplified by popular, middle-class member groups like the Sierra Club. It would draw on the monkeywrenching fiction of Edward Abbey, the naturalism of John Muir and the Deep Ecology of Aldo Leopold. Its primary method would be direct action in the defence of natural areas, using the tactics of guerrilla theatre, civil disobedience and monkeywrenching.[2] Earth First! would pursue protection of 'the whole ecosystem', rather than merely focusing on how air, water and soil pollution affected human health.[3] The old-growth forests of the Pacific Northwest of the USA served as a poignant symbol of the fate of the world's wilderness ecosystems, and the most visible antagonist of the movement would become the logging companies that sought to manage or clear-cut those forests, putting immediate profits over environmental or even corporate sustainability.[4] The clear-cutting strategies, use of law enforcement, deployment of private police and suppression of non-violent protest of the loggers in *A Friend of the Earth* all have clear historical sources. Earth First!'s focus on whole ecosystems meant that the activists in the movement were early to recognize the dangers of systemic climate change,

1 James Guignard, '*A Friend of the Earth* by T. Coraghessan Boyle (review)', *Western American Literature* 36/3 (Fall 2001), 307–8.
2 Christopher Manes, *Green Rage: Radical Environmentalism and the Unmaking of Civilization* (Boston, MA: Little, Brown and Company 1990), 69.
3 Manes, *Green Rage*, 69–71.
4 Manes, *Green Rage*, 90, 206.

but its tactical focus on individual forests or even trees detracted from its ability to address a global, distributed problem.

In the novel, Ty Tierwater is initiated into activism with Andrea, Teo and Ty's daughter, Sierra, as they blockade a logging road in southern Oregon. Their action mirrors familiar Earth First! tactics of shutting down logging roads by using the protesters' own, vulnerable bodies.[5] Ty and his daughter's humiliating treatment at the hands of the sheriff draws him to more explosive acts of revenge. Later, he sets fire to a second-growth forest, and then is caught as he tries, alone, to bring down pylons using a propane torch. Earth First! had drawn condemnation for comparable acts of arson, and Dave Foreman stood trial for attacks on electrical towers in 1990.[6] After Ty gets out of prison, he is apprehended trying to poison California's water system, egged on by undercover law enforcement agents. His actions follow a clear progression from specific direct action to undirected, misanthropic violence.

Three of the principal characters in *A Friend of the Earth*, Ty Tierwater, his wife Andrea and Teo, are not directly biographical, but bear resemblance to figures in the Earth First! movement that are slowly being forgotten. Ty, like Dave Foreman in real life,[7] loathes the 'snake oil and trinkets' of EF! bumper stickers and T-shirts. Andrea, his wife, bears similarities to Judi Bari, a major organizer of sustained protests against logging companies in the Pacific Northwest in the early 1990s.[8] Bari was controversial for her attempts to build solidarity with loggers, changing the focus of the movement from defence of wilderness to consciousness-raising about nature. Teo resembles members of Oregon's radical environmental movement a decade later, as the novel was being composed. Specifically, he resembles Tre Arrow, a household name for his sitting protests and leadership in ecotage,[9] and Craig Rosebraugh, a spokesperson for the Earth

5 Manes, *Green Rage*, 86–7.
6 Manes, *Green Rage*, 194.
7 Susan Zakin, *Coyotes and Town Dogs: Earth First! and the Environmental Movement* (New York: Penguin, 1995), 361.
8 T. Coraghessan Boyle, *A Friend of the Earth* (New York: Penguin, 2000), 161.
9 See Andrew Macleod, 'Tre Arrow, The Straight Arrow: Imprisoned activist talks about extradition, raw food and bolt cutters', in *Willamette Week*, 29 March 2005/24 January 2017 <http://www.wweek.com/portland/article-4252-tre-arrow-the-straight-arrow.html> accessed 3 April 2018.

Liberation Front who also blockaded a fur store in Seattle. He is criticized, like Arrow and Rosebraugh, for training credulous younger people to take actions he no longer would. Although Boyle's lush prose returns repeatedly to the sensuous attractions of late petro-capitalism, the novel gives a scathing account of Teo and Andrea's moral compromises as they find a home in the suburbs, bring picnics to actions and schmooze donors.

A more uncompromising form of non-violent protest was tree-sitting. Long-term tree-sits emerged in 1985 as acts of civil disobedience in which activists put their lives in danger to protect trees from being felled. Inspired by Teo, Ty's daughter, Sierra stages a marathon tree sit, evades violent, misogynistic attempts to dislodge her by loggers and finally slips and falls to her death. During the composition of *A Friend of the Earth*, Julia Butterfly Hill made national news by living in a Coast Redwood for 738 days, braving violent intimidation and bitter storms, before finally negotiating a settlement to preserve her stand of redwoods. Boyle's novel, in which Sierra's accidental fall forms the tragic centre, was completed before Hill's safe descent.

The sections of the novel set in the future create a space to reflect on the impact of climate change on late twentieth-century environmentalism in America. The economy of California has disintegrated as traditional crops have become impossible to grow, the safety nets of property insurance, health insurance and retirement have collapsed and homes are destroyed by endemic hurricanes and flooding. Ty has given up ecotage, and in his old age he tends a private zoo of uncharismatic, endangered animals funded by a patron, Maclovio Pulchris (a figure based on Michael Jackson). His protective instincts have survived his own incarceration and the death of Sierra: despite being repeatedly mauled by the animals in his care, he uses extraordinary ingenuity and sacrifices his own body to protect them. Nevertheless, the zoo is destroyed by storms and flooding; its animals are moved into Maclovio's mansion, and then are systematically killed by a SWAT team after Maclovio is mauled by a lion. Ty's and his patron's individual, private efforts to conserve the animals prove futile. The coalition-based environmentalism of Andrea and Teo has accomplished no more. Andrea's career fails to grant her personal security; she leans on Maclovio to fund a memoir about Sierra that manages to be both tawdry and obtuse in portraying her as a 'Martyr to the Trees'. Finally, Ty and Andrea try to escape back to a cabin in the woods, only to find that

the pristine forest has been bowled over by a storm. Climate change wreaks a degree of unplanned destruction that dwarfs the scale of logging companies and tree-sitters.

The failure of both Ty's programme of direct action inspired by Deep Ecology and Andrea's more moderate, social environmentalism raises important questions about the response to climate change at the turn of the twenty-first century. The novel's narrative arc strips away the thin denials of American corporations and right-wing politicians by apprehending a future moment when California's climate has already become unrecognizable. The persistent disasters of 2025 show that Earth Forever was profoundly right in its attempts to draw attention to the impacts of industrial action unchecked by environmental limits. Nevertheless, Ty is bitter in his appraisal of his early activism, conceding that he accomplished 'Nothing... Absolutely nothing'.[10] In the time of climate change, whole ecosystems and whole human developments are regularly felled by storms that were unprecedented before the Anthropocene. Ty's love for the specific, particular places and creatures proves inadequate in the face of global transformation. Were either Ty's or Andrea's approaches justified, given this reality? What is the reader to make of environmentalism's failure to avert climate catastrophe? Given the impact of greenhouse gas emissions from distant nations, and the impossibility of protecting individual species or forests when the planetary weather has been altered, is there any point in seeking an environmental movement to build community coalitions or organize direct actions? *A Friend of the Earth* models localism and globalism in the Anthropocene, and holds them up to critical scrutiny.

This aspect of the book can be a compelling subject for classroom discussion, but the novel also raises other interesting questions. *A Friend of the Earth* has a peculiarly loquacious, bitter, self-flagellating narrator, whose framing of the action is oddly contrasted to April Wind's tabloid biography. The self-conscious mode of narration raises the question of how the novel's models of time and history might warp under the pressure of climate change. The book also has interesting things to say about inherited wealth and inherited environments: both are treated sensuously, longingly, satirically and then elegiacally.

10 Boyle, *A Friend of the Earth*, 270.

Ty Tierwater's rage, despair, poverty and age make it difficult for the reader to identify with him, but his passionate attachments to specific animals, humans and places mean he should not be too easily dismissed. Similarly, the hypocrisy which all the characters share can be a painful mirror of contemporary society, while at the same time prompting the deeper question of how much individual hypocrisy matters in the face of climate change. The novel also challenges ahistorical assumptions that 'something should have already been done', by interrogating who might have made what difference, what real figures actually did and what that means for critical practices today.

When *A Friend of the Earth* was published in 2000, climate change and radical environmentalism were emerging as major respective preoccupations of the American left and right. Early criticism of the novel used its depiction of the future as a tool to reflect on a moment in American environmentalism that was still contiguous with the present; the failure of twentieth-century activism and the passing of a time when pure wilderness could still give rise to a philosophical orientation and political movement. Nearly two decades later, the novel's major elision has become clear. Boyle imagined a future where environmental politics has collapsed. He could not foresee the ways in which climate activists have become ever more sophisticated; developing countries' conservation actions have found national buy-in and fought the most cynical efforts to undermine them; national leaders have forged major accords, even while corporations have polluted with ever more sophistication; and world leaders have issued catastrophic denials. As Boyle's novel is read in the future time it both anticipated and feared, the moral simplifications of the late twentieth century must be criticized anew.

Chris Pak

Kim Stanley Robinson's *Science in the Capitol* Trilogy (2004–2007)

Forty Signs of Rain, *Fifty Degrees Below* and *Sixty Days and Counting* (the *Science in the Capitol* trilogy)[1] explore the relationship between science and politics in addressing climate change. They examine how institutions generate scientific knowledge that informs our understanding of Earth's physical systems, how transforming these systems causes disruptions that are unevenly distributed amongst global communities and how politics mobilizes or circumvents responses to climate change. Robinson is concerned with solutions to the disastrous climate events portrayed and, to that end, the narrative considers issues relevant to sustainability and permaculture, geo-engineering (the adaptation of Earth's planetary climate), rewilding (the restoration of species now extinct in their original habitats, or completely extinct worldwide) and genetically modified organisms. These scientific and often speculative themes are complemented with a social and economic critique of capitalism as a primary source of climate disruption. The narrative considers how socially and politically engaged scientists, working within established institutions and in alliance with political leaders, might devise and implement multi-levelled solutions to address the climate crisis.

1 Kim Stanley Robinson, *Forty Signs of Rain* (New York: Bantam, 2005); Robinson, *Fifty Degrees Below* (New York: Bantam, 2007); Robinson, *Sixty Days and Counting* (New York: Bantam, 2007). For Robinson's views on the effects of the hurricane, see Erik Assadourian, 'Exploring a Climate of Disaster: Interview with Erik Assadourian', at <https://www.thefreelibrary.com/Exploring+a+climate+of+disaster%3a+interview+with+Erik+Assadourian.-a0151190133>.

The trilogy traces the transformations visited upon America as the climate crisis worsens, portraying the uneven repercussions for those living in the USA and secondarily on global communities. The first novel opens with a meeting between one protagonist, Anna Quibler, and representatives from the fictional island nation Khembalung, displaced Tibetans who petition the US government for support in the face of rising sea levels. Each book is divided into sections narrated from the perspective of a character closely involved with developing scientific and political strategies for combating climate change. Thus, we see the interpenetration of science and politics through the eyes of Anna, an administrator at the National Science Foundation (NSF) who leads an interdisciplinary committee to fund proposals for climate mitigation and thus co-ordinate national responses to the crisis, her husband Charlie Quibler, an environmental advisor to senator Phil Chase, and Frank Vanderwal, a scientist from the University of California, San Diego, on secondment to the NSF. These three perspectives are complemented in *Sixty Days and Counting* by Chase's blog posts after he assumes the US presidency, which reflect a change of direction for the administration and a new imperative to communicate directly with people at national and global levels.

Each book tracks changes to climate events worldwide, but the reader sees them primarily as they affect the North American continent, particularly Washington. The first book ends with Washington flooded by tidal surges, while the second portrays efforts to cope with a severe winter. In the third, Chase begins his presidency with a programme to combat climate change in his first sixty days in an attempt to shift the direction that the administration has thus far taken. As the climate rebounds in the third book, swinging from an extreme winter to a scorching summer, Chase embarks on a Roosevelt-style New Deal programme to apply geo-engineering techniques to mitigate the effects of climate change as biotechnologically modified lichens are seeded in Siberia. The trilogy thus speculates on a series of technical solutions that challenge the limits of what is presumed feasible, and it does so alongside a critique of economic models that externalize the costs of industry and development and which thus attempt to forestall solutions that these models assess as economically unviable.

The *Science in the Capitol* trilogy is a work of sci-fi that draws from a number of traditions central to the mode to shape its engagement with climate

change. It takes several approaches to do so: it offers a warning of the scope and nature of the threats of climate change, it identifies the sources that retard efforts to adequately address these effects, it educates readers about the institutions and the resources available to mitigate these effects and it attempts to motivate by offering plausible strategies for reflection, debate and action. It builds on a long tradition of apocalyptic scenarios to portray the irregularities of the effects of climate change and the severity of their impact upon populations living within those locales. In doing so, it details the despair and struggles individuals and communities face as they attempt to cope with a transformed environment. Robinson's approach is utopian and seeks to explore how we might overcome the challenges involved in addressing the effects of climate change at technical, political and social levels. This utopianism is contingent, however, and the reader is made critically aware that the utopian space the narrative seeks to establish can be overturned.

While the narrative is concerned with the utopian potential of science in developing and implementing strategies to ameliorate the effects of climate change, it also pays attention to the aesthetic and personal dimensions of the human relationship to nature, with extended scenes that reflect on new ways to organize urban habitation: one narrative development, for example, sees animals released from Washington's zoo in the face of a severe flood, many of which settle in Rock Creek Park. Frank, made homeless by the same deluge that floods Washington at the end of *Forty Signs of Rain*, temporarily settles in a treehouse that he builds in the park (Figure 12). This provides an opportunity to explore the significance of adaptation and animal otherness for human wellbeing.

The trilogy is ultimately comic,[2] not because the world is restored to a state preceding the effects of climate change, but because our faith in the

2 Roger Luckhurst, 'The Politics of the Network: the Science in the Capital Trilogy', in William J. Burling, ed., *Kim Stanley Robinson Maps the Unimaginable: Critical Essays* (Jefferson, NC: McFarland, 2009), 170–80; De Witt Douglas Kilgore, 'Making Huckleberries: Reforming Science and Whiteness in Science in the Capital', *Configurations* 20/1–2 (2012), 89–108; Robert Markley, '"How to Go Forward": Catastrophe and Comedy in Kim Stanley Robinson's *Science in the Capital* Trilogy', *Configurations* 20/1–2 (2012), 7–21.

Science and Politics in Cli-Fi

Science and Politics in Cli-Fi

Figure 12. The catastrophic damage caused by Hurricane Katrina in New Orleans in 2004, which was anticipated by the flooding of Washington as portrayed in *Forty Signs of Rain*. In the public domain.

possibility of alleviating some of the consequences of climate change is restored, and because the infrastructures and the political will required to adequately address climate change are created. It celebrates the actions of the scientists who toil unremarked to ameliorate the effects of climate change. It is not at the hands of the remarkable and heroic that change is made possible, but in actions made heroic because they are conducted in spite of the fear and despair that climate change begets. Its optimism, like its utopianism, is thus qualified by the losses to human and non-human life and welfare that are already underway. The trilogy concludes with a productive alliance between politics and science, symbolized by the marriage between Diane Chang, the head of the NSF, and President Chase.[3] This alliance is mirrored by one between science and Buddhism as Frank moves in with the Khembali who, as climate

3 Markley, 'How to Go Forward', 12.

migrants, settle in Maryland. The personal and the religious are thus wedded to science and its practice in a move that seeks to highlight how science itself is a utopian discourse offering sources of inspiration and wonder in ways that parallel conceptions of Buddhism.

Nevertheless, the trilogy's contingent optimism and commitment to tackling the climate crisis is predicated on political will. While ultimately comic, the gains made by tackling the climate crisis are only possible because of an American president who is willing to take up the challenge of the climate crisis in good faith. There is thus a double-voicing to the comic and the utopian, where incremental gains cannot be taken for granted and must be shored up by continued effort.

The *Science in the Capitol* trilogy is an example of near-future sci-fi that is in dialogue with other sci-fi texts, with science, particularly climate science and futures studies, and with environmental literature such as Emerson's and Thoreau's. Roger Luckhurst describes those instances in which the narrative adheres to recognizably familiar present-day realities as 'proleptic realism'.[4] The narrative's portrayal of climate change is based on the insights of a Pentagon report commissioned by Andrew W. Marshall, 'Imagining the Unthinkable', which outlines possible future scenarios in the event of abrupt climate change caused by the stalling of the Gulf Stream.[5] The trilogy also engages in dialogue with alternate histories: Robinson describes the work of understanding the present as 'a mix of historical work and science fictional speculation'.[6] The trilogy can be read as alternate history if we understand the two presidents portrayed in the trilogy as figures for George W. Bush and Al Gore, and the narrative as speculating on a future that might have been, had Gore won the

4 Roger Luckhurst, 'The Politics of the Network: The Science in the Capital Trilogy', in *Kim Stanley Robinson Maps the Unimaginable: Critical Essays*, ed. William J. Burling (Jefferson, NC: McFarland, 2009), 170–80.

5 Peter Schwartz and Doug Randall, 'An Abrupt Climate Change Scenario and its Implications for United States National Security', *Climate Institute* (2003) <https://www.iatp.org/sites/default/files/An_Abrupt_Climate_Change_Scenario_and_Its_Impl.pdf> accessed 26 March 2018.

6 Doug Davis and Lisa Yaszek, 'Science's Consciousness: An Interview with Kim Stanley Robinson', *Configurations* 20.1/2 (2012), 187–94; here 189.

Science and Politics in Cli-Fi

2000 presidential nomination. The trilogy is thus a hybrid form that combines multiple traditions and ideas to speculate on the future of climate change.

The *Science in the Capitol* trilogy met with praise for its plausible portrayal of scientists working within institutions to address the climate crisis. Its dramatization of climate change sharply contrasted with other narratives, such as the film *The Day After Tomorrow* (2004),[7] released in the same year as *Forty Signs of Rain*, which implausibly elevated the scale of the effects of climate change. Robinson's ability to combine scientific and technical speculation, social, political and economic critique and depiction of the everyday lives of people as they are affected by climate change enables him to invest what might, at the hands of another writer, have been abstract scientific, political and economic treatises with human significance. Nevertheless, Robinson revised the *Science in the Capitol* trilogy as the single volume *Green Earth*,[8] which condenses many of the novels' explorations of science, politics and society in an attempt to make the work more appealing to a wider readership.

The timing of the publication of *Fifty Degrees Below*, just months before the catastrophic flooding of New Orleans in August 2005 (Figure 13), added another dimension to critiques of the novel, with some commentators reflecting on the misplaced optimism of the narrative's portrayal of a New Orleans under threat of a flood that the US Army is quick to prevent.[9] Other commentators, however, noted the narrative's resonance with real-world events, highlighting how this gives credence to its portrayal of the severity of climate change.[10] Still others have taken issue with the trilogy's primary focus on North America and its failure to extend its exploration to include plausible depictions

7 *The Day After Tomorrow* (dir. Roland Emmerich, 2004).
8 Robinson, *Green Earth* (London: HarperCollins, 2015).
9 Jeet Heer, 'The New Utopians', *The New Republic* (April 2016); Gregory Feeley, 'When Nature Calls', *The Washington Post* (21 December 2005).
10 Andrew Leonard, 'The Anti-Crichton', *Salon.com* (3 June 2007) <https://www.salon.com/2007/03/06/kim_stanley_robinson/> accessed 14 November 2017; Douglas Barbour, 'Apocalytpic Change in the Weather', *Edmonton Journal* (Alberta) (12 February 2006); Peter Millar, 'Washington, Not Waving But Drowning', *The Times* (1 October 2005).

of international politics and the action of individuals, communities and institutions worldwide in their efforts to combat climate change.[11]

The trilogy's scope and its engagement with a cluster of interpenetrating issues offer many avenues for teaching. As a work of popular fiction in the sci-fi tradition, it takes its place in a long line of speculation about the modification of the Earth's planetary environment. Its engagement with utopian themes makes it useful for exploring how such traditions are adapted in contemporary popular literature. As such it can be positioned as an example of contemporary sci-fi in courses that explore the development of sci-fi and utopia and its engagement with environmental themes alongside works such as Ernest Callenbach's *Ecotopia* (1975), Ursula K. Le Guin's *Always Coming Home* (1985) and other contemporary narratives such as Paolo Bacigalupi's *The Water Knife* (2015).[12] Its focus on science and its relationship to politics and society make it relevant to science and technology studies and courses exploring the relationship between science and literature. Because the trilogy takes politics and utopia as central to climate change, it invites ideological critique from utopian, Marxist and pragmatic perspectives and can be used as a way to explore and test the application of political theory to literature. In this vein it also offers an arena for thought about issues in environmental philosophy, environmental ethics and ecocriticism. The trilogy can also be used in courses in futures studies, particularly as it offers scope for understanding techniques such as causal layered analysis, which considers how multiple influences shape the outcome of the future, such as: economic, cultural, political and historical factors; institutional and social structures; discourse, metaphor and myth; and assessments of contemporary trends. The scope of Robinson's engagement with issues in climate change and the opportunities that sci-fi affords for exploring the relationship between science and society make the *Science in the Capitol* trilogy a rich source for reflection and debate in a wide variety of academic disciplines.

11 Fred Pearce, 'Science in Fiction: *Sixty Days & Counting* by Kim Stanley Robinson', *New Scientist* (25 August 2007).

12 Ernest Callenbach, *Ecotopia: A Novel About Ecology, People and Politics in 1999* (London: Pluto Press, 1978); Ursula K. Le Guin, *Always Coming Home* (Toronto: Bantam, 1985); Paolo Bacigalupi, *The Water Knife* (New York: Penguin, 2016).

Figure 13. NASA satellite image of Hurricane Katrina. In the public domain.

Figure 14. Monarch butterflies, as described in *Flight Behaviour*.
From <http://pixabay.com>.

Sylvia Mayer

Barbara Kingsolver's *Flight Behaviour* (2012)

Barbara Kingsolver's *Flight Behaviour* is a climate change novel that strongly focuses on how climate change is experienced in place. Set in rural Tennessee, in a small farmers' community in the Appalachian Mountains, it draws attention to how local place in times of global warming must be understood: as deterritorialized space, that is, as a place defined by a combination of local as well as global ecological, economic, social and cultural forces; as multi-layered in terms of the different meanings it may have for its inhabitants at any particular moment; and as dynamic, both in the sense that it constantly undergoes concrete transformations and in the sense that the meanings attributed to it change over time. It is the novel's protagonist, 28-year-old Dellarobia Turnbow, who experiences dramatic transformations of the place in which she lives and thus gradually develops such a complex sense of place. Through her accumulating experiences of place, the novel's central themes become visible: the theme of climate change as a force of globalization that manifests in both non-human and human migration and entails the danger of species extinction, and the theme of climate change as a phenomenon that people perceive, interpret and assess very differently. The novel explores how different knowledges – most prominently, scientific and religious – attempt to make sense of climate change, it draws attention to the significance of social class and the role of the media in responding to and communicating climate change and it engages with climate change as a global risk and with the question of how to develop a climate ethical stance.

Flight Behaviour tells the story of Dellarobia and her family. The Turnbows are sheep farmers, and they own some land, but also have to rely on odd jobs to make ends meet. The Feathertown area, in which they and their neighbours live, is economically impoverished and has more recently suffered further

from striking weather anomalies. Excessive rainfall and unusual seasonal temperatures have considerably damaged the forests, fields and orchards over the summer and autumn. It is these weather anomalies, but especially the sudden appearance of millions of Monarch butterflies in a tract of woods the Turnbows own that introduce climate change as a driving force of globalization. When Dellarobia first encounters the butterflies, she does not realize that they are a manifestation of climate change, that global warming has caused the animals to change their migratory route and no longer spend the winter at their accustomed winter roosting site in Michoacán, Mexico. She also does not realize that this change also indicates the threat of species extinction, since the Tennessee temperatures may be too low for the butterflies' successful overwintering. Dellarobia learns about all this a little later, in conversations with the scientists who come to her place to study the butterfly phenomenon. Moreover, when she meets the family of her son Preston's classmate Josefina, she also finds out that the effects of global warming cause not only the migration of animals, but also the migration of people. With the transformation of the Michoacán mountainsides by climate-related factors, both the winter habitat of the Monarchs and the homes of the Delgados and their neighbours were destroyed. Animals as well as humans were forced to move somewhere else and thus become climate refugees. Dellarobia discovers that such experiences occur in many parts of the world, she learns that local place is affected by forces that originate elsewhere and she realizes that ecological and socioeconomic transformations are inextricably intertwined.

The differences in human perception, interpretation and assessment of climate change become particularly striking in the novel's juxtaposition of how science and religion interpret the butterflies' appearance. Most Feathertown people, on the one hand, regard the Monarchs as a benevolent and beautiful sign of divine power and resist any scientific explanation. The townspeople reject the idea of climate change; they are unwilling to even consider the possibility that the animals may be endangered and that they embody a process of ongoing destruction of habitats and homes. Dellarobia, on the other hand, becomes convinced by the scientific explanations she gets from scientist Ovid Byron and his research team. The knowledge she gathers about the species and its 'misdirected' choice of migratory route teaches her about the spatial and temporal scope of climate change, about its causes and effects and about

its dangers to both non-human and human inhabitants of a place. Her work with the scientists is, however, not just an educating experience for her; they also learn from her. Most importantly, she teaches them to acknowledge that science is a practice that cannot be separated from its social, political and economic contexts. She insists that scientists must make an effort to inform the public about their work.[1]

The reasons for these differing responses are explained in the novel by drawing attention to the impact of social class and the mass media. Acceptance of the results of climate science depends on a sound scientific education which Feathertown, due to its relative poverty, cannot provide. However, resistance against a science-based environmentalism cannot simply be explained by a lack of scientific knowledge. Climate scepticism or outright denial is not simply caused by a lack of formal education or by plain indifference. Instead, it is often motivated by fear of social destabilization and loss of control and by an acute sense of class privilege. Environmentalism to most of the Feathertown people is something that only the economically secure middle or upper classes can afford.[2]

Dellarobia's expanding sense of place also reflects the impact of the media. Once the news about the butterflies spreads, her home becomes the focus of media attention and attracts a variety of strangers: in addition to the scientists and the climate refugees, journalists, environmentalists and tourists arrive, who all add new meaning to the place she lives in. In conversations with them, but also through information by various media – television, radio and, arguably most importantly, the Internet – Dellarobia becomes immersed in the contested debate on global anthropogenic climate change and gradually realizes that she lives in a place that is both economically and ecologically connected to other places on the planet.

1 Sylvia Mayer, 'Science in the World Risk Society: Risk, the Novel, and Global Climate Change', *Zeitschrift für Anglistik und Amerikanistik* 64/2 (2016), 207–21.
2 Axel Goodbody, 'Risk, Denial, and Narrative Form in Climate Change Fiction: Barbara Kingsolver's *Flight Behaviour* and Ilija Trojanow's *Melting Ice*', in Sylvia Mayer and Alexa Weik von Mossner, eds, *The Anticipation of Catastrophe: Environmental Risk in North American Literature and Culture* (Heidelberg: Winter, 2014), 39–58.

The introduction of climate change as a contested and controversial issue and the fact that the indicators of climate change – the weather anomalies and the butterflies – foreshadow transformations of place that may become even more destructive in the future, show that *Flight Behaviour* engages with climate change as a global risk. The novel engages with experiences of uncertainty, lack of secure knowledge and threat, thereby exploring local experiences of what Ulrich Beck called the 'world risk society'. All the major characters in the novel realize that their world is changing; they are pressed to respond to situations that are characterized by insecurity, destabilization and the anticipation of a larger catastrophe. From such a context of risk emerges the climate ethical position of various characters, most notably that of the novel's protagonist. Dellarobia develops an ethical stance that is informed by a deterritorialized, globalized sense of place and that acknowledges the necessity to attribute moral value to both human and non-human beings.[3]

The novel's focus on climate change as environmental risk, as anticipation of a larger climate catastrophe, leaves no doubt that it presents a warning. It is permeated by dystopian elements, most prominently the destructive weather that culminates in the flooding of the place at the end of the novel, but also the appearance of the butterflies that expresses not just awe-inspiring beauty but must be recognized as a frightening symptom of a changing climate. This warning is, however, not alarmist. It is balanced by the hope that even though climate change may be unstoppable, there may be ways to adapt or mitigate its effects. Such hope is expressed most forcefully in the trust in scientific knowledge – indicated ultimately by Dellarobia's decision to become a scientist herself – and by the fact that at least some of the butterflies, those that resume their migration at the end of the novel, seem to survive the winter in Tennessee.

This sense of hope, along with the fear and shock that the gradual realization of the seriousness of the issue generates, is also created by a key formal feature: the choice of Dellarobia as the novel's single focalizer. All plot events and all characterization rely on this character's perceptions, feelings, interpretations

3 Sylvia Mayer, 'From an Ethics of Proximity to an Ethics of Connectivity: Risk, Mobility, and Deterritorialization in Barbara Kingsolver's *Flight Behaviour*', *Amerikastudien/ American Studies* 61/4 (2016), 489–505.

and evaluations, thereby putting strong emphasis on a specific female experience of climate change. Central to Dellarobia's thinking and feeling are not just intellectual acuity and an ability to empathize, but also the ironic attitude she often displays towards her surroundings and towards herself. For her, irony functions both as a mechanism of self-defence – against fear, frustration and even despair, for instance, when she becomes aware of the implications of climate change for her children's future – and as a way of observing and drawing conclusions from a distance. Her ironic observations, whether they expose the partial ignorance of some of the townspeople, scientists, environmentalists or her own, provide the novel with humour and a lightness of tone that balances the didacticism created in passages that focus on communicating significant insights of climate science. In fact, in many parts the novel is simply hilarious, not least when Dellarobia and her friend Dovey dissect the habits and routines of everyday Feathertown life.

The overall character constellation in *Flight Behaviour* puts emphasis on class difference, thereby drawing attention to the impact of socio-economic position on the perception and assessment of climate change. Its reliance on families and on child characters, most importantly on Dellarobia's son Preston and his friends, draws attention to the meanings of climate change for future generations. The shifts in character constellation, finally, highlight different types of migration, both human and non-human, that are caused by climate change: whether through the appearance of the butterflies, of Mexican climate refugees, or of scientists, environmentalists and media people, climate change emerges as an ultimately global driving force of environmental and social transformation.

Flight Behaviour, moreover, is marked by suspense. On the level of plot, various questions that arise create suspense, most importantly the questions of what Dellarobia will do, stay or leave, and whether the butterflies will survive. In addition, suspense partly defines the novel as an environmental risk narrative, which is defined by uncertainty, lack of knowledge and the anticipation of a catastrophic ending.

In terms of style, the novel works with a variety of features, most prominently perhaps with biblical imagery and with telling names. The recurring images of the flood or the lamb give climate change an almost mythical, even epic dimension, indicating, moreover, the novel's engagement with the pastoral and the apocalyptic traditions. Telling names add layers of meaning through

intertextual reference. The name Ovid Byron, for instance, references two poets whose work can be understood as providing views of non-human nature and society characterized by transformation and complexity – views that are basic to an understanding of the dynamics of global climate change. The title of the novel, *Flight Behaviour*, can, finally, be read as pointing out the inextricable connection between human and non-human nature, as it links Dellarobia's behaviour with that of the butterflies.

Since *Flight Behaviour* focuses heavily on the development of its protagonist, the novel can be categorized as a *Bildungsroman* or novel of formation. In addition, it bears traits of the conversion narrative, and its underlying sense of uncertainty and anticipation of a larger catastrophe in the future marks it as an environmental risk narrative. Throughout the novel, moreover, we see Kingsolver work with elements of the pastoral, sublime and apocalyptic modes.

The reception of *Flight Behaviour* has predominantly been a very positive one. Critics have praised the novel as an important and unique contribution to the discourse of global anthropogenic climate change from a class-, gender- and place-specific perspective. They have praised its humour, its fair characterization of its diverse range of characters and its ability to make not only the experience of climate change tangible, but also to effectively communicate essential aspects of climate science. At the same time, its undeniably anthropocentric focus, most strikingly visible in Dellarobia as single focalizer, has been criticized as symptomatic of a failure of climate change novels in general to develop more innovative narrative techniques when it comes to imagining climate change as the key manifestation of the Anthropocene.[4]

Flight Behaviour's wide spectrum of themes and the variety of genre categorizations point in several directions when it comes to teaching the novel. It can be taught, for instance, in courses that focus on climate change fiction and the Anthropocene, on the literature of migration and environmental justice, on 'science-in-fiction' literature, or on environmental risk fiction. Inclusion of the text in courses on contemporary 'life writing', moreover, will introduce a definition of the human self as inextricably linked to non-human nature.

4 Timothy Clark, *Ecocriticism on the Edge. The Anthropocene as a Threshold Concept* (London: Bloomsbury, 2015).

Hannes Bergthaller

Nathaniel Rich's *Odds Against Tomorrow* (2013)

When Hurricane Sandy struck New York in October 2012 (Figure 15), Nathaniel Rich had to revise the proofs of his novel *Odds Against Tomorrow*.[1] Set in an alternative near future, the novel's climactic event is the flooding of the city by a superstorm named Tammy. Much like the novel's protagonist Mitchell Zukor, Rich got 'scooped by reality'[2] – and acquired something of a reputation for his prophetic powers. What makes *Odds Against Tomorrow* interesting as a work of climate fiction, however, is neither the remarkable accuracy with which it anticipated a particular catastrophe that was itself widely seen as anticipating the 'new normal' of a climate-changed world,[3] nor the vividness with which it imagines the aftermath of this catastrophe. Rather, it has to do with how the novel frames this event as a crisis of rationality that puts into question the different ways in which people respond to risk. *Odds Against Tomorrow* is a satire of the financial industry, an essay on the apocalyptic imagination and a meditation about the dream of the simple life. On all of these thematic levels, it raises the question of how life is affected by the attempt to anticipate, pre-empt, or confront the dangers that threaten it.

1 Nathaniel Rich, *Odds Against Tomorrow* (New York: Farrar, Straus and Giroux, 2013).

2 Emily Gogolak, 'Nathaniel Rich Wrote About Hurricane Sandy Before It Hit', *The Village Voice* (18 April 2013) <https://www.villagevoice.com/2013/04/18/nathaniel-rich-wrote-about-hurricane-sandy-before-it-hit/> accessed 31 January 2018.

3 Tom Zeller, 'In Hurricane Sandy's Fury, the Fingerprint of Climate Change', *The Huffington Post* (29 October 2012) <https://www.huffingtonpost.com/2012/10/29/hurricane-sandy-climate-change_n_2038859.html> accessed 31 January 2018.

Figure 15. Stranded ambulance in New York after Hurricane Sandy © Alex Perkins. Reproduced under Creative Commons 2.0.

The novel is divided into three parts. The first part focuses on Mitchell's work as a risk consultant for FutureWorld, a company whose business model is summarized by its CEO: 'We make recommendations to our clients about how to reduce their exposure to catastrophe [...]. But we're merely consultants. If our recommendations are insufficient, we're not liable. And our clients, as long as they pay for our services, are not liable either.'[4] In other words, FutureWorld facilitates a legal shell game whereby corporations reap the benefits of their own risk-taking and pass on the costs to the public. The world of high finance is one in which disaster is deliberately courted as an opportunity for financial gain. It is a world dominated by cold-blooded predators in the stereotypical mould of a Gordon Gekko (Rich explicitly references the protagonist of Oliver Stone's *Wall Street* early in the novel),[5] people who are wilfully oblivious to

4 Rich, *Odds Against Tomorrow*, 29.
5 Rich, *Odds Against Tomorrow*, 43.

the harm their machinations inflict on others and supremely confident that no matter what happens, they will come out ahead. Mitchell's problem is that, despite his six-figure salary, he cannot share their confidence. His single defining character trait is an obsessive fearfulness which allows him to conjure up worst-case scenarios with mathematical precision and authentic urgency. Yet the more time he spends pondering the statistical odds of imagined catastrophes, the more crippling his anxieties become.

That is what attracts him to his former classmate Elsa Bruner, whose approach to risk is the polar opposite of Mitchell's. Elsa suffers from Brugada syndrome, a condition that makes her liable to suffer a heart attack at any moment. Nevertheless, she joins a hippie commune in rural Maine. This move leaves Mitchell baffled: 'Not that Augusta's hospital was a state-of-the art operation [...]. Besides, Elsa didn't have access to the Internet or telephones, so calling an ambulance was out of the question. And if that weren't enough, she was submitting herself to a frightening cocktail of activities that seemed designed to induce cardiac arrest: strenuous exercise, narcotics, and physical shock (jumping into a freezing lake)'.[6] Elsa's decision to 'drop out' is presented as a deliberate choice to forgo the spurious safety of modern society. What fascinates Mitchell above all is Elsa's apparent lack of fear, despite the imminent threat of death. A pop-psychological gloss on the dynamic that links the two characters is furnished by a quotation from a book Mitchell owns, Ernest Becker's 1973 bestseller *The Denial of Death*: 'The irony of man's condition is that the deepest need is to be free of the anxiety of death and annihilation; but it is life itself which awakens it, and so we shrink from being fully alive'.[7] This suggests that Mitchell's desire to protect life by rationally calculating risk is self-defeating, and hence irrational, whereas the apparent irrationality of Elsa's behaviour reflects the vital insight that the incalculability of risk is an essential and inevitable feature of life.

This conclusion seems to be borne out by the second part of the novel. When Hurricane Tammy hits New York, it catches Mitchell and his employers at FutureWorld unprepared. What allows him and his colleague and lover Jane Eppler to escape from the water-logged city is a psychedelically painted canoe,

6 Rich, *Odds Against Tomorrow*, 35.
7 Rich, *Odds Against Tomorrow*, 49–50.

which Mitchell had stumbled into at a local gallery and bought on an impulse after reading the artists' programmatic statement: 'Rationality has made a mess of this world [...]. We want to trust our impulses more'.[8] Confronted with an actual disaster, Mitchell turns out to be calm and self-possessed, even exhilarated by the surreal beauty of the flooded downtown. After he and Jane make it to a Red Cross camp in New Jersey, his first thought is for Elsa, whom he now begins to idolize as the embodiment of a radical alternative to his former way of life. The third part of the novel narrates their futile quest to locate Elsa, whose commune in Maine turns out to have collapsed after having been overrun by refugees. In a vision, Elsa (whom he believes to be dead) appears to him as 'St. Elsa of the fields', egging him on to follow his obsessions.[9] In the final chapters, Mitchell refuses to join Jane's newly founded risk consultancy, Future Days, turning down the opportunity to cash in on his newly won fame as the man who prophesied the flood. Instead, he sets out to realize what he believes to have been Elsa's goal, taking up the life of a hermit farmer in the devastated, depopulated 'Flatlands' that Hurricane Tammy has left behind in the city's outer boroughs. Accepting vulnerability to risk as a necessary part of life, Mitchell feels himself reborn. He bathes in a tidepool: 'The coldness was shocking, but when he resurfaced, everything had sharpened. The whiteness of the sky, the marsh's clicking insect choruses, the breeze against his face like a fresh shave. On the way back he congratulated himself for not worrying about the toxins that must have tainted his little bath – mercury, PCB, dioxins, sewage'.[10] Mitchell's experiment in self-reliance and simple living is described as a post-apocalyptic reboot of Thoreau's classic *Walden*.

This would make for a tidy narrative arc: from the false securities and fake futures of the insurance business to the sustainability of subsistence farming, from the denial of death to the affirmation of life, with Elsa the prophetess and Mitchell her true disciple. Clearly, this is how Mitchell wishes to see himself. Yet it is not how the novel ends. On its last pages, Jane visits him in his 'homestead' to deliver a message: not only is Elsa alive, after all, she also seems to have heeded Mitchell's earlier enjoinders to take a more rational approach

8 Rich, *Odds Against Tomorrow*, 98.
9 Rich, *Odds Against Tomorrow*, 264.
10 Rich, *Odds Against Tomorrow*, 282.

to her illness: 'Jane told him about her decision to undergo open-heart surgery to implant an automatic cardiac defibrillator – a device that carried a number of risks, but seemed necessary given the alternative'.[11] Now she is studying environmental law at Stanford, and applying for an internship at Future Days. She has also asked Jane to return a postcard Mitchell had written to her just before he started to work for FutureWorld. The card reads: '"By the time you get this, I'll be a futurist." It was in Mitchell's handwriting, with his signature. Only Elsa had crossed out Mitchell's name and signed her own'.[12]

The neatly symmetrical reversal of roles upends Mitchell's interpretation of his own life: the Elsa whose footsteps he saw himself as following, who strove for a life that was 'self-reliant, sovereign, irreproachable',[13] turns out to have been a projection of his desire to escape an anxiety-ridden existence, his homestead in the Flatlands, the latter's photographic negative. Rather than as diametrical opposites, *Walden* and *Wall Street* are revealed as distant points on a conceptual Moebius strip, with both revolving around promises of security and self-possession. Such a reading is also suggested by the novel's closing scene. Up until this point, Mitchell had been the narrative's focalizer; now, we see Mitchell from the perspective of Jane, who regards him with the same alarmed concern that had characterized Mitchell's relationship to Elsa. Whereas earlier she appeared to be perfectly insouciant, Jane is now consumed by anxiety and begins to fantasize about the wholly different way of life Mitchell has embraced. Driving back to a meeting in Manhattan, she muses 'that she would like to live in the Flatlands herself one day. She felt that she wanted to live in the Flatlands rather desperately. [...] She buzzed [the chauffeur]. "Ms. Eppler? Everything all right back there?" No, she thought. Everything is not right, not at all. I am *scared*'.[14]

Odds Against Tomorrow does not address the vast spatial and temporal scale of anthropogenic climate change, nor do its characters reflect on the role their own behaviour might play in its unfolding. As Antonia Mehnert

11　Rich, *Odds Against Tomorrow*, 302.
12　Rich, *Odds Against Tomorrow*, 303.
13　Rich, *Odds Against Tomorrow*, 289.
14　Rich, *Odds Against Tomorrow*, 306.

suggests in her reading of the novel,[15] its most salient contribution lies in the way in which it charts the mental topology of what Ulrich Beck has described as 'risk society' – that is, a society which glorifies risk-taking even as it obsesses over security and revels in fantasies of self-destruction, in which the belief in the rational calculability of risk yields patently irrational outcomes, and in which the collective strategies for the protection of life that were essential to the process of modernization are increasingly recognized as a source of danger. The novel challenges readers to reflect on the problem of what it might mean for an individual and for society to deal rationally with the exorbitant risks of climate change – and how narrow conceptions of rationality engender what Beck calls 'organized irresponsibility'.[16] Rick Crownshaw thus reads the novel as a critique of the 'actuarial imaginary' of a global capitalism whose efforts to commodify environmental risks foreclose the possibility of imagining a future without profits.[17] At the same time a 'narrative of anticipation' and a 'narrative of catastrophe', in Sylvia Mayer's terms,[18] *Odds Against Tomorrow* explores the social and psychological implications of the apocalyptic imagination. The central idea that efforts to protect life may end up weakening it, and that, conversely, exposure to risk can strengthen vitality, links Rich's novel both to the environmentalist tradition of voluntary simplicity and to liberal conceptions of subjectivity. In this respect, it also resonates with the general theory of immunity developed by the philosophers Roberto Esposito and Peter Sloterdijk, as well as with the notion of biopolitics Michel Foucault developed in his later writings on the subject.

15 Antonia Mehnert, *Climate Change Fictions: Representations of Global Warming in American Literature* (Basingstoke: Palgrave Macmillan, 2016).

16 Ulrich Beck, *Gegengifte: Die organisierte Unverantwortlichkeit* (Frankfurt a. M.: Suhrkamp, 1988).

17 Rick Crownshaw, 'Climate Change Fiction and the Future of Memory: Speculating on Nathaniel Rich's *Odd Against Tomorrow*', *Resilience*, 2–3/4 (2017), 127–46; here 130.

18 Sylvia Mayer, 'Explorations of the Controversially Real: Risk, the Climate Change Novel, and the Narrative of Anticipation', in Sylvia Mayer and Alexa Weik von Mossner, eds, *The Anticipation of Catastrophe: Environmental Risk in American Literature* (Heidelberg: Winter, 2014), 21–38; here 24.

Alexa Weik von Mossner

Franny Armstrong's *The Age of Stupid* (2009)

Franny Armstrong's climate change documentary *The Age of Stupid*[1] opens with a sequence of images that is somewhat unusual for a non-fiction film. After a creative visualization of the 'big bang', viewers are presented with a racing timeline and a quick succession of images that show the evolution of life on earth. The last few seconds of the sequence depict human civilization from its early days to the recent past and then extends into a speculative future, ending on a series of post-apocalyptic images: London flooded, the Taj Mahal in ruins, Las Vegas buried in sand and the Sydney Opera House up in flames (Figure 16). This, viewers are told, is the state of the world in 2055, and the film that follows is a look back from that speculative future to the time when humans burned fossil fuels as if there was no tomorrow, a time that is now recognized as the 'age of stupid'. Other climate change documentaries, too, have alluded to apocalyptical themes at times and fiction films such as *The Day After Tomorrow* (2004) revel in the visual spectacle of global apocalypse. What makes *The Age of Stupid* special is its use of a hybrid form of storytelling that mixes the factual with the fictional while passing itself off as a documentary. This unusual combination has been quite successful in influencing viewers' attitudes toward climate change, and Armstrong's film also received attention for its pioneering crowd-funding scheme and innovative distribution system. All of this makes it an important cli-fi text that warrants closer examination.

Given the dire warnings sounded by climatologists and other renowned experts about the risks entailed in an unchecked process of climatic change,

1 *The Age of Stupid*, dir. Franny Armstrong (Spanner Film, 2009).

Figure 16. London is devastated in *The Age of Stupid*'s dystopian frame narrative. *The Age of Stupid*, dir. Franny Armstrong (Spanner Films, 2009).

it is perhaps unsurprising that apocalyptic storytelling is quite common in documentary films on the issue. Many of these films are deeply political in approach and intent, relying on a combination of emotional appeals and scientific facts in order to issue warnings and, in some cases, offer solutions. *The Age of Stupid* is no exception in that it aims to warn its intended audiences in the UK and other industrialized nations that they must change their oil-guzzling lifestyles before it is too late and future generations will have to suffer the dire consequences. In order to make that argument the film presents viewers with its fictional frame narrative, set in 2055, in which an old Archivist, played by the late Pete Postlethwaite, is zapping through documentary material from 'the period leading up to 2015' as well as several explanatory cartoons, ostensibly to answer for himself the questions that torment him: 'Why didn't we save ourselves when we could?' and 'What does that say about us as a species?' Out of the old man's mental journey through his archive, six documentary storylines emerge, all of them filmed between 2005 and 2008, which trace the interconnections between the social inequalities and environmental repercussions of our global oil culture (Figure 17).

Figure 17. The Archivist zaps through the documentaries on his transparent touch-screen. *The Age of Stupid,* dir. Franny Armstrong (Spanner Films, 2009).

The stories that are told in those six documentary strands range from the ironies involved in the life of a Katrina survivor who works for Shell, a major oil company, to that of a young woman in Nigeria whose family is deeply affected by the environmental toll of Shell's oil exploration in the region. In addition, viewers are confronted with stories about a new airline in India whose owner hopes to get every countryman into a plane, about two Iraqi children who had to flee their country during the war and now grow up in Jordan hating America, about an old French mountain guide who mourns the loss of the Alpine glaciers, and about a British engineer who tries to sell wind turbines to people who complain about their spoiled views. While all of these stories are related in some way to global petroculture and/or climate change, they are only loosely associated, which is in fact the reason why Armstrong, after a first test screening, chose to add the fictional frame narrative in order to give her documentary more cohesion and perspective. In the completed film, the future Archivist not only acts as a moderator who introduces and comments on the documentary and news reel clips he presents; he also serves as the moral compass of the narrative. Even more importantly, he is an identification figure for viewers once they recognize that he belongs to their own generation and

therefore is responsible for the disastrous state of the earth in 2055. Viewers are invited to share the deep regret the Archivist expresses over his past attitudes and actions and to recognize that, unlike him, they are still in a position to *do* something about the matter, to change the 'age of stupid' into something more intelligent and foreseeing.

Another remarkable feature of the film is the cartoons that are periodically called up by the Archivist. Narrated by what sounds like children's voices (actually distorted versions of Armstrong's voice and that of her producer Lizzie Gillett), they inform viewers about the history of war over resources, the ultimate victory of consumerism, the large differences between ecological footprints in different parts of the world, and other topics that speak to the social and environmental justice dimension of the film. Through their humorous approach to very serious issues, these cartoons offer comic relief and thus a much-needed emotional offset to the film's dark and fear-inducing frame narrative (Figure 18). Scholars such as Gregg Mitman[2] have argued that climate change documentaries that tell stories 'of environmental doom and despair' can in fact not do without some lighter notes because their dire messages will otherwise overbear their audience emotionally. This is in keeping with much of the scholarly literature on the topic, which, as the sociologist Rachel Howell points out, tends to display 'anxiety that the use of shocking images and disaster narratives reduces efficacy to act because people feel overwhelmed and have a reduced sense of agency'.[3]

In order to get some empirical data on viewers' engagement with *The Age of Stupid*'s treatment of climate change, Howell conducted a three-part reception study on the film at the time of its release. Randomly selected participants during twenty-one screenings at the Edinburgh Filmhouse had to fill in the first questionnaire before watching the film, a second one after the screening, and – if they had agreed to that – a third one ten to fourteen weeks later. Howell concludes that the often suspected negative and depoliticizing effect of disaster narratives 'largely does not appear to have happened in this

2 Gregg Mitman, *Reel Nature: America's Romance with Wildlife on Film* (Seattle and London: University of Washington Press, 2009), 213.
3 Rachel A. Howell, 'Lights, Camera, Action? Altered Attitudes and Behaviour in Response to the Climate Change Film *The Age of Stupid*', *Global Environmental Change* 21/1, 177–87; here 184.

Figure 18. Cartoons explain consumerism and the global oil culture. *The Age of Stupid*, dir. Franny Armstrong (Spanner Films, 2009).

case. Respondents emerged from the film with an increased motivation to take action, and an increased belief that they could do something to prevent climate change getting worse, along with the sense that they are not already doing everything they can'.[4] However, Howell's research also makes clear that, like all non-fiction films, climate change documentaries such as *The Age of Stupid* face a double problem: their audiences are often atypical of the general public in that they already exhibit high levels of concern, and their effects on viewer attitudes tend to be short-lived. In a follow-up study, published in 2014, Howell reports that '[t]he heightened levels of concern, motivation to act, and sense of agency about action that were initially generated by the movie did not measurably persist over the long term', and that '[t]he results also show that behavioral intentions do not necessarily translate into action'.[5]

4 Howell, 'Lights, Camera, Action', 184.
5 Rachel A. Howell, 'Investigating the Long-Term Impacts of Climate Change Communications on Individuals' Attitudes and Behavior', *Environment and Behavior* 46/1 (2014), 70–101; here 70.

This might seem disheartening for Armstrong and other filmmakers who hope to impact public opinion, but research on the long-term effects of climate change communication suggests that emotional appeals can work in oblique and complicated ways that are often difficult to trace.[6]

Moreover, it makes an important difference whether we watch a film on our own in a movie theatre or in a class setting with ample opportunity for contextualization and critical discussion. As the film scholar Adrian Ivakhiv has pointed out, there is a wide range of questions that students can ask about any environmentally themed film, questions related not only to content, but also to rhetoric, style and structure as well as to the material conditions of production, distribution and exhibition.[7] As a hybrid format that integrates fictional elements with documentary material, *The Age of Stupid* is a particularly interesting subject for classes on climate change communication or environmental film, not least because discussions can be extended to the unusual production and distribution schemes for the film, and to the ways in which the filmmakers sought to extend its impact through the launching of the 10:10 website and campaign. In order to be creatively independent from big television stations such as the BBC, Armstrong decided to crowd-fund her movie, which at the time was a relatively new approach to film financing. Even before the opening credits, viewers are informed that '228 ordinary individuals and groups [...] invested between £500 and £35,000 to make a total of £450,000' and that an additional £400,000 was later raised for the marketing of the film. The creative and political implications of such a crowd-funding scheme are a good subject for critical discussion, as is the filmmakers' decision to circulate *The Age of Stupid* instead through an Indie Screenings model, which allowed them to stay away from major distribution companies and premiere their documentary in solar-powered theatres. The 'Making Of' video that is included in the DVD package of the film provides valuable information on

6 David Roberts, 'Does Hope Inspire More Action on Climate Change than Fear? We Don't Know', *Vox* (5 December 2017) <https://www.vox.com/energy-and-environment/2017/12/5/16732772/emotion-climate-change-communication> accessed 26 March 2018.

7 Adrian Ivakhiv, 'Teaching Ecocriticism and Cinema', in Greg Garrard, ed., *Teaching Ecocriticism and Green Cultural Studies* (Basingstoke: Palgrave Macmillan, 2012), 144–54; here 145.

these material dimensions of its production and distribution – including its carbon footprint – that can all be used productively in a teaching context.

Like many other cli-fi texts and films, then, *The Age of Stupid* aims to intervene in a debate around the ecological, economic and existential risks that societies face in an age of accelerating climate change. Although it is rooted in a Western perspective, the film aims to paint a bigger picture that is sensitive to the unequal distribution of impacts and opportunities. Citing Steven Soderbergh's drug crime drama film *Traffic* (2000) as one of her creative influences, director Franny Armstrong wants to convince her viewers that the interwoven issues foregrounded in the documentary portion of her film will have real-world consequences that may be different in degree but not necessarily in kind from the fictional future scenario with which they are presented.[8] The effectiveness of that message likely depends in part on the ideological and political mindset that individuals bring to the viewing experience, and it will also be influenced by experiences that viewers make *after* seeing the film. In his review of research on the efficacy of climate change communication, David Roberts concludes that '[w]hat matters in an overall assessment of someone's disposition toward climate change is not their raw feelings in the immediate aftermath of an emotionally significant experience [...] but how those responses are reinforced and strengthened (or not) over the course of the following days and years'.[9] Seen in this light, all forms of cli-fi – be they fiction, non-fiction or hybrid forms such as *The Age of Stupid* – contribute their share to transforming the abstract, vast phenomenon of climate change into something that is viscerally relatable.

8 Alexa Weik von Mossner, 'Troubling Spaces: Ecological Risk, Narrative Framing, and Emotional Engagement in Franny Armstrong's *The Age of Stupid*', *Emotion, Space and Society* 6/1 (2013), 108–16; here 112.
9 Roberts, 'Does Hope Inspire More Action'.

Part IV

Thriller, Crime, Conspiracy and Social Satire

Alexa Weik von Mossner

Roland Emmerich's *The Day After Tomorrow* (2004)

Much as it was criticized at the time of its release in 2004, Roland Emmerich's *The Day After Tomorrow*[1] holds a special status within the emerging genre of cli-fi cinema. Despite its many scientific inaccuracies, the movie stands out as the first Hollywood mega-blockbuster that self-consciously was *about* climate change rather than just using a climatically changed environment as narrative setting and background. Other climate-themed films such as Bong Joon-ho's *Snowpiercer*[2] and George Miller's *Mad Max: Fury Road*[3] feature spectacular environments that severely limit what their protagonists can and cannot do, but these protagonists are not scientists, nor do those films aim to bring to life, as *The Day After Tomorrow* does, an actual scientific scenario such as the shutdown of the Atlantic Meridional Overturning Circulation. Countless commentators, scientists and otherwise, have stressed that the spectacular disasters on display in Emmerich's film are not actually part of this or any other scientific scenario, and that the scenario itself is a hypothetical model rather than a prediction.[4] However, the film's treatment of climate change nevertheless was pertinent enough at the time of its release to fuel a national debate. In the USA, *The Day After Tomorrow* received more than ten times the press coverage

1 *The Day After Tomorrow*, dir. Roland Emmerich (20th Century Fox, 2004).
2 *Snowpiercer*, dir. Bong Joon-ho (CJ Entertainment, 2004).
3 *Mad Max: Fury Road*, dir. George Miller. (Warner Bros Pictures, 2015).
4 Stefan Rahmstorf, '*The Day After Tomorrow* – Some Comments on the Movie', *Home page of Stefan Rahmstorf, Potsdam Institute for Climate Impact Research* (2017) <http://www.pik-potsdam.de/~stefan/tdat_review.html> accessed 27 March 2018.

of the 2001 IPCC report[5] and the Bush administration was so nervous about the potential impact of the film that it tried to muzzle NASA climatologists in order to keep them from publicly discussing the film.[6] These facts alone underline the special status of a movie that, in its speculative and spectacular way, has helped shape the way the general public envisions climate change.

The socio-political and cultural impact of *The Day After Tomorrow* is to a large degree due to the fact the film translates abstract scientific notions about our changing climate into concrete images of an increasingly hostile nature and a heart-warming story about particular people: the paleo-climatologist Jack Hall (Dennis Quaid) and his teenage son Sam (Jake Gyllenhaal), who get separated in the cataclysmic events that follow the stalling of the Atlantic Meridional Overturning Circulation and are reunited at the end of the movie. As is typical for Hollywood action films, both men are highly idealized, melodramatic heroes, Jack even more so than his son who, for most of the film, is stuck in the New York Public Library to escape the raging ice storm outside. Not only is Jack righteous, vigorous and 'notoriously brave', he also has, as Matthew Nisbet has observed, a number of other laudable qualities: 'He drives a hybrid car [...] shares a strong bond with his co-workers, and risks his life early on in the film to save his colleague [...]. The only downside to Quaid's character is that he is a workaholic. He is completely devoted to climate science while missing out on his family life'.[7] Jack thus has a number of virtues and only one serious (and forgivable) flaw, which he will resolve to correct in the course of the story as he travels – on foot – from Washington, DC to New York City through catastrophic conditions in order to save his son (Figure 20). Moreover, he tries to save other lives by warning the US government and the world about what is in store for them. Those who believe Jack – like his son – have a chance to survive the abrupt and drastic climate shift, and those

5 Anthony A. Leiserowitz, 'Before and After *The Day After Tomorrow*: A U. S. Study of Climate Risk Perception', *Environment* 46/9 (2004), 23–37; here 34.

6 Leiserowitz, 'Before and After', 31.

7 Matt Nisbet, 'Evaluating the Impact of *The Day After Tomorrow*: Can a Blockbuster Film Shape the Public's Understanding of a Science Controversy?', *CSICOP On-Line: Science and the Media* (2004) <https://www.csicop.org/specialarticles/show/evaluating_the_impact_of_the_day_after_tomorrow> accessed 27 March 2018.

who doubt him – like the American government – are inevitably doomed. At the end of the film, the new US president (and former vice president) is forced to admit that he 'was wrong' when he decided to ignore scientific insights in the reckless pursuit of economic growth.

As a dystopian disaster film, *The Day After Tomorrow* thus offers a spectacular apocalyptic scenario that plays on people's need for excitement and fears of the future, while at the same time offering them a likeable and righteous identification figure and a clearly spelled out moral message.[8] This combination not only ensured that the film was a global success at the box office, but it also seems to have changed viewers' minds about the risks associated with climate change. This is what is suggested by the five reception studies on *The Day After Tomorrow* that were conducted more or less simultaneously in four different countries, examining the attitudes of audiences toward climate change before and after seeing the film and, in one case, also comparing them to the attitudes of non-viewers. The five studies differ in methodology and approach but a comparative view can nevertheless offer some relevant conclusions. The American study found that despite its apocalyptic – and often unscientific – disaster scenarios, the film 'had a significant impact on the climate change risk perceptions, conceptual models, behavioral intentions, policy priorities, and even voting intentions of moviegoers'.[9] The results of the other reception studies were somewhat but not entirely different.[10] As a popular cli-fi film, *The Day After Tomorrow* seems to have been moderately successful, at least in the short run, in raising awareness for climate change risks among its audiences (across cultures), and it also seems to have encouraged some viewers to engage in personal, political and social action.

Whether changes in attitude that were provoked by a climate-themed film are stable over longer periods of time and whether they translate into changed behaviours is notoriously difficult to measure. However, one way to encourage a deeper, and potentially more lasting, engagement with the issues

8 Alexa Weik von Mossner, *Affective Ecologies: Empathy, Emotion, and Environmental Narrative* (Columbus: Ohio State University Press, 2017), 153–61.

9 Leiserowitz, 'Before and After', 34.

10 Fritz Reusswig, 'The International Impact of *The Day After Tomorrow*', *Environment* 46/9 (2004), 41–3; here 43.

Figure 19. Manhattan is engulfed by an enormous tidal wave. *The Day After Tomorrow*, dir. Roland Emmerich (Centropolis Entertainment/Lionsgate Films/Mark Gordon Company, 2004).

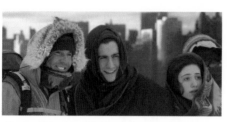

Figure 20. Jack Hall is reunited with his son at the film's happy ending. *The Day After Tomorrow*, dir. Roland Emmerich (Centropolis Entertainment/Lionsgate Films/Mark Gordon Company, 2004).

raised in a film such as *The Day After Tomorrow* is to teach it in a way that encourages critical discussion. While educators might shy away from Emmerich's film due to its attention-grabbing and formulaic storytelling, its combination of memorable imagery and overt environmentalist ethical stance make it an ideal teaching subject, be it in the university classroom or in the realm of (public) science education. Sylvia Mayer suggests that teaching environmentalist Hollywood movies – even movies that shamelessly exploit scientific scenarios to maximize melodramatic effect – in a university context can 'contribute to the efforts made in the field of environmental education'.[11] Not only can an engagement with a popular cli-fi movie such as *The Day After Tomorrow* help develop research and analytical skills, but it can also strengthen students' understanding of climate change, factual errors and distortions notwithstanding. Mayer stresses the importance of contextualizing Emmerich's film, for example, by providing students with information about melodramatic storytelling and 'the environmental issues at stake'[12] to encourage and facilitate analytical viewing rather than superficial enjoyment.

With popular Hollywood productions, such an analytical approach can be particularly difficult since everything in the film – from its editing pace to its spectacular imagery and the dramaturgical use of sound and music – is actively working against it. Students sometimes report feeling 'sucked into' such films, even when they plan to view it analytically, which is why it can help to isolate scenes and watch them repeatedly, each time paying attention to a different audiovisual or narrative feature. The scene when Jack Hall presents his model of the Atlantic Meridional Overturning Circulation at the UN conference in

11 Sylvia Mayer, 'Teaching Hollywood Environmentalist Movies: The Example of *The Day After Tomorrow*', in Mayer and Graham Wilson, eds, *Ecodidactic Perspectives on English Language, Literatures and Cultures* (Trier: Wissenschaftlicher Verlag, 2006), 105–20; here 107.
12 Mayer, 'Teaching Hollywood Environmentalist Movies', 110.

Delhi at the beginning of the film is among those that are particularly well suited to such detailed analysis, since it allows for the discussion of both the scientific and the political and cultural dimensions of climate change while also drawing connections to actual UN conferences on the subject (Figure 21). At the same time, the scene can also be taken as a starting point for a critical discussion of the melodramatic universe of the film – the way it pits good (and smart) scientists against evil (and stupid) politicians in a manner that can feel quite formulaic.

Figure 21. Protagonist Jack Hall explains the AMOC to the United Nations. *The Day After Tomorrow*, dir. Roland Emmerich (Centropolis Entertainment/Lionsgate Films/ Mark Gordon Company, 2004).

The Day After Tomorrow thus remains a central text for university classes on climate cinema or even environmental narratives more generally. Contrasting the blockbuster film with more 'serious' documentaries on the topic such as, for example, Davis Guggenheim's *An Inconvenient Truth*,[13] allows for a discussion of the different narrative strategies of fiction and non-fiction film and the ways in which *The Day After Tomorrow* may have contributed to the surprising success of Guggenheim's documentary (which includes CGI footage from Emmerich's film). Moreover, it can serve as a springboard for a more scientific engagement with climate change. In the realm of public science education, stills and clips from *The Day After Tomorrow* continue to be used in this way as eye catchers and/or discussion starters. In a blog post for the website *Yale Climate Change Connections*, Michael Svoboda wonders about the 'lingering influence' of Emmerich's film, citing science educators such as Sunshine Menezes from the Metcalf Institute on Marine and Environmental Reporting, who attests to the continued relevance of the film to their work.[14]

13 *An Inconvenient Truth*, dir. Davis Guggenheim (Paramount Pictures, 2006).

14 Michael Svoboda, 'The Long Melt: The Lingering Influence of *The Day After Tomorrow*', *Yale Climate Connections* (5 November 2014) <http://www.yaleclimateconnections. org/2014/11/the-long-melt-the-lingering-influence-of-the-day-after-tomorrow/> accessed 4 January 2018.

Last but not least, the unusual staying power of *The Day After Tomorrow* also manifests itself in the fact that the film has become a reference point for other Hollywood directors who aim to tackle the issue of climate change. In a scathing review of Dean Devlin's *Geostorm*,[15] Svoboda asserts 'the continuing influence of Roland Emmerich' on the emerging cli-fi film genre in terms of both narrative and visual style.[16] While no other production has been as commercially successful or culturally influential as Emmerich's groundbreaking blockbuster film, its combination of science-defying special effects and melodramatic storytelling continues to be emulated by other filmmakers who seek to exploit our fear of apocalyptic climate change for the creation of commercially viable movies.

So far, none of these movies has managed to bring climate change-related scenarios to life in a way that would have sparked similar press coverage and public debate, let alone provoke an intervention from the US government. Without belittling this perhaps unexpected achievement of a movie that first and foremost was made to entertain and make money, it seems regrettable that there are not more, and perhaps somewhat more nuanced, cli-fi films that have the capacity to engage a mass audience in questions related to climate change. Whether it is a question of timing, funding or general climate fatigue is hard to tell, but it seems high time for another climate-themed film that can captivate the popular imagination in the way *The Day After Tomorrow* did in its time.

15 *Geostorm*, dir. Dean Devlin (Warner Bros Pictures, 2017).
16 Michael Svoboda, '*Geostorm*: A (Very) Imperfect Storm', *Yale Climate Connections* (14 November, 2017) <https://www.yaleclimateconnections.org/2017/11/ geostorm-a-very-imperfect-storm/> accessed 27 March 2018.

Greg Garrard

Michael Crichton's *State of Fear* (2004)

State of Fear[1] is an action thriller by Michael Crichton, the author of numerous novels and screenplays, including *Congo* (1980), *Jurassic Park* (1990), *Disclosure* (1994) and early seasons of *ER* (1994–2009). *State of Fear* stands out from most other cli-fi because of its overt, not to say outlandish, scepticism about anthropogenic climate change. However, questioning of climate science and political opposition to environmentalism are important aspects of contemporary climate change culture, and so *State of Fear* deserves a place in this volume.

The protagonist of Crichton's novel, Peter Evans, is an idealistic environmental lawyer who is caught up in a murderous global conspiracy devised by the fictional Environmental Liberation Front (ELF). The ELF plans a series of artificially induced climate disasters to try and influence the outcome of a climate conference in California. Evans is saved, and the plot foiled, by a team of computer hackers and scientists led by a mysterious climatologist-cum-secret agent called Kenner. In the interludes between enjoyable scenes of derring-do that showcase Crichton's skills as an author of movie-ready novels, Kenner disabuses Evans of his naïve environmentalist views, citing selected scientific studies for which Crichton provides footnotes. Chapter headings give locations, dates and times – 'Santa Monica, Wednesday, October 13th, 9:33AM' – that reinforce the globe-spanning race against time. The author's unambiguous message is underlined by an 'Author's Message' at the end that explains 'Why Politicized Science is Dangerous'. *State of Fear*'s challenge to apocalyptic environmentalism is sporadically engaging, but Crichton's hybridization of the genres of spy thriller and thesis novel is ultimately unsatisfactory.

1 Michael Crichton, *State of Fear*, 2004. Kindle.

State of Fear is a fictional realization of American right-wing sceptics' assertions about climate change: at best, its potential impact has been exaggerated; at worst, the whole thing is a hoax. According to an anti-environmentalist sociology professor, a character introduced solely to explain the book's thesis, the 'politico-media-legal complex'[2] has tightened its grip on power in America by means of 'the constant creation of fear. And there is no countervailing force. There is no system of checks and balances, no restraint on the perpetual promotion of fear after fear after fear'.[3] This alleged 'state of fear' promotes, not prevalent right-wing concerns about moral decline, uncontrolled immigration or gun control,[4] only over-hyped environmental anxieties. Thus, Kenner suggests that the banning of DDT, inspired by Rachel Carson's *Silent Spring*, caused 'more than fifty million needless deaths'.[5] Unfortunately, there are no well-informed environmentalist characters in the book to respond rationally to such arguments.

There are two types of environmentalist in *State of Fear*: well-meaning liberals who think Nature is all flowers and cuddly animals, and evil radicals who creep around in conspicuous blue Priuses killing off climate dissidents. Ted Bradley is the first kind, a Hollywood actor modelled closely on Martin Sheen. He is a hypocrite, a 'Gulfstream environmentalist',[6] who mouths green platitudes about 'the balance of nature' that Kenner immediately contradicts. The ultimate reproof to Bradley's naïve love of Nature is delivered by a tribe of Solomon Islanders, previously idealized by him as having 'a natural ecological sense',[7] who cut him up and eat him. The second type of environmentalist is epitomized by the ELF, dubbed a 'serious Alpha extremist group', whose breathtaking conspiracy is 'global in scope, immensely complicated, extremely expensive.'[8] ELF assassination techniques are baroque: they either

2 Crichton, *State of Fear*, 455.
3 Crichton, *State of Fear*, 456.
4 Arlie Russell Hochschild, *Strangers in Their Own Land: Anger and Mourning on the American Right* (New York: The New Press, 2016).
5 Crichton, *State of Fear*, 487.
6 Crichton, *State of Fear*, 124.
7 Crichton, *State of Fear*, 499.
8 Crichton, *State of Fear*, 33–4.

Denialist Cli-Fi

use a rare venomous octopus, kept in a plastic bag, or attract lightning bolts to their enemies. Their plot involves breaking off a chunk of Antarctic ice-sheet; geo-engineering freak storms and flash floods in Arizona on a holiday weekend; and triggering a second Asian tsunami. The environmental radicals are never permitted to speak for themselves.

Kenner's critique of Bradley's uninformed beliefs is often well-founded, and the book's argument against environmentalist and media 'alarmism' is not without merit.[9] However, the alignment of climate change with shallow Nature-worship and media scare stories is simplistic and poorly supported by the scholarly sources cited by Crichton. The book includes several demonstrably false (but endlessly recirculated) sceptical claims, such as that the 1995 IPCC Summary report was written 'after the scientists themselves had gone home'.[10] The IPCC itself is inaccurately described as 'a huge group of bureaucrats, and scientists under the thumb of bureaucrats'[11] and a 'political organization, not a scientific one'.[12] Kenner's more-in-sorrow-than-anger conclusion is that 'Climate science simply isn't there yet [...] One day it will be. But not now'.[13] George Morton, a billionaire environmentalist whose disillusionment motivates the subplot, claims that:

9 Richard North, *Life on a Modern Planet: A Manifesto for Progress* (Manchester: Manchester University Press, 1995); Martin W. Lewis, *Green Delusions: An Environmentalist Critique of Radical Environmentalism* (Durham, NC and London: Duke University Press, 1992); Daniel B. Botkin, *Discordant Harmonies: A New Ecology for the Twenty-First Century* (New York and Oxford: Oxford University Press, 1990).

10 Crichton, *State of Fear*, 245. See 'The Consensus-Building Process of the IPCC', *SkepticalScience* 23 February 2012 <https://www.skepticalscience.com/ben-santer-1995-ipcc-report.htm>; 'Close Encounters of the Absurd Kind', *RealClimate*, 24 February 2010 <http://www.realclimate.org/index.php/archives/2010/02/close-encounters-of-the-absurd-kind/ both> accessed 27 March 2018.

11 Crichton, *State of Fear*, 245.

12 Crichton, *State of Fear*, 246; compare with Simon Shackley and Tora Skodvin, 'IPCC Gazing and the Interpretative Social Sciences: A Comment on Sonja Boehmer-Christiansen's "Global Climate Protection Policy: The Limits of Scientific Advice"', *Global Environmental Change* 5/3 (1995), 175–80.

13 Crichton, *State of Fear*, 249.

> Right now, scientists are in exactly the same position as Renaissance painters, commissioned to make the portrait the patron wants done. And if they are smart, they'll make sure their work subtly flatters the patron. Not overtly. Subtly. This is not a good system for research into those areas of science that affect policy.[14]

This familiar sceptical claim substantially understates: the ambivalence of even liberal and social democrat political actors towards climate change; the autonomy of research funding agencies; the effectiveness (though not the faultlessness) of peer review mechanisms; and the complex, often contradictory, values, incentives and social practices that influence working scientists. Unlike most sceptics, Crichton seems to offer a constructive alternative: Morton concludes the book by imagining a new free-market environmental organization that would solve problems, rather than over-hyping them. Thus far, none of Crichton's conservative admirers have taken up the challenge.

One is tempted to ask: what formal qualities does the book possess? Readers of literary fiction will find the characters wooden and one-dimensional, the plot implausible and the overt messaging tiresome. At over 600 pages, *State of Fear* is also very long. The women are all beautiful, athletic and indistinguishable, except by hair color. Kenner is essentially a superhero:

> Professor Kenner got a doctorate from Caltech at twenty. Got his law degree from Harvard in two years instead of three. Professor at MIT when he's twenty-eight ...[15]

He is also a world-class skier, mountaineer and spy, who is expert with a gun. The latter quality is initially lacking in the protagonist Evans, whose character arc takes him from wimpy environmental lawyer to hard-bitten, gun-toting, fast-driving climate sceptic. Sarah, one of the hard-bodied women, is disappointed that Evans 'behave[s] like such a wimp' despite being 'good-looking' with the 'strong physique of an athlete',[16] but later comes to admire his courage and skill in combat. A feminist critique of the novel's characterization would be like shooting fish in a barrel.

14 Crichton, *State of Fear*, 564.
15 Crichton, *State of Fear*, 56–7.
16 Crichton, *State of Fear*, 322.

Nevertheless, formal analysis of *State of Fear* could draw attention to the spliced narrative elements of the spy thriller and the thesis novel. The movie-like pace and narrative framing is sustained by action scenes dotted through the book at regular intervals, whereas the footnoted discursive sections slow it down interminably. Crichton has compromised his skill as an author of thrillers for political reasons.

The reception of *State of Fear* exemplifies the partisan divide in American politics concerning climate change.[17] Before his death in 2008, Crichton was invited to meet President George W. Bush and to testify before a US Senate hearing. The novel led the *New York Times* bestseller list, won the 2006 journalism award from the American Association of Petroleum Geologists, and was excerpted in Senator James Inhofe's 2012 book, *The Greatest Hoax: How the global warming conspiracy threatens your future*. George Handley suggests, tongue in cheek, that Crichton is 'the Rachel Carson of climate change skepticism'. He goes on to show that Crichton's beliefs about science and climate change are both incoherent in their own right and incompatible with those of conservative Christians who cite his work.[18]

State of Fear was panned by reviewers in broadsheet newspapers[19] and science journals. Michael Crowley suggested that *State of Fear* reflects Crichton's desire to be taken more seriously, and his embrace of conservative populism: 'By trashing the conventionally trained expert, Crichton has helped create an anti-intellectual ethos where the country's most powerful political leaders can embrace a science-fiction writer as a great authority'.[20] Myles Allen, writing in

17 Aaron M. McCright and Riley E Dunlap, 'The Politicization of Climate Change and Polarization in the American Public's Views of Global Warming, 2001–10', *The Sociological Quarterly* 52/2 (2011), 155–94.

18 George Handley, 'Climate Scepticism and Christian Conservatism', in Greg Garrard, Axel Goodbody, George Handley and Stephanie Posthumus, *Climate Change Scepticism: A Transnational Ecocritical Analysis* (New York: Bloomsbury Academic, forthcoming).

19 Bruce Barcott, '*State of Fear*: Not so Hot', *New York Times Sunday Book Review*, 30 January 2005 <http://www.nytimes.com/2005/01/30/books/review/state-of-fear-not-so-hot.html> accessed 27 March 2018.

20 Michael Crowley, 'Jurassic President', *The New Republic*, 20 March 2006 <https://newrepublic.com/article/65354/michael-crichtons-scariest-creation> accessed 27 March 2018.

Nature, dismisses the novel as 'Viagra for climate sceptics'.[21] Only recently has *State of Fear* been considered as an example, however questionable, of cli-fi.[22]

State of Fear is limited as a teaching text, thanks to its length and poor literary quality. Moreover, there are too few examples of sceptical cli-fi for it to feature on a course focusing on anti-environmentalist cultures. Nevertheless, Crichton's novel does epitomize the sceptical critique of apocalyptic environmentalism, as well as exemplifying a genre that is very widely read, even if not typically appreciated by literary critics. If provided in the form of excerpts, the novel's hybridity and moments of justified critique of popular environmentalism would provide opportunities for discussion without burdening students with unrewarding reading.

Perhaps the most interesting aspect of *State of Fear* is its idealistic treatment of science. Even as it rejects the consensus of climate scientists as politically biased, the novel anxiously quotes selected (opponents would say 'cherry-picked') studies to legitimate its contrarian argument – an odd strategy for a novel that claims the whole subject is a hoax. Moreover, Crichton recalls traditional ideals of scientific impartiality in his 'Author's Message', which he argues have been abrogated by environmentalist activism. As Ted Nordhaus and Michael Shellenburger argue, the need to maintain strict separation between science and politics is a staple of many climatologists, too:

> The conventional wisdom is that environmentalists and global warming deniers like best-selling novelist Michael Crichton disagree over the value of science. But both share most of the same beliefs about Science and the need for it to stay clear of values and politics. This statement – 'Because in the end, science offers us the only way out of politics. And if we allow science to become politicized, then we are lost' – was uttered by Michael Crichton, but it could just as easily have been uttered by most environmental scientists.[23]

21 Myles Allen, 'A Novel View of Global Warming', *Nature* 433 (20 January 2005), 198 <https://www.nature.com/articles/433198a> accessed 27 March 2018.

22 Greg Garrard, 'The Unbearable Lightness of Green: Air Travel, Climate Change and Literature', *Green Letters* 17/2 (2013), 175–88; Garrard, Axel Goodbody, George Handley and Stephanie Posthumus, *Climate Change Scepticism: A Transnational Ecocritical Analysis*, ed. Garrard and Richard Kerridge (London: Bloomsbury Academic, forthcoming 2018); Adam Trexler, *Anthropocene Fictions: The Novel in a Time of Climate Change* (Charlottesville: University of Virginia Press, 2015), 35–46.

23 Ted Nordhaus and Michael Shellenberger, *Break Through: From the Death of Environmentalism to the Politics of Possibility* (Boston MA: Houghton Mifflin, 2007), 139.

Scholars in the field of science and technology studies, by contrast, suggest that climate change reveals how science and politics (and their synonyms fact and value, truth and opinion), have been productively entangled in one another all along.[24] What are the implications if a misleading 'Boy Scout image of science'[25] is maintained by both environmentalists and sceptics like Crichton? Is a more accurate sense of the capacities and limits of climate science commensurate with the huge challenge of building a social consensus around climate mitigation? The questions raised by *State of Fear* are more intriguing than the novel itself.

24 Bruno Latour, *Politics of Nature: How to Bring the Sciences into Democracy* (Cambridge, MA and London: Harvard University Press, 2004).

25 Marianne Ryghaug and Tomas Moe Skjølsvold, 'The Global Warming of Climate Science: Climategate and the Construction of Scientific Facts', *International Studies in the Philosophy of Science* 24/3 (2010), 287–307; here 302.

Terry Gifford

Liz Jensen's *The Rapture* (2009)

English novelist Liz Jensen's sixth novel, published in 2009, titled *The Rapture*, is a thriller set in England in 2013. The theme of the novel is concerned with alternative responses to impending environmental disaster. Here, everyone wears dark glasses and there is a turbine in view from every window, but still 'the latest projections predict the loss of the Arctic ice cap and a global temperature rise of six degrees within Bethany's lifetime if nothing is done now'.[1] 'After the Copenhagen climate summit failed to deliver', Planetarian eco-groups have set up sustainable communities to await the extinction of the human species as Gaia does her work.[2] An alternative is provided by 'the Faith Wave creed brought over by the British citizens who abandoned their sunshine homes in Florida and returned to the UK after the global crash' and have now established 50,000 churches.[3] With their own kind of fatalism they await signs of the 'Rapture' – the beginning of the apocalypse when the faithful will be lifted up to heaven and the remainder punished with natural disasters extinguishing the species. So, in this novel, faith in sustainable communities is set against a particular form of religious faith, in their different responses to an impending environmental crisis. But the 'generalized malaise' is global in the range of its concerns: 'world preoccupations remain an uneasy, toxic mix' that includes not only advanced signs of economic meltdown, social breakdown and 'the violence in Iran and Israel', but an increased frequency of hurricanes, tsunamis and earthquake activity.[4] The novel asks if there are other forms of responsible action in this apparently

1 Liz Jensen, *The Rapture* (London: Bloomsbury, 2009), 23.
2 Jensen, *The Rapture*, 33.
3 Jensen, *The Rapture*, 23.
4 Jensen, *The Rapture*, 45.

accelerating end-of-the-world scenario. As will be noted, the novel abandons this question in pursuit of the immediate survival dilemmas facing its central characters, resulting more in a general critique of human exploitation of the earth than in offering alternatives.

Bethany is a violent and abusive teenager, brought up in a repressive evangelical Faith Wave home, who has viciously murdered her mother and is being treated in an Adolescent Secure Psychiatric Hospital. Her family have believed her to be possessed by the Devil and she has adopted this persona. Assigned to Bethany as her art therapist is the sympathetically drawn, sensitive character of Gabrielle Fox, in whose person the novel is narrated. She is in her first job since a car accident in which her married lover died and she was confined to a wheelchair. Bethany is able to intuit and manipulate Gabrielle's vulnerabilities, but more significantly the teenager is able to predict global natural cataclysms to a precise date. As she says, 'I have fucking satellite vision. Like the Hubble telescope'.[5] Bethany puts this ability down to the metal in her blood that is stimulated by the ECT treatment that she has come to crave. At first Gabrielle is sceptical: 'I try to quell my distaste for this girl, and for the unimaginativeness of her cataclysmic visions – visions shared by half the population, along with a belief in miracles and tarot readings'.[6] But the accuracy of successive predictions brings to Gabrielle guilt at an inability to alert global populations to the imminent threats that Bethany predicts.

Gabrielle seeks the help of a physicist, Fraser Melville, who recognizes in Bethany's notebooks patterns that suggest her sensitivity to the systems of 'turbulence' that he happens to be studying in the air, the oceans and the earth itself. He offers Van Gogh's skies as an image of such unseen natural activity. Significantly, Jensen acknowledges that Melville's ideas here are based upon the real research of the Mexican physicist José Luis Aragón.[7] Fraser and Gabrielle become convinced that Bethany's prediction of a truly apocalyptic disaster on 12 October requires that they alert the world to this, and the latter part of the novel, which is marketed as a psychological thriller, is concerned with attempts to do so with the help of both international scientific authorities and

5 Jensen, *The Rapture*, 25.
6 Jensen, *The Rapture*, 25.
7 Jensen, *The Rapture*, 343.

the fatalistically reluctant Planetarian guru Harish Modak. Coincidentally, this date has somehow been sensed as the day of the Rapture by the Faith Wave Christians, so the novel's climax takes place at the post-2012 Olympic stadium in East London where the Faith Wavers have gathered for the Rapture event, led by Bethany's evangelical father.

Another theme is revealed by character development. Bethany's lack of self-worth as a result of her internalization of her family's belief that she is 'possessed by evil'[8] ('I have the mark of the Beast [...]. That's where the electrodes go')[9] has led her to adopt a defensive strategy first of silence, then of abusive sarcasm. But her ability to intuit natural disasters gives her a value recognized by Frazer Melville, and it is his intention to alert the world to impending apocalypse. That this change in Bethany is mediated by Gabrielle draws attention to Gabrielle's parallel development through her love relationship with Frazer Melville. After a car accident has left her paralysed from the waist up, she has lost confidence in her therapeutic abilities. In fact, the relationship between Bethany and Gabrielle, fraught and abrasive as it is, turns out to be mutually therapeutic, and Gabrielle eventually finds that she can have a sexually successful relationship with Frazer. In Jensen's novel, flawed characters find compromised but workable ways of growing, by accepting the imperfect circumstances and becoming empowered by what had seemed to be their flaws.

Helen Mundler, author of the only monograph on Jensen's work, makes a case for reading *The Rapture* as a parody of 'Rapture fiction', a genre that, since at least 1905, has embodied the conservative and misogynist values of the evangelical Christian Right in America, typified by the *Left Behind* series by Tim LaHaye and Jerry B. Jenkins in the 1950s.[10] But it is the thriller genre which drives the narrative of the novel towards a climax on 12 October with a tension that pitches Gabrielle and Fraser's hope for a helicopter against the packed stadium's hope for the Rapture. In this atmosphere of charged anticipation, Bethany grabs a microphone and reveals the cruel hypocrisy of her father's treatment of her, before being dragged into the helicopter with the

8 Jensen, *The Rapture*, 13.
9 Jensen, *The Rapture*, 24.
10 Helen E. Mundler, *The Otherworlds of Liz Jensen: A Critical Reading* (New York: Camden House, 2016), 160–1.

others. From the air they all witness the tsunami and Bethany chooses to roll out of the aircraft to her death, but only after sensing new life in Gabrielle's womb. If the thriller genre is a crafting of a succession of suspenses and surprises, Jensen manages to sustain this right up to her last page and, indeed, her last words. Gabrielle imagines the bleak earth on which she and her child will struggle to survive:

> I look out on to the birthday of a new world. A world a child must enter.
> A world I want no part of.
> A world not ours.[11]

Most reviewers of the novel assumed that it was about 'apocalyptic global climate change'.[12] Certainly the novel is set in a period in which the effects of climate change are producing devastating weather events, as we are told from the novel's first sentence: 'That summer, the summer all the rules began to change, June seemed to last for a thousand years'. Heat, then winds and storms are called 'weather extremes', which are 'becoming the norm across the globe'.[13] Bethany is able to sense turbulent weather events and earthquakes as an animal does, but perhaps with more precision, in a reading of signs in the earth and atmosphere that have been characterized as 'biosemiotics' in practice.[14] The TV 'eco-debates' tend towards complacency: 'The times are changing and we're changing with them. Adapting. As we've always done'.[15] But the tsunami anticipated at the climax of the novel is precipitated by fracking in the North Sea, rather than climate change. There is growing evidence that fracking will contribute to climate change through increased greenhouse gas emissions[16] and

11 Jensen, *The Rapture*, 341.

12 See for instance the review in *Publishers' Weekly* <https://www.publishersweekly.com/978-0-385-52821-4> accessed 27 March 2018.

13 Jensen, *The Rapture*, 3, 4.

14 Terry Gifford, 'Biosemiology and Globalism in *The Rapture* by Liz Jensen', *English Studies: A Journal of English Language and Literature*, 91/7 (2010), 713–27.

15 Jensen, *The Rapture*, 34.

16 See the *Guardian* article 'How fracking can contribute to climate change', 29 May 2016 <https://www.theguardian.com/environment/2016/may/29/fracking-contribute-climate-change> accessed 27 March 2018.

also evidence that earthquakes, perhaps caused by fracking activities, can be linked to climate change.[17] In the novel 'a series of massive sub-sea avalanches' triggered by fracking are linked to 'sudden global warming'[18] as a consequence of human greed for natural resources. The 'domino effect' of landslides in the ocean floor releasing long buried methane which combusts in contact with oxygen and burns away protection from the sun is carefully explained as the crisis unfolds.[19] This link is perhaps unique in climate change novels and makes a clear indictment of human exploitation of natural resources without fully understanding the consequences.

The reception of this novel was unreservedly positive, with most reviewers admiring the ability of Jensen to do so much more than might be expected of the thriller genre in terms of character complexity and climate change. In *The Guardian* Irvine Welsh wrote that, 'it's a masterclass on how to write an engaging thriller about a relevant contemporary issue while still respecting the reader's brain cells'.[20] There was widespread praise from reviewers for Jensen's narrative skills in holding the reader in a compelling 'good read'. However, elsewhere, I have drawn attention to what is missing from *The Rapture*, arguing that the novel fails to root environmental concern in any images of valued nature, in a local place, for example: 'Without a localized awe, the thriller's race to warn of the coming global disaster is dislocated from its sense of values which are anthropocentric and generalized. Ultimately the narrative reveals that its final thrust is not really about saving people, but only Gabrielle and Fraser Melville. They and their unborn baby – Bethany's parting insight – face a bleak future which Gabrielle says in the novel's final lines will be in a new world that she simply "wants no part of" (page 341)'.[21] So finally the novel tends toward anthropocentrism and an abandonment of issues of the wider responsibility that it had seemed to offer in its early stages. Helen Mundler

17 See ChiChing Liu, Alan T. Linde & I. Selwyn Sacks, 'Slow Earthquakes Triggered by Typhoons', *Nature* 459 (11 June, 2009), 833–6.

18 Jensen, *The Rapture*, 300.

19 Jensen, *The Rapture*, 324.

20 Irvine Welsh, 'To the End of the Earth' *The Guardian*, 13 June 2009 <https://www.theguardian.com/books/2009/jun/13/the-rapture-liz-jensen> accessed 27 March 2018.

21 Gifford, 'Biosemiology and Globalism', 727.

suggested that 'Bethany "becomes" the Earth, embodying it, predicting where it will crack under the strain of the fracking and other invasive operations to which it is subjected, and feeling its pain as her own'.[22] But is this just another anthropocentric gesture by the novelist, subordinating global environmental crisis to individual crisis and pain? And is Bethany's death really a redemption as Mundler suggests ('[S]he does die in a sense absolved of her act [of murdering her mother]')?[23] Indeed, is it satisfactory to say of Bethany's gift of apocalyptic insight, as Mundler does, that it 'ultimately remains mysterious, even mystic, and irreducible'?[24]

Questions such as these offer some ideas that might be explored by those teaching *The Rapture*. Whilst it could be argued that Cormac McCarthy's novel *The Road* (2006) establishes, by implications and omissions, the very values by which we could still act to avoid its narrative model,[25] does *The Rapture* merely exploit current anxieties, without a sense of the values by which we might act to avoid its narrative outcome? Greg Garrard concludes his discussion of apocalyptic literature in *Ecocriticism* with the suggestion that, 'Only if we imagine that the planet *has* a future, after all, are we likely to take responsibility for it'.[26] The planet certainly has a future at the end of *The Rapture*, but are there any signs that anyone at any point in the novel is willing to take responsibility for it? Indeed, has the very success of the thriller in its final following of its central characters compromised its ability to engage with the wider issues of human responsibility that it seemed to promise? If Jensen's novel raises the question of whether humans can survive on the planet, how would her readers answer this on the basis of her novel?

22 Mundler, *The Otherworlds of Liz Jensen*, 164.
23 Mundler, *The Otherworlds of Liz Jensen*, 167.
24 Mundler, *The Otherworlds of Liz Jensen*, 172.
25 See, for example, Terry Gifford, 'Cormac McCarthy's *The Road* and a Post-Pastoral Theory of Fiction', in Martin Simonson, David Rio and Amaia Ibarraran, eds, *A Contested West: New Readings of Place in Western American Literature* (London: Portal Editions, 2013), 43–60.
26 Greg Garrard, *Ecocriticism* (Abingdon: Routledge, 2nd edn, 2012), 116; italics in the original.

Bradon Smith

Will Self's *The Book of Dave* (2006)

Will Self's 2006 novel *The Book of Dave*[1] weaves together two worlds: one, an account of the episodes from 1987 to 2003 seen through the eyes of a misanthropic London cabbie, Dave Rudman; the other, a post-apocalyptic vision of a flooded England and a society governed by a curious theological system. The two worlds are connected by the book of the title. Separated from his wife, and denied access to his son by a restraining order, Dave has a schizoid episode and writes a book containing all his views on the world and society – his legacy for his son – and buries it: 'a bundle of proscriptions and injunctions [...] derived from the working life of London cabbies, a cock-eyed grasp on a mélange of fundamentalism, [and his own] vindictive misogyny', as his psychiatric doctor describes it.[2] Hundreds of years later, rising seas caused by climate change have turned the hills of Southern England into islands, creating an archipelago, Ing, and the Book of Dave has been unearthed as the foundational text of this new society and its religion.

The novel is, most obviously, a scathing satire of organized religion, and especially its more fundamentalist factions. The absurdity of the future society of Ing having formed its repressive social structures and theology based on the rantings of a deranged taxi driver mocks the idea of a literal reading of any foundational religious text. At one point, in a typical example of the ironic ways in which the two worlds echo each other, Dave himself questions a friend who, it turns out, is a 'highly advanced believer in the literal truth

1 Will Self, *The Book of Dave: A Revelation of the Recent Past and the Distant Future* (London: Viking, 2006).
2 Self, *The Book of Dave*, 281.

of the ancient text [the Koran]' and who describes it as 'a blueprint' for society.[3] The epigraph of the novel, from *The South Country* (1909) by Edward Thomas, also indicates the novel's preoccupation with Nature reclaiming the land in the aftermath of the collapse of our present society: 'I like to think how easily Nature will absorb London as she absorbed the mastodon [...] her grass to cover it pitifully up'.[4] This power of Nature to reclaim, and the transient nature of our urban landscapes, is reflected too in the rural epiphany that the previously resolutely urban Dave Rudman experiences: Nature reclaims him much as it will do London.

As the chapters set in our near past progress, we see the changes that come over Dave himself. In 1987, Dave 'loved everything to do with driving – driving made him feel free. It was easy, it was simple, it was open to all. The minute you got in a vehicle and turned the ignition the world was revved up with possibilities'.[5] It is this freedom that leads him to life as a cabbie. But from freedom the cab becomes a form of imprisonment, and by 2003 Dave sells it, and walks out of London, sloughing off the city and his former life: 'He was losing it – whole chunks of the city were falling out of him'. Gradually the city gives way to 'saw-leafed patches of nettles and the whippy stalks of brambles'. He feels the city emptying out of him: 'He was disembowelled – he was losing it; and as he lost it the crushed plastic bottle of his soul expanded with sudden cracks and pops'. During this epiphany as he walks out of London, Dave crosses the M11, and sees the 'drivers' faces [...] jaws bunched, eyes white-rimmed with exhaustion'.[6]

As the thoroughly dislikeable character of Dave discovers some kind of redemption in a rural life with a motherly partner, the novel indicates the capacity for change that our environmental challenges demand. Changed by his new-found experiences of the countryside outside London, Dave realizes the bitterness of his previous views. A second book takes shape in which he will urge his son (and by implication us all) to 'strive always for RESPONSIBILITY [...] the ice caps may melt, the jungles shrivel, the prairies frazzle, the family

3 Self, *The Book of Dave*, 209.
4 Self, *The Book of Dave*, epigraph.
5 Self, *The Book of Dave*, 91.
6 Self, *The Book of Dave*, 405.

of humankind may have, at best, three or four more generations […] yet there can be no EXCUSE for not trying to DO YOUR BEST and live right'.[7]

Dave's Book is not the only way in which this novel depicts how the actions of the recent past and present can have far reaching and dramatic effects on the future. Facilitated by the split narrative between the late twentieth century and the sixth century After Dave (AD), the novel shows us the changes in landscape, climate and society in this time. The flooded landscape of England implies a dramatic rise in sea levels caused by climate change in the intervening period, but the reader can only confirm this by piecing together hints that look forward from our present, and half-remembered history from 500 years AD (After Dave). As Dave leaves London on foot in the episode already described, he foresees the coming deluge, imagining all of the detritus of the city 'torn away by a tsunami of meltwater that dashed up the estuary'.[8] He feels he has a momentary gift of 'second sight into deep time' and sees a 'great wave' carrying an array of moulded plastic objects 'which would remain there for centuries …'. This mention of meltwater is one of the only explicit indications that the coming flood is an effect of climate change. Having had this vision, Dave, symbolically, 'turned and wandered away into the woodland'.

The prophetic vision is prefigured in a number of episodes. In an earlier dream, Dave feels 'an aqueous queasiness when he saw the long line of the North Downs to the far south – they were distant islands, uninhabited and uninhabitable. At his back he sensed the ridge of Barnet and then the Chilterns rising up, wooded shores against which London lapped'.[9] These high points of the south of England and of London – Barnet, the Chilterns, Hampstead – become, in truncated form, the islands of the world 500 years AD: Barn, Chil, Ham. A few months after his dream Dave picks up a fare, a runner on a 'sortuva awfurred film about the Thames. This guy, see, he thinks the river's gonna flood and all the like … well, like shit an' that, is gonna come y'know … bubbling up to the surface'; and the doctor who eventually takes an interest in Dave's case finds himself listening to Dave talk about his Book and watching the gulls 'riding the thermals over Whitestone Pond. *What is it with these*

7 Self, *The Book of Dave*, 420–1.
8 Self, *The Book of Dave*, 405.
9 Self, *The Book of Dave*, 168.

seafowl? he wondered. *Have they come inland because they anticipate a deluge? Should we get maintenance to start building an ark?*[10]

In a chapter set in 2003, we see another indication of the climate change to come: an unnaturally warm autumn is followed by only a brief winter: 'Winter was a long time in arriving that year. The earth refused to relinquish its heat, no winds came and the leaves, declining to exit the trees, remained there limp and furled'.[11] When the winter does come, it occupies only two pages of the novel, and then spring returns: '[T]he daffodils stalked from the copses in January – the apple blossom burst before the end of February. Winter, out-gunned, retreated'.[12] In one of the novel's numerous echoes between our near past and distant future, the autumn of 522 AD is likewise late, causing anxiety among the Hamsters (inhabitants of Ham) and evoking memories of the past changes in the climate. The rain, called 'screenwash' by England's inhabitants of the future, 'came late that autumn – not until NOV was almost over' and the older members of the community tell 'tales of former times, when during such spells freakish waves had reared up out of the Great Lagoon'.[13]

Two formal features of the novel are particularly prominent: firstly, its constructed language of the future world of the Ing Archipelago; secondly, its split narrative between the two worlds of the near past and distant future. The novel has several distinct registers and languages. The chapters of our recent past are written in the voice of a narrator with a liking for elaborate similes – 'Dave combed the coin in his bag, finger waves pitter-purling on metal shingle'[14] – but are shot through with the thoughts of Dave himself: 'Achilles was up on his plinth *with his tiny bronze cock*';[15] 'a beautiful young woman *if you like the freckled Irish type and I can't say I do*';[16] 'an atrium, where stripy stones propped up *dildo cactuses*'.[17] The chapters of the distant future also have a narrative voice of contemporary English, but contain numerous pieces of invented vocabulary in Arpee (RP, received pronunciation), derived from the language of the Book

10 Self, *The Book of Dave*, 263, 279.

11 Self, *The Book of Dave*, 457.

12 Self, *The Book of Dave*, 459.

13 Self, *The Book of Dave*, 314.

14 Self, *The Book of Dave*, 40.

15 Self, *The Book of Dave*, 27.

16 Self, *The Book of Dave*, 104.

17 Self, *The Book of Dave*, 406.

of Dave, and hence heavily influenced by driving and cabbie slang and car parts: the day is divided into three 'tariffs', rain is 'screenwash' and so on. Added to this, dialogue is mostly in Mokni, a combination of txt-speak, Arpee vocabulary, and a phonetic rendering of a broad Cockney: 'Vass ve édlite [moon] ven iss on fulbeen we C ve lites ahtside'.[18] Self saw the invention of Mokni as essential in order to 'imbue the distant future with a believable strangeness'; writing at the time of the novel's publication, he declared himself 'amazed by how Chaucerian the Mokni ended up looking on the page, suggesting that the spine of the language remains surprisingly constant over the centuries'.[19] The split narrative, with chapters alternating between our contemporary society and that of the distant future society of Ham, helps to emphasize the collapse of our current society, but perhaps more importantly to reveal the continuities that result from the future adherence to the Book of Dave.

The Book of Dave received mixed reviews. Reviewers tended to see Self's 'wordsmithing' as a distraction, and the success of individual coinages in Arpee and Mockni as patchy. Most reviewers considered the chapters set in Dave's present (1987–2003) to be more successful than those of the future of the Hamsters in the sixth century After Dave. It is worth noting that many reviews did not mention climate change, or global warming, and made reference only to floods or rising sea levels. Self himself was clear that the flooding was 'as a result of environmental catastrophe',[20] but the novel was published in 2006, and thus pre-dated the recent rise of cli-fi as an identified genre. It has, however, received some academic attention more recently in the context of cli-fi. In particular, Adam Trexler has placed it in the context of other postdiluvian novels such as Maggie Gee's *The Flood* (2004) and Richard Cowper's *The Road to Corlay* (1978), and noted the care with which Self mapped the consequences of rising sea levels on the topography of England, and the resulting archipelago. Trexler argues that Self's novel satirizes the idea of utopian localism common in other speculative fictions, exposing instead the brutality of a society that has regressed to medieval life.[21]

18 Self, *The Book of Dave*, 22.
19 Will Self, '*The Book of Dave*: Genesis', *The Guardian* (16 June 2007).
20 Self, 'The Book of Dave'.
21 Adam Trexler, *Anthropocene Fictions: The Novel in a Time of Climate Change* (Charlottesville: University of Virginia Press, 2015), 96.

The novel invites comparison with other cli-fi novels, and with precursors in post-apocalyptic fiction. The clearest influence is from Russell Hoban's *Riddley Walker* (1980),[22] which shares with *The Book of Dave* a constructed language (complete with glossary) and a return to a primitive society in the wake of a disaster. There are echoes of Hoban's novel in the central chapter of David Mitchell's *Cloud Atlas* (2004) too, which again uses a phonetic future-English, again in a post-apocalyptic narrative. Placed together, these novels could be used to question why writers of post-apocalyptic narratives have felt the need to reinvent the language of a future society in this way. An interesting parallel could be also drawn between these novels and Paul Kingsnorth's *The Wake* (2014), in which Kingsnorth uses an invented form of eleventh-century English – what he calls a 'shadow tongue' – in a novel described in its blurb as a 'post-apocalyptic novel set a thousand years ago'.[23] This comparison could be used to ask what difference it makes that Kingsnorth's novel is set in a real, historical moment as opposed to a fictional future.

The novel also invites comparison with other post-apocalyptic novels which, while not utilizing an invented vocabulary of their own, still demonstrate an interest in the ways in which language is formed, lost and reconstituted in a post-apocalyptic society. Novels like Margaret Atwood's *Oryx and Crake* (2003) and Cormac McCarthy's *The Road* (2006) are fascinated by the way in which the loss of language reflects other forms of loss in the world: 'the names of things slowly following those things into oblivion'.[24] *The Book of Dave* can also be compared to Richard Jeffries's early example of the post-apocalyptic genre, *After London* (1885), to which it owes a debt, and to J. G. Ballard's *The Drowned World* (1962). Indeed, the title of the first part of Jeffries's novel, 'The Relapse into Barbarism', would serve well as a description of Self's future society on the archipelago of Ing. All three of these novels use the geography of a dramatically altered London; a comparison between them could centre on how they construct and make use of this literally submerged cityscape and how it might function as a form of cognitive estrangement for the reader.

22 Russell Hoban, *Riddley Walker* (London: Jonathan Cape, 1980).
23 Paul Kingsnorth, *The Wake* (London: Unbound, 2014).
24 Cormac McCarthy, *The Road* (London: Picador, 2006), 93.

Richard Kerridge

Ian McEwan's *Solar* (2010)

Why has there been so little realistic fiction about climate change? This is a
specialized version of the larger question why societies and individuals have
so far been unable to act upon their knowledge. Why can we not behave as if
we knew what we know? The answers offered have often pointed to the scale
of climate change and other large environmental problems, and the extreme
mis-match between their scale and that of the perspectives and narratives that
define the individual human life-story, and to which our evolved responses
are adapted. These are questions of spatial and temporal scale. Environmental
problems reach across the globe and connect the already-distant past with the
probable future.

Consumerism in the rich world has environmental consequences in places
that the consumers do not see, smell, touch or hear. Val Plumwood invented
a term for these far-off places.[1] She called them 'the shadow places of the
consumer self', and asked how – by what strange disruptive expansion or col-
lage – we could come to perceive with our senses their distress and damage.
Timothy Clark asks the same question when he writes of the derangements of
scale that climate change brings, especially the way in which actions conven-
tionally too small and routine to be worth any narrative attention acquire on a
different scale – the scale of climate change – a cataclysmic importance.[2] Can
we imagine a novel in which the plot turns not upon falling in love or facing
immediate personal danger but upon whether the protagonist relinquishes

[1] See Val Plumwood, 'Shadow Places and the Politics of Dwelling', *Australian Humanities
 Review* 44 (March 2008) <http://press-files.anu.edu.au/downloads/press/p38451/pdf/
 ec002.pdf> accessed 9 August 2018.
[2] See Timothy Clark, *Ecocriticism on the Edge: The Anthropocene as a Threshold Concept*
 (London: Bloomsbury Academic, 2015), 71–96.

British Comic Cli-Fi

Figure 22. Installing solar panels on a barn roof © Kristian Buus. Reproduced under Creative Commons 2.0. From <http://flickr.com>.

air-travel or remembers to switch off lights? (Figure 22) Timothy Morton raises similar questions when he identifies climate change as a 'hyperobject', so massively distributed across space and time that we are never in a position to see it whole: we are always already inside it.[3]

These theorists are arguing in general terms, but their observations bear directly upon the technical decisions that writers face. The challenge is especially difficult for writers in the realist genres. In a realistic work, material is presented as observed from someone's viewpoint, or sometimes a series of viewpoints. There is a narrator or, in a poem, a 'speaker', telling a story or giving descriptions or reflections. What can appear in such a work is restricted to what it is possible for a character to see or otherwise sense, or what it is possible for a narrator to describe on the basis of expert information. This latter narrator, well-informed and able to see the points of view of different characters and know what is happening in different places, is sometimes called 'omniscient', albeit inaccurately, since this narrator does not know all, but only what a well-informed writer can know with the help of research.

Realism entails an obligation to be accurate. Unrealistic events cannot occur. People do not levitate or come back from the dead – unless what is happening is understood to be the sensation or illusion of such a thing; it isn't *really* happening, and the character-narrator who perceives it to be happening becomes in the act an unreliable narrator. Examples like this show how realism merges with other genres. Elements of Gothic supernatural may be introduced into realistic stories with convincing characters. Thrillers take realistic characters and subject them to stresses no real body or psyche could take with such composure. Narratives set in the future and counterfactual

3 Timothy Morton, *Hyperobjects: Philosophy and Ecology after the End of the World* (Minneapolis: University of Minnesota Press, 2013).

histories generally create a texture of realism, setting up realistic characters with individualized viewpoints, even in unreal settings. Some whole works are founded on the practical and ethical discipline of realism. In other cases, there are *elements* of realism in play with non-realistic effects, and the question is how these different effects interact.

Many of the greatest ecological threats, climate change especially, do not take forms that are as yet available to direct experience – not direct experience in the places inhabited by readers in affluent societies, anyway. For the time being, a literary treatment of climate change that is realist in technique will be about the idea of climate change, and the troubling effect of the idea. To represent climate change itself, writers need futuristic scenarios, part-realist and part-speculative, or indirect forms of representation such as allegory and symbol, or forms, such as graphs, statistics and databases, that forsake the dramatic-experiential view in order to accommodate perceptions on a different scale from the personal. Various expedients are used to insert these forms of representation into human drama. A scientist giving an explanation may be included among the characters of a novel or play.

Ian McEwan adopted this device in his climate change novel *Solar* (2010).[4] The novel's anti-hero protagonist is Michael Beard, a Nobel prize-winning physicist who attempts to develop a new solar energy technology – a technique for producing artificial photosynthesis. Beard's efforts are in a dialectical relationship with the spectacular mess of his personal life, which frequently gives him occasion to improvise wildly. Unable to resist sex or food, he spends much of his time frantically trying to salvage, manage or escape his various relationships with women, while ignoring a crescendo of warnings from his indulged and abused body.

McEwan's strategy is to make Beard a comically excessive figure but nevertheless a broadly representative one. In order to preserve this representative quality in Beard, the novel has to refrain from enquiring deeply into his psychological depths, which might reveal reasons and motives for his behaviour. That would risk making him too individual to be sufficiently representative. Yet the novel needs the dramatic interest that comes from tracking a character

4 Ian McEwan, *Solar* (London: Jonathan Cape, 2010).

closely; it cannot deal purely in generalities and allegorical figures. So it follows him closely without taking him fully seriously as a person, as a realist novel would aspire to do.

Naïve, selfish, extravagant, pathetic, indefatigable, insensitive, subject to numerous pratfalls and drawn into melodramatic plot-twists, Beard seems both larger and smaller than a real person – larger in his comic-epic quality and smaller in his emotional and imaginative range. In real life, of course, there are people who seem as lacking in empathy and conscience as Beard, or perhaps as repressed. The traditional redemptive mission of the liberal realist novel in relation to such people is to attempt to explore the reasons for their emotional and moral blankness, and to open up their sealed-off feelings, making contact with them, opening dialogue. With Beard, this aspiration has been sacrificed so that his character can be simplified and given a representative function, while he remains just real enough for his mishaps to arouse some anxiety. As individuals, we may not all be as restlessly insatiable as Beard, but in a vital respect he stands for most of us. Formidably good at adapting to his immediate short-term environment, he is catastrophically poor at adapting to long-term considerations. What was long-term eventually becomes short-term. Beard's failure to restrain or change his appetites for the sake of his own long-term well-being and humanity's represents the collective failing of wealthy consumers to change their behaviour in response to the threat of global warming. In places the novel becomes straightforwardly allegorical, as when a party of concerned artists and scientists on an expedition to inspect Arctic glaciers cannot resist pilfering each other's equipment left in the boot room. This is a micro-example of the general problem.

By constructing Beard in this way, McEwan is able to sketch a broad opposition between our instinctively opportunistic physical appetites and the effort to avert disastrous climate change. Beard's spontaneous lunges for sex, food, fame and money undermine his promising attempt to find technologies to save us. In this, he is no different from most people in affluent societies. Beard's spectacular personal recklessness represents the recklessness of consumerism.

In *Solar*, the crisis doesn't bring the best out of anybody. No one rises to the occasion. The one person who does is killed off early on, when he too has just endangered his scientific work through sexual risk-taking. *Solar* finds almost no space, then, for the serious thoughtful and emotional life of the

conscience – the life with which the traditional liberal-realist novel would be most concerned. The book does offer a glimmer of salvation, but a bitterly unheroic salvation, undignified, random and drained of moral meaning.

Beard's technological project is undermined by the chaos of his personal life. Yet the project arose from that chaos. Personal emergencies and chance accidents bounced Beard into the photosynthesis venture, which really gets going once an insensitive remark has cost him an academic sinecure, throwing him upon his own devices. The development of the technology is motivated by the restless energy of his appetites and defensive ruses.

At the novel's end, it looks as if the commercial venture Beard has set up will collapse, destroyed as a result of his multiple follies. A huge irony of scale looms before us. Humanity has lost its chance of escape because the various people concerned with the invention – Beard and everyone else – could not set aside their personal desires, rivalries and bitternesses – their compulsions to sex, food, money, reputation and revenge. Compared to what all the characters know to be at stake, these personal affairs are trivial and transient, yet no character will wait even the single day that might make all the difference. Beard's reckless personal life ripens to its catastrophic crisis just hours before the scheduled public switch-on at which his invention is to prove itself. It is like a fateful accident of timing in a Thomas Hardy novel – a stroke of bad luck that didn't have to happen, yet was always going to happen, one way or another. The blatant orchestration of the plot to produce this tense countdown, this near run thing, mocks any lingering assumption that providence will save us in the nick of time.

But *Solar* doesn't adopt a tragic tone. To give Beard and his generation – and by implication the whole human species – the dignity of tragic protagonists, the novel would have to raise Beard's carnal appetites to the status of something more than personal weakness. Beard's behaviour would have to be seen not as a distinctive personality trait but as the product of humanity's evolutionary nature. This tragic view would involve bringing some empathy to bear on the question of why all the characters' desires and rages – petty when we step back to contemplate history and ecology – are not petty to the characters themselves, but all-consuming. Then the story of the human species would become an epic tragedy, with humanity as the protagonist caught between the two inexorable physical laws of the greenhouse effect and the evolved disposition of the species.

Solar opts not to give us this dignity. McEwan chooses low comedy rather than high tragedy partly as a rebuke to the conscientious, the people who care about the danger. They haven't yet done enough, the novel implies, for their dilemmas and feelings to be foregrounded. He also chooses comedy to keep open a different possibility, small though it may be: the possibility of accidental escape, morally meaningless escape. Beard's project collapses, but his discoveries may yet have a saving potential in the hands of others, who may take the project forward for similarly self-serving reasons. In the midst of its pessimism, *Solar* keeps alive – just about – this ironical possibility: that ignoble, amoral, clumsy, unselfconscious, earthy vitality may be the saving of us, not idealism, unselfishness, far-sightedness and a sense of potential tragedy.

Technological solutions may emerge. If so, it may be that the impetus will have come from commercial motives like Beard's rather than prudence and altruism. But if we trust to this outcome, we will be gambling everything on a frighteningly random chance. In its finale, when, as is traditional in farce, all the characters arrive in one place, McEwan's novel shows how easily the vicious crossfire of personal desires can tear down such an enterprise. Implicitly, it also rebukes us bitterly for leaving the field so empty of other kinds of hope.[5]

5 For further reading on *Solar* and environmentalism, see Greg Garrard, 'Ian McEwan's Next Novel and the Future of Ecocriticism', *Contemporary Literature* 50/4 (Winter 2009), 695–720; Greg Garrard, '*Solar*: Apocalypse Not', in Sebastian Groes, ed., *Ian McEwan: Contemporary Critical Perspectives* (2nd edn, London: Bloomsbury Academic, 2013), 123–36; Pascal Nicklas, 'The Media Persona of Ian McEwan and the Mediation of the Media in *Solar*', *Focus on Ian McEwan* (*Anglistik* 21/2, 2010), 93–101.

Lieven Ameel

Antti Tuomainen's *The Healer* (2013)

Antti Tuomainen's *The Healer* (2013) is set in a near-future Helsinki where climate change is wreaking havoc both in the Finnish capital and abroad. Incessant rain and floods are the most visible climate change-related curses in Tuomainen's Helsinki, but there is also news of global pandemics, destructive forest fires and water wars. Society is breaking down, and amidst the radical upheaval, a serial killer, the eponymous 'Healer' – the 'healer for a sick planet' – is murdering people he holds responsible for accelerating climate change.[1] The plot revolves around the endeavours of the protagonist, the Finnish poet Tapani Lehtinen, to find his lost wife Johanna, who has been investigating the murders as a journalist. As Tapani learns more about the mysterious Healer, he also makes unexpected discoveries about the past of his wife, who turns out to have known the Healer intimately. In his journey through flooded Helsinki, Tapani guides the reader on a tour of how different areas in the city, as well as different affected citizens, are coping with the dramatic changes.

The novel won the most prestigious crime fiction prize in Finland and is one of the most widely translated contemporary Finnish novels to date. It is routinely mentioned in international climate fiction research.[2] In Finland, however, the author is mainly known as a crime fiction writer, and the novel has received little academic attention. The novel can be positioned also within the context of Nordic crime fiction, and, in Finland, as part of the recent surge

1 Antti Tuomainen, *The Healer*, trans. Lola Rogers (London: Harvill Secker, 2013), 12. The Finnish original, *Parantaja* (Helsinki: Like) was published in 2010.
2 See, for example, Karen Thornber, 'Climate Change and Changing World Literature', in Stephan Siperstein, Shane Hall and Stephanie LeMenager, eds, *Teaching Climate Change in the Humanities* (London: Routledge, 2017), 265–71; and Rebecca Tuhus-Dubrow, 'Cli-Fi: Birth of a Genre', *Dissent*, 60/3 (2013), 58–61.

of dystopian fiction. Thematically, the novel focuses on investigating what is lost and what is left when established norms and rules fall away. Desperate care for a loved one and the imperatives of bare survival take the foreground. In its relation to the causes and effects of climate change, key questions posed in the novel are: how to act in the face of disaster; what could have been done to avert this; and whether anyone can be personally held responsible for global climatic events (as the acts of the Healer imply). Two topical features that can be found in this novel as well as more broadly in climate fiction and in the popular imagination are climate refugees and the imagined Arctic as a possible safe haven. Helsinki in *The Healer* is packed with refugees, so much so that, for the protagonist, the city has 'finally become an international city'.[3] Terrified inhabitants are fleeing to Northern Finland and Norway, selling their homes to be able to pay the exorbitant price of train tickets north. The topos of Northern Finland and more broadly the Arctic region and Lapland as possible last resorts is a feature *The Healer* shares with a range of contemporary Finnish dystopian and cli-fi novels, such as Emmi Itäranta's *Memory of Water*[4] and Annika Luther's *De hemlösas stad* [The City of the Homeless].[5]

The Healer has strong satirical tendencies, foregrounding and amplifying existing socio-political fissures in the society from which it writes. It conveys a stark loss of normalcy, with several characters commenting on the disappearance of things that are taken for granted in the Nordic welfare society, such as public health services, a functioning democracy and safe public space. In this sense, the book can be seen as continuing a common theme from Nordic crime fiction: the critical examination of the dismantling of the Nordic welfare state. There is also a subtle stab at the centre-right politics that have steered Finland towards a neoliberalist course in the early twenty-first century in the description of the novel's serial killer as resembling the prime minister, Alexander

3 Tuomainen, *The Healer*, 229.
4 Emmi Itäranta, *Memory of Water* (London: Harper Voyager, 2012).
5 Annika Luther, *De hemlösas stad* (Helsinki: Söderströms, 2011). See also Saija Isomaa and Toni Lahtinen, 'Kotimaisen nykydystopian monet muodot', *Pakkovaltiosta eko-dystopiaan. Kotimainen nykydystopia. Joutsen/Svanen*, Special Studies 2 (2017), 7–16; here 11.

Stubb.[6] It is an intriguing detail that Stubb, a centre-right politician, became prime minister only in 2014, some years after publication of the novel.

A side role is assigned to the question of surveillance, information wars and the unreliability of digitally transmitted data. In the novel, security firms take over public functions as well as public space. The key associate of the Healer turns out to be one of the leaders of the malicious security firm A-Secure (a wink to Finnish global internet security brand F-Secure), which is taking over the infrastructure of the state. Similar themes are taken up in another contemporary Finnish dystopian novel, Esa Mäkinen's *Totuuskuutio* [Truth Square]).[7] More generally, technology is presented as not to be trusted in a world beset by disastrous climate change. Automated lights and electric key cards cease to function, making life in the most modern housing blocks the most difficult to sustain. The novel can thus be read as a reaction to the hubris of post-industrial knowledge society, with strong nostalgic tendencies and a distrust of information technology.

One of the most intriguing features of the novel is also one that will be most invisible to a non-Finnish audience. The novel presents a complex commentary to the early twenty-first century urban planning projects for the Finnish capital.[8] Several of the city districts (Jätkäsaari, Pasila, Kalasatama), and also the western extension to the metro network described in the novel, were only in a planning phase at the time of publication, but have already become obsolete in the future world depicted in *The Healer*. When disaster strikes, the novel argues, the fancy waterfront developments planned by the Helsinki city planning department in the early twenty-first century will be the first to go under.

While the novel presents intimations of what will be lost when the world continues onto a path towards climate catastrophe, there are few implications anything could have been done by the protagonists to mitigate or counter

6 The reference to Stubb is, however, omitted in the English translation: see Tuomainen, *The Healer*, 139.

7 Esa Mäkinen, *Totuuskuutio* (Helsinki: Otava, 2015).

8 Lieven Ameel, 'Towards a Narrative Typology of Urban Planning Narratives *for*, *in* and *of* Planning in Jätkäsaari, Helsinki', *URBAN DESIGN International* 22/4 (November 2017), 318–30.

climate change. In its approach to climate change as something the reader could deal with it in the referential world, the dominating sense in the novel is arguably one of resignation and despair. Possible actions are presented as too little or too late. A telling example is a newspaper article from thirteen years prior to the events in the novel, which describes a new 'eco-efficient' housing district in Helsinki. With the benefit of hindsight, however, eco-efficient housing never constituted a viable mitigation strategy in the storyworld of *The Healer*:

> Everything about the neighbourhood was twenty years too late – although the houses produced their own energy and were entirely recyclable, sustainable and non-polluting, the environment was already so changed by then that the innovations were meaningless. On top of that, the houses were too expensive for an ordinary person to afford [...].[9]

The events of *The Healer* are set somewhere in the 2020s or early 2030s; placing the eco-efficient houses (built 'a few decades too late') thirteen years earlier (possibly as early as the early 2010s) means that the last window for meaningful mitigation is *well before* the moment of publication of the novel, possibly in the late 1980s and 1990s. Quite disturbingly, it is the Healer himself, a cold-blooded killer, who appears as the only character with a long-standing ecological interest and with the concomitant desire to act according to his convictions.

In addition to its obvious echoes of the biblical flood, *The Healer* is organized around strong and overt Christian symbolism. The novel is structured following the liturgical year, beginning two days before Christmas with events running up to Christmas Eve. An epilogue, adding temporal depth and some knowledge of what happened after the main events, comes in the form of a short chapter set on the morning of Good Friday. The plot thus moves from darkness to light, and from despair to redemption. It is even possible to discern elements of morality plays (which developed out of Easter plays) at work, with the protagonist as an everyman on a fatal journey, abandoned by his friends and loved ones, who has to consider where humanity has gone wrong.

Several of the themes described above could offer fruitful avenues for teaching the novel. One possibility would be to approach it in terms of its

9 Tuomainen, *The Healer*, 87.

reception and genre, with a specific focus on how the novel's implications for climate change depend on the generic prism with which it is approached – Nordic noir or crime fiction; dystopia or climate fiction? A discussion of *The Healer* in tandem with other Finnish dystopian novels, or as a part of a selection of Nordic speculative fiction, would attune students also to the importance of the cultural and historical specificity of literary responses to climate change outside of the English-speaking world. As a novel set in a recognizable real-world setting, the novel could also be integrated in courses that examine the interaction between fictional texts and urban planning narratives.

A last approach would be to examine the novel as part of a course on representations of agency and responsibility in climate fiction. Who is held responsible in this novel for catastrophic climate change, and what room is there for mitigating strategies? Given the role played by climate terrorism in the novel, *The Healer* could also provide insights into changing (and often genre- and culture-specific) depictions of ecological terrorists.[10]

The Healer plays on the fear of the future in dystopian and apocalyptic scenarios. Rather than offering concrete insights into the dynamics and the possible effects of climate change, it presents a chilling rendering of what it feels like to live in a society disrupted by radical climate change. The presence of recognizable and everyday environments being turned into war zones, such as the iconic Stockmann department store in central Helsinki during Christmas shopping period, is particularly gripping. At least in explicit terms, the novel does not seek to warn, nor does it spell out specific pathways that have caused the imagined global climate catastrophe, or how the characters in the novel could have averted this. The protagonist is largely impotent throughout the novel, a bystander to events. Towards the end of the novel, there is a glimmer of hope, with the disappearance of the Healer, the rescue of the protagonist's wife, and the arrival of spring. The conclusion of the novel does not give any information, however, as to how life can be sustained in the forbidding clima-tological and societal circumstances described in the novel. The dominating feeling is arguably a sense of nostalgia for a time when life was less complicated and constructed on more solid ground; the novel ends with a panoramic view

10 See the essays on Michael Crichton's *State of Fear* and T. C. Boyle's *A Friend of the Earth* in this volume.

of the city seen from the granite heights of Herttoniemi, the 1950s concrete suburb of Helsinki that is the home of the protagonist and his wife. By the end of the novel, no solutions to the storyworld's life-threatening climate crisis have surfaced, but the couple and its suburban home have withstood the storms. The dénouement of the novel arguably confirms the continuing preoccupation of the genre of the novel with the nuclear family and the bourgeois home, even in times of threatening climate change.

Part V

Children's Film and Young Adult Novels

David Whitley

Chris Buck and Jennifer Lee's
Frozen (2013)

> Some say the world will end in fire,
> Some say in ice.
> From what I've tasted of desire,
> I hold with those who favour fire.
> But if it had to perish twice,
> I think I know enough of hate
> To say that for destruction ice
> Is also great
> And would suffice.
>
> — ROBERT FROST[1]

Disney's massively popular 2013 animation *Frozen*[2] may not be the most obvious choice for a narrative with the potential to affect people's responses to climate change. With its fantastical, fairy tale plot (very loosely adapted from Hans Christian Andersen's *The Snow Queen*), and lack of reference to any features of real-world global warming, it seems an unlikely candidate for fresh thinking about how the arts may fulfil an educative function in relation to climate change. But it is an engaging fable that is clearly focused on the consequences of anthropogenic – indeed drastic – change to the climate. This central conceit – combined with its popularity and affective power in relation to young audiences especially – suggest that it may be fruitful to consider whether it also has educative potential, if approached in the right way.

1 Robert Frost, 'Fire and Ice', in *Selected Poems* (London: Penguin, 1973), 127.
2 *Frozen*, dir. Chris Buck and Jennifer Lee (Disney, 2013).

If the central emotional theme of *Frozen* is the restorative power of love, then the ice that pervades its landscape is much more than a mere background. Not only the title of the film but also its opening song, which focuses on the literal work of splitting ice apart so that it is available for human use, highlight the beauty and power of a frozen world. In an arctic setting, where sentient beings have adapted positively to the affordances of a periodically frozen environment, the film also makes it abundantly clear that, as Robert Frost puts it, 'for destruction ice / is also great / and would suffice' to enact devastating change. The plot conveys the story of two sisters, Elsa and Anna, whose playful childhood bond is interrupted when Elsa discovers that her emerging powers to transform the world through freezing have catastrophic potential. In attempting to save her sister from injuring herself by falling, Elsa accidentally puts a sliver of ice into Anna that could have proved fatal. Although Anna recovers, Elsa tries to lock herself in thereafter to stave off the risk of hurting those for whom she cares as her magical powers grow stronger. When this strategy fails, and Elsa's powers are revealed publicly, Elsa becomes the object of mass hatred and hysteria. Fleeing to the mountains, she finally feels liberated, creating a magnificent ice palace where she lives in isolation. But she is unaware that her solipsistic freedom has come at a price. The frozen environment she has unwittingly created has placed the lives of the community she has left in jeopardy. Anna's attempts to persuade Elsa to rectify this and reclaim her sister result in Anna being frozen to the point of death herself. In a revisionist version of the fairy tale trope of the regenerative lover's kiss, it is Elsa's loving embrace that finally frees Anna from the icy death lock. In the process, by sympathetic magic, the whole environment is restored to its natural cycle and climatic stability. The film thus embodies an important subtheme, connecting the central human drama to the regeneration of the whole society and environment.

Clearly, *Frozen* is not in any simple sense a cautionary tale about human interference within ecological systems. Neither can it be understood, at least without a great deal of interpretive strain, as a drama that seeks to motivate audiences to act in relation to the perceived dangers of climate change. Indeed, given that the vast majority of contemporary forecasts emphasize global warming as the direction of travel for climate change, it is unlikely that most audiences would connect the film with this issue at all, left to their own devices.

Figure 23. 'Ice determines the sensuous, shimmery texture of Elsa's costume, artefacts and mountain home'. *Frozen*, dir. Chris Buck and Jennifer Lee (Disney, 2013).

It is true that earlier periods of significant climate change have often involved radical reductions in global temperatures, and that localized predictions of climate change phenomena include the possibility of freezing (as explored melodramatically in the live action film *The Day After Tomorrow*).[3] However, such possible repercussions of a destabilized climate system tend to be seen as marginal generally, compared to the more pervasive forecasts of ice melts, sea level rises, flooding, unbearable heat waves and desertification. *Frozen*'s approach to climate change issues is best seen as primarily symbolic, deriving from the distinctive forms in which it engages with archetypal patterns. Symbolic patterns are not the same as abstractions, however; they are deeply rooted and embodied in particulars. In this respect, the medium of change that

3 *The Day After Tomorrow*, dir. Roland Emmerich (20th Century Fox, 2004).

the film focuses on is significant. The incursion of ice and snow in *Frozen* may be metonymic for climate change more generally, but the specific form of ice itself – and the associations it carries with it – are significant. Ice determines the sensuous, shimmering texture of Elsa's costume, artefacts and mountain home (designed around the hexagonal form of the snowflake); the sisters are linked through the figure of the snowman; and the arctic scenery is evoked with an artistry that renders it a source of interest in its own right, persistently engaging the viewer's attention (Figure 23). As the opening song puts it:

> Beautiful, powerful, dangerous, cold
> Ice has a magic can't be controlled
> Stronger than one, stronger than ten
> Stronger than a hundred men.

As well as having a strange beauty that urges viewers towards an 'attentiveness stance'[4] in relation to the environment, the way the arctic landscape is rendered also suggests that collective human agency is ultimately limited, compared to the power that nature exhibits (Figure 24). In this sense, the film models an ethical stance that is environmentally attuned: the drama of anthropogenic climate change at the heart of the film can be seen in this context. This drama is delivered through a combination of romantic melodrama, song and comedy, however. The mix of genres through which the film operates is clearly important in conveying whatever underlying message we impute to it.

Formally, then, *Frozen* operates within a classic Disney mix of film genres: sentimental melodrama and romance; musical; and comedy that relies extensively on gags and slapstick. There are several consequences of working the films' themes through this classic Disney animated form. First, the songs provide a powerful medium within which the central themes can be conveyed and held in collective memory. Many of the young girls who are the primary fan-base of *Frozen* know most of the lyrics by heart and take pleasure in singing along to them in repeated viewings of the film. The theme that has received most attention within public media in this respect is the young heroine's breaking

4 See Val Plumwood's use of this concept in *Environmental Culture: the Ecological Crisis of Reason* (London and New York: Routledge, 2002), 194.

Figure 24. Ice is portrayed as 'Beautiful, powerful ... stronger than a hundred men'.
Frozen, dir. Chris Buck and Jennifer Lee (Disney, 2013).

free of repressive social conventions to realize her full autonomy and power. Rejecting the social edict to 'be the good girl you always have to be', Elsa's keynote anthem validates her in finding a space where she can 'let it go', as the song's title suggests, and finally realize the full extent – both creative and destructive – of her powers. This liberating message has somewhat obscured the film's antithetical focus on the destructive consequences of such individualism on the social fabric and the environment, however. The songs actually anchor the narrative drive towards individual fulfilment in a network of affiliations and relations that will eventually restore balance. Elsa's keynote song, for instance, affiliates her in a Romantic way with the natural world: she is 'one with the wind and sky', her power activated through her 'soul [...] spiralling in fractals all around', like the snow itself. This affinity with natural forces is echoed in the film's engendering appreciation of the materiality of ice and snow in an environmentally sensitive way, as we have already noted.

Sentimental melodrama is actually a powerful genre within which to embody the force of such an ethical stance. As Linda Williams argued, the social efficacy of Hollywood romantic melodrama has been downplayed because the form has tended to be positioned weakly as a women's genre.[5] No doubt the effect of this gender bias is further enhanced, in this instance, by *Frozen* being seen as primarily for children. In this context, it is also important to consider the effect of comedy. It is sometimes argued that comedy is the most ecologically attuned of the major genres.[6] And, indeed, the necessary but humourless – sometimes self-righteous – urging of responsibility within discourses on climate change has the potential to exhaust as much as inspire public response. More specifically, in relation to *Frozen*, the figure of the snowman Olaf carries much of the film's comic charge. Lacking human experience, Olaf's naiveté provides the basis for his comic appeal: the gags surrounding him play movingly on a mixture of his resilience and fragility, particularly his vulnerability to thawing as the temperature of the environment changes (Figure 25). The comedy is subtly layered with an emotionally charged sensitivity to the effects of climate change, developed with the licence and affective power of fantasy.

Frozen is one of the highest grossing animated films of all time and has clearly enjoyed enormous popularity worldwide. Critical response to the film was positive, but slightly qualified. A number of critics considered the film to have strong qualities but inferior to modern Disney fairy tale classics such as *Beauty and the Beast* and *The Little Mermaid*.[7] Much of the critical and media attention focused on revisionist aspects of the film, especially the way the traditional tropes of heterosexual romance had been finessed in favour of a resolution centred on the emotional power of sisterhood. Less attention was generally paid to environmental aspects of the film, although the sensuous, lyrical detail of the arctic settings drew positive comment. However, Admiral

5 Linda Williams, 'Melodrama Revised', in Nick Browne, ed., *Refiguring American Film Genres* (Berkeley: University of California Press, 1998), 42–88.

6 Joseph W. Meeker, *The Comedy of Survival: Studies in Literary Ecology* (New York: Charles Scribner's Sons, 1974).

7 See, for instance, Roger Ebert, review of *Frozen* (27 November 2013), <https://www.rogerebert.com/reviews/frozen-2013> accessed 30 January 2018. *Beauty and the Beast*, dir. Gary Trousdale and Kirk Wise (Disney, 1991). *The Little Mermaid*, dir. Ron Clements and John Musker (Disney, 1989).

Figure 25. Olaf 's naiveté provides the basis for his comic appeal.
Frozen, dir. Chris Buck and Jennifer Lee (Disney, 2013).

Robert Papp, the US Special Representative to the Arctic, was reported in *Time* magazine as having urged Disney to develop a Public Service film, using characters from *Frozen* to educate children about climate change and the vulnerability if the arctic environment. Disney were apparently lukewarm about this idea, feeling that it might compromise their core mission to 'tell stories that project optimism and have happy endings'.[8]

In the classroom, it would obviously be possible to approach *Frozen* from a standpoint of unmasking its implicit ideologies, positioning it as epitomizing a kind of facile, blind optimism that tacitly undermines the seriousness of climate change challenges we face in reality. Seen from this perspective, the film offers a distraction from the more serious work of first facing up to and then attempting to mitigate the consequences of climate change. Clearly, the restorative power of a loving hug between two sylph-like, saucer-eyed cartoon sisters is hardly going to offer what the poet W. B. Yeats called 'befitting emblems of adversity' in relation to the dangerously unstable environment that we face.[9] This response seems to me limited in its efficacy, however, since

8　Charlotte Alter, 'Official Wants *Frozen* to Teach Kids about Climate Change', *Time* (23 January 2015), <http://time.com/3680495/frozen-climate-change> accessed 30 January 2018.

9　William Butler Yeats, 'My House', *Meditations in Time of Civil War* (1922), in *The Poems: W. B. Yeats* (London: J. M. Dent, 2001), 248, line 30.

it fails to engage with either the artistry or emotive force of the film on its own terms. A better way of approaching the film might be to focus initially on what characterizes Anna's heroic quest to restore the climatic conditions necessary for her society and environment to thrive. Clearly, the challenges she faces in achieving this quest are not realistic, but the qualities she epitomizes do have potential salience for debates about real world responses to climate change. These include determination; a clear grasp of the importance of her mission; forging alliances with others who have different perspectives; resilience in adapting to environmental change; care, for both humans and non-humans; exposure and responsiveness to the natural world; humour and imaginative play. Once these qualities have been brought into focus, one could then consider what the value – and limitations – of embodying them in this particular form may be. This might include debating whether the film may still tacitly trivialize climate change issues, by casting them into a feel-good, fairy tale fantasy. But the debate can be more nuanced, recognizing positive potentialities too, and asking questions about the range of narratives we need as imaginative resources in our present crisis.

Reinhard Hennig

Jostein Gaarder's *The World According to Anna* (2013/2015)

In the original Norwegian version, the subtitle of Jostein Gaarder's novel *The World According to Anna* is *En fabel om klodens klima og miljø* [A Fable about the Planet's Climate and Environment], which points to the work's central theme of anthropogenic environmental and climatic change. The novel's main character is a 16-year-old girl named Anna Nyrud living in southern Norway in the year 2012, at a time when the first effects of global warming are already noticeable. Anna frequently has dreams in which she sees the world of the year 2082 through the eyes of her own great-granddaughter Nova. In Nova's time, global warming has led to highly detrimental changes in the climate and ecosystems worldwide. The central question to which Anna, inspired by these dreams, tries to find an answer is how this future scenario can be prevented from becoming a reality.

On the surface, it may seem that the novel takes a rather nostalgic, mournful approach to climate change and its consequences. Nova finds it 'sad' and 'tragic' that many species have gone extinct at her time and thinks that the planet has lost its former beauty, while the aged Anna (appearing as Nova's great-grandmother in the dreams), feels 'deep sorrow' and 'remorse' over the environmental and climatic degradation that has happened without her having done enough to prevent it.[1]

However, this mourning only pertains to the future level of the novel, whereas the main approaches to climate change on its contemporary level are didactic, ethical and activist. Most of the dialogues in the text contain facts

[1] Jostein Gaarder, *The World According to Anna*, trans. from the Norwegian by Don Bartlett (London: Weidenfeld & Nicolson, 2015), 28 and 40.

and rather detailed explanatory information on global warming, concerning, for example, current carbon dioxide levels in the atmosphere, the greenhouse effect, and the likely consequences if anthropogenic climate change is not counteracted. Anna also collects from newspapers 'all the climate articles she could find',[2] and sorts them into two boxes titled 'What is the world?' and 'What has to be done?' Most of these articles quoted in the novel convey knowledge about ecosystems and the climate. The novel's educational purpose is also obvious in the many detailed and explicit references to other sources of information on environmental issues, such as websites, TV documentaries, the Worldwatch Institute's annual *State of the World* reports, the Norwegian Red List, and books such as Tim Flannery and Peter Schouten's *A Gap in Nature*.[3] Moreover, processes of environmental education are themselves narratively represented in the novel, such as when children are described as educating their parents on ecosystem services and climate change, or when Anna persuades an employee of the United Nations World Food Programme to give a lecture at her school on the effects of global warming on food security.

Another prominent approach to climate change in the novel is ethical. The text frames global warming on the one hand in relation to questions of environmental justice, pointing to differences in responsibility between rich and poor countries. On the other hand, however, the main focus of the ethical questions dealt with in *The World According to Anna* is on intergenerational justice. Nova calls climate change 'a conflict between *generations*',[4] and one of the newspaper articles that Anna reads expresses fear that 'one day [...] we will be judged by our own heirs'.[5] Another of these articles posits as an ideal to 'do to the next generation as you would have had the previous one do to you'.[6] In this context, the importance of being capable of envisioning future generations is emphasized, exemplified by Anna's lively imaginative power that motivates her to take over responsibility for what the future will be like.

2 Gaarder, *The World According to Anna*, 26.
3 Tim Flannery and Peter Schouten, *A Gap in Nature: Discovering the World's Extinct Animals* (New York: Atlantic Monthly Press, 2001).
4 Gaarder, *The World According to Anna*, 170.
5 Gaarder, *The World According to Anna*, 118.
6 Gaarder, *The World According to Anna*, 52.

This perspective merges in the novel into a decidedly activist approach to climate change, with the catastrophic future scenario being rather explicitly posited as a warning to the present. In dialogues with adults and her boyfriend Jonas, Anna criticizes excessive consumption, wastefulness and greed, as well as climate change denial, pessimism and passivity. She emphasizes the urgency to act, stating that this is the 'very last chance',[7] but also that there is hope and that it still is not too late to counteract climate change and species extinction. Anna is confirmed in her activism by a psychiatrist who tells her that it is unhealthy to let oneself be consumed by one's worries, and that the only remedy is to do something about the underlying problem. As a consequence, Anna and Jonas get in touch with representatives of environmental NGOs in Oslo, and then start an own environmental group at their school.

In terms of genre, *The World According to Anna* can be considered an environmental dystopia in the form of a young adult novel. However, it also contains elements of romance (the love story between Anna and Jonas on the one hand, and between Nova and an unnamed climate refugee on the other hand), of fantasy (an antique ruby ring that is said to have magical qualities), and of metafiction (as when a flaw in the novel's logic is explicitly addressed by one of the characters). The chapters usually alternate between the present and the future settings of the story. However, the dystopian aspect of the future scenario increasingly fades into the background, and the initially realistic style of narration gradually evolves into a more fantastic one, with the two temporal settings eventually overlapping and even becoming indistinguishable from each other (such as when Nova spots Anna and Jonas through the window of a cabin, and Anna later believes she sees Nova walking in the woods). Also, in the latter parts of the novel, the future episodes gain a more anecdotal character, often serving to illustrate a particular point or message, concerning, for example, the ineffectiveness of emissions trading for fighting climate change. The novel is generally narrated in the third person, alternating between the points of view of Anna and Nova, but dialogues as well as

7 Gaarder, *The World According to Anna*, 45.

Didactic Cli-Fi

excerpts from newspaper articles and letters make up a considerable proportion of the text.

The World According to Anna has had a rather mixed reception both in Norway and abroad. Opinions on it were very much divided among professional literary critics as well as among 'normal' readers. Many criticized the novel for neglecting aesthetic qualities in favour of didactic elements. A frequently expressed view was that the central characters are too flat and too implausible to invite any identification.[8] Others, however, highly welcomed the attempt to disseminate knowledge about climate change and environmental degradation in the form of a novel, and found the text thought-provoking and even a motivation to action.[9] In Norway, *The World According to Anna* can be said to have contributed to initiating a debate about the potential of literature to influence readers' environmental behaviour. Many aspects of this debate resurfaced in the context of the reception of later literary works addressing environmental and climatic change, such as Britt Bildøen's *Sju dagar i august* [Seven Days in August] or Maja Lunde's *Bienes historie* [The History of Bees].[10] Shortly after *The World According to Anna* was published in Norway in spring 2013, Forfatternes klimaaksjon [the Norwegian Writers' Climate Campaign] was founded as probably the first international association of writers committed to climate action, and with strong involvement from Gaarder himself. Since then, a large number of novels addressing climate change have been published in Norway (many more than in all the other Nordic countries combined), a fact that probably can at least in part be attributed to the attention to global warming that the campaign has created among Norwegian writers. While this trend is not directly attributable to *The World According to Anna*, it seems

8 See, for example, Petra J. Helgesen, 'Dromedar på Hardangervidda' (*Bergens Tidende*, 4 March 2013), 6.

9 See, for example, Hilde Eskild, 'Tilgi oss ikke, for vi vet hva vi gjør!' *Utdanning* (26 April 2013), 35.

10 Britt Bildøen, *Sju dagar i august* (Oslo: Det norske samlaget, 2014), trans. Becky Crook as *Seven Days in August* (London: Seagull Books 2016); Maja Lunde, *Bienes historie* (Oslo: Aschehoug, 2015), trans. Diane Outley as *The History of Bees* (London: Touchstone, 2017).

clear that the novel has at least played some role in making global warming a relatively frequent topic in Norwegian contemporary literature.

The World According to Anna differs from many other young adult novels addressing climate change in that it does not present a coherent dystopian scenario. Through its two temporal settings, the future catastrophe appears as being avoidable, provided that appropriate action is taken. It is more than clear from the text that being motivated to action is precisely what is expected from the intended young readership, and the Norwegian original even contains at its end a list of webpages of environmental organizations and of climate research centres. *The World According to Anna* could therefore be used in teaching as a marked example of an environmental *littérature engagée*, illustrating the often complicated relation between the dissemination of knowledge from climate science and environmental ethics on the one hand, and the aesthetic qualities of literary texts on the other hand.

Figure 26. Greenpeace activists protest against Norwegian drilling for oil in the Arctic, in a campaign supported by Jostein Gaarder © Will Rose/Greenpeace. Reproduced with kind permission of Greenpeace.

In addition, a comparative reading of Gaarder's novel in relation to cli-fi texts from other cultural contexts could reveal national particularities of such works. *The World According to Anna* is not only set in Norway; it also relates to a discourse of climate change that in many respects is specifically Norwegian.[11] The novel contains a strong criticism against the Norwegian oil industry, which has made Norway one of the world's wealthiest countries, but also, with oil and natural gas constituting by far the most important national export, contributes relatively substantially to global warming. At the time when *The World According to Anna* was written and published, environmental organizations started to increasingly demand an end to Norwegian oil drilling (especially in the Arctic), often, like the novel, pointing to responsibility for the well-being of future generations (Figure 26). In addition, the novel idealizes traditional rural life in Norway, which usually is imagined as having embodied characteristics such as closeness to nature, modesty and rational resource use. Through highlighting such ideals, *The World According to Anna* refers to central elements of Norwegian national identity, and uses them as a counter-discourse to what it criticizes in contemporary Norwegian society and culture. The novel could thus be used to illustrate the important role of national concerns, debates and narratives concerning climate change.

11 On Norwegian climate change discourse see Kari Marie Norgaard, *Living in Denial. Climate Change, Emotions, and Everyday Life* (Cambridge, MA: MIT Press, 2011).

Sina Farzin

Saci Lloyd's *The Carbon Diaries 2015* (2008)

Environmental issues are issues of intergenerational justice. If mankind's actions of the past and present affect and determine the living conditions for future generations, narratives about climate change almost always raise questions of intergenerational relations, responsibilities and conflict.[1] Saci Lloyd's novel *The Carbon Diaries 2015*, first published in 2008, investigates those themes by weaving them into a dystopian narrative for young adults written from the standpoint of a teenage narrator.[2] The novel is set in what was, at the time of its publication, a future London of the year 2015. After catastrophic events caused by anthropogenic climate change, especially a great storm in 2010 which devastates large parts of the national infrastructure, the UK decides to introduce strict carbon rationing for all citizens without any exceptions. Closely monitored by the government, carbon budgets are implemented for everybody and controlled via the mandatory use of carbon cards.

The dystopian scenario laid out in *The Carbon Diaries 2015* revolves around Laura Brown and the challenges faced by her and her family, peers and neighbours while adapting to the new governance of carbon spending and facing increasing environmental disasters due to the progression of climate change. The focus of this analysis will be the intergenerational aspects of the coping strategies which are displayed by a variety of characters that do

1 See Adeline Johns-Putra, 'Borrowing the World: Climate Change Fiction and the Problem of Posterity', *Metaphora: Journal for Literature, Theory and Media* 2 (2017), 1–16.

2 Saci Lloyd: *The Carbon Diaries 2015* (London: Hodder Children's Books, 2008). In 2009, a sequel, *The Carbon Diaries 2017*, was published. The focus of the interpretation laid out here remains on the first book.

not only represent different forms of social ties and kinship but also specific characteristics grounded in generational experience.

The formal qualities of the novel address a specific generation as audience. Lloyd combines two genres popular among and mostly written for teenagers and young adults. On the one hand, *The Carbon Diaries 2015* is a classic coming-of-age story: it is written in the form of diary, authored by Laura, a 16-year-old girl from an average middle-class family with average symptoms of dysfunctionality, but more or less intact, until the carbon regime transforms their lifeworld into unknown territory for both children and parents. Laura's first-person narration presents the events from the perspective of a teenage girl, constantly at odds with her older sister Kim and her parents Nick and Julia, but also a sharp and sometimes funny observer of her world. Following Laura's diary entries we witness the deterioration of her parents' marriage and the growing pressure on her neighbourhood caused by increasing numbers of weather-related disasters and subsequent social tensions. The narrative structure as well as the subjective standpoint of a teenage narrator, combined with Laura's and her family's emotional development during the course of events, align the formal and generic qualities of *The Carbon Diaries 2015* with iconic titles such as J. D. Salinger's *Catcher in the Rye* (1951) and Sue Townsend's popular *The Secret Diary of Adrian Mole, Aged 13¾* (1982) – a connection Lloyd makes herself in the preface of the sequel *The Carbon Diaries 2017*, where she names characters such as Holden Caulfield or Adrian Mole as influential on her writing.[3]

On the other hand, the novel also features elements of a critical dystopia.[4] Critical dystopias can be described as texts that depict future societies gone nightmarishly wrong and yet maintain some grain or small space of hope. As Alexa Weik von Mossner convincingly argues, the embrace of openness and hope in an otherwise pessimistic or even devastating setting is a typical genre marker of dystopian fiction written for young adults (but may also be found in critical dystopias directed at older readerships, such as much of Margaret

3 Saci Lloyd, preface, *The Carbon Diaries 2017* (London: Hodder Children's Books, 2009).
4 Tom Moylan, *Scraps of the Untainted Sky: Science Fiction, Utopia, Dystopia* (Boulder, CO: Westview Press, 2000), 188.

Figure 27. Laura Brown's carbon ration card in *The Carbon Diaries* © Saci Lloyd.
Reproduced with kind permission from the publisher (Hachette) and the author
(Saci Lloyd).

Atwood's or Paolo Bacigalupi's work, to name just two very popular examples).[5]
In *The Carbon Diaries 2015*, Laura and her generation are confronted with the
ruinous consequences of lifestyles they have not wilfully chosen and decisions
made before they were born. However, the inter-generational struggle around
questions of accountability and responsibility displayed in the novel is not
simply a blame game but is also a resource of hope and coping.

The beginning of the novel introduces us to the Browns on the eve of
the new carbon restriction era (Figure 27). Soon, it becomes clear that, in this
moment of unprecedented insecurity, the roles in the Brown family are reversed.
No one really knows at this point how the new politics will affect their estab-
lished lifestyle since no one has any experience with carbon rationing. But it is

5 Alexa Weik von Mossner, 'Hope in Dark Times: Climate Change and the World Risk
 Society in Saci Lloyd's The Carbon Diaries 2015 and 2017', in Carrie Hintz, Balaka Basu,
 and Katherine A. Broad, eds, *Contemporary Dystopian Fiction for Young Adults: Brave
 New Teenagers* (London: Routledge, 2013), 69–83.

Coming-of-Age Cli-Fi

the parents who spend the last hours of unlimited carbon use in denial, 'staring blindly at the TV like amoebas' while Laura wonders about the changes and their (un)likely success, describing the UK as guinea pig nation for future European climate politics.[6] Throughout the novel, Laura's entries make clear that she neither receives nor expects guidance or help from her parents' generation, whom she describes in a school essay as 'selfish' and 'the most dangerous kind because they really believe their lives are worthwhile'.[7] Faced with the loss of their known world, it is her parents who show the kind of quirky adolescent behaviour one would expect from their teenage daughters: Julia has a hard time letting go of her old, consumerist lifestyle to the point where she tearfully strokes the car she is not allowed to drive anymore while on her way to the bus-stop[8] and both Julia and Nick temporarily leave their family during the year while struggling with their personal identity and marriage crises. But other authorities from the parental generation are also depicted as helpless: a fireman whom Laura and her friend meet after a blackout tells the two to walk home alone since he won't be able to protect them from any looters and her school principal thanks her generation for finally choosing to change their lifestyle, while simultaneously announcing the school has been overspending its carbon budget and therefore cannot be heated anymore until spring.[9] That we experience all these incidents through Laura's subjective accounts, tinged with her acid humour, hints that the deterioration of moral competence and responsibility in the adults' generation is a widespread phenomenon.[10] When Laura watches a climate disaster movie with her peers, people in the audience laugh at the depicted struggle of a family, especially when 'dad hero' saves his family in the final scene, a sequence her friends loudly make fun of as 'Bullshit!.[11]

As the storyline of the novel unfolds, it becomes clear that the action narrative Laura sees in the movie is not even close to the changes of her own lifeworld, as it spirals downwards and becomes increasingly dystopian: a series

6 Lloyd, *The Carbon Diaries 2015*, 2, 4.
7 Lloyd, *The Carbon Diaries 2015*, 27.
8 Lloyd, *The Carbon Diaries 2015*, 11.
9 Lloyd, *The Carbon Diaries 2015*, 36, 269.
10 For Lloyd's use of humour see Alyson Miller, Rebecca Hutton and Elizabeth Braithwaite, 'Dead Funny?: The Ideological use of Humour and Comedy in Saci Lloyd's "The Carbon Diaries 2015 and 2017"', *Papers: Explorations into Children's Literature* 25/1 (2017), 51–72.
11 Lloyd, *The Carbon Diaries 2015*, 44.

of extreme weather events (blizzards, draughts, heatwaves, floods) cause cumulative supply shortages and social struggles. Laura, who in the beginning still wants things to get back to 'normal', as they used to be before restricted carbon use, becomes aware how unrealistic her wish is. She starts coping with the new conditions and is the only one in her family who manages to stay within her carbon budget. The tensions between the generations and the partial 'reversal' of roles between parents and children intensify the dystopian dissolution of social order, safety and security.

But despite these feelings of abandonment and rage by the young adults, the text also articulates moments of hope rooted in the relation between different generations. While Laura feels betrayed by the childish behaviour of her parents until the very end, when the family finally comes around and works together to save Laura's sister Kim, her elderly neighbour Arthur, a Second World War veteran, becomes a role model for her: 'Arthur Stoat-Wilson is the poshest and happiest man I've ever met'.[12] What draws Laura to Arthur is his stoic yet positive attitude, despite the restrictions and unknown dangers they face. It is his past experience with war and rationing that provides Laura with a bearable perspective when it comes to dealing with her longing for normality under adverse conditions. Arthur tells her: 'The thing about rationing I remember most clearly was that everyone did their damndest to carry on as if it were normal. And soon it *was*'.[13] But Arthur's perspective does not only lead a path to acceptance; by drawing on historical experience, he also provides the grain of utopian hope typical of young adult dystopias. In his memory, rationing functioned also as a social leveller and sparked people's ability to form new collectives out of solidarity when faced with a common challenge. '[...] they were very happy times – all pulling together, knowing we were doing something good for the country'.[14] The possibility of new forms of collectivity derived from the collective memory Arthur embodies allows for an at least partially hopeful perspective against all the odds faced by Laura and her generation. However, while in *The Carbon Diaries 2015* the politics of carbon rationing include a moment of hope, these undertones are replaced by a darker mood in the sequel *The Carbon Diaries 2018*. Here, the political

12 Lloyd, *The Carbon Diaries 2015*, 53.
13 Lloyd, *The Carbon Diaries 2015*, 315.
14 Lloyd, *The Carbon Diaries 2015*, 315.

climate drifts towards right-wing authoritarianism while Laura and her peers become increasingly politicized and express their rage via counterculture and punk music.[15]

The Carbon Diaries 2015 provides an original contribution to climate fiction as a new form of realism of the possible. The dystopian near-future scenario Lloyd imagines is not too distant or too different from today's world to be relatable, especially for the young readership the book targets. As a mixture of coming-of-age narrative and critical dystopia, it is well suited for teaching and discussing the effects of climate change with high school and young undergraduate students in a 'close to home' scenario. In particular, the focus on inter-generational conflict between Laura, her parents and other adults provides a recognizable frame for young readers to address ethical questions about generational responsibility and climate justice. For younger as well as advanced students, the historical references of the carbon-rationing scenario might also be a good starting point to ask how in climate fiction contemporary social questions of solidarity and sustainability are related with collective memories of past experiences. We can find such references in many works of climate fiction focused on generational responsibility. A popular example is the use of the dustbowl documentary footage in the movie *Interstellar* (2014),[16] connecting the future plot of the movie with one of the first anthropogenic extreme weather events, a decade of severe dust storms in the northern USA and Canada caused by deep ploughing in the 1930s. Just like in *The Carbon Diaries 2015*, historic events are used as a touchstone and blueprint for developing coping strategies and identifying obstacles. However, when teaching *The Carbon Diaries* outside the UK, Arthur's positive attitude towards rationing politics grounded in his personal experience of the Second World War probably needs some further framing, since the collective memories of this particular epoch differ substantially between cultural and national contexts. In this line of inquiry, general questions about cultural differences of imagining climate change could be addressed via comparative regional or national analyses.

15 Alexandra Nikoleris, Johannes Stripple and Paul Tenngart, 'Narrating Climate Futures: Shared Socioeconomic Pathways and Literary Fiction', *Climatic Change* 143/3 (2017), 307–19.

16 *Interstellar*, dir. Christopher Nolan (Warner Bros., 2014).

Part VI

Literary Modernism

Ursula Heise

David Brin's *Earth* (1990)

David Brin's *Earth* explores global warming as part of an epic portrayal of our planet's future. The novel develops a panoramic view of the middle of the twenty-first century thematically, through its explorations of demographic growth, socio-economic inequality, resource extraction, biodiversity loss, pollution, rising sea levels, political conflicts, digital technologies, global media, privacy and surveillance, and weapons technologies. It also models planetarity formally through a multidimensional narrative architecture that seeks to encompass the vast multiplicity of perspectives that global issues involve, at the same time that it aims to convey a sense of the planet's societies joined in crisis. Given the ambitious scope of Brin's novelistic project, it is little surprise that the novel falls short in some of its engagements with gender, violence and justice. But by fusing epic narrative with the parallax and fragmentation of the high-modernist urban novel, *Earth* delivers a structural blueprint for novels that aim to engage with climate change as a global social and ecological crisis.

Set in 2038, *Earth* focuses on the possibility of global destruction – at first sight, not because of climate change but a techno-scientific experiment gone wrong. The British physicist Alex Lustig, one of the world leaders in 'cavitronics', the artificial creation of diminutive black holes, has discovered a black hole in the Earth's crust, which is threatening to absorb the planet from the inside out. He and his international team assume at first that a government or corporation has lost control of an experiment that was intended to yield a deadly new weapon. But as the team explores ways of secretly removing the black hole so as to avoid international conflict, they discover that this particular singularity predates the science of cavitronics and might be of alien origin. They attempt to destroy it with so-called 'gravity lasers' that cause earthquakes and disasters all over the globe, and thereby attract the attention of various governments, military organizations and secret services who seek

to wrest control over the potential superweapon away from them. In spite of their secrecy, a particularly passionate and technologically savvy environmentalist and hacker, Daisy McClennon, tracks down information about the gravity lasers on the 'Net', Brin's eerily accurate anticipation of today's Internet. McClennon appropriates the technology and deviates it to her own fanatic struggle against the global destruction of nature, which includes, in her plan, the reduction of the human population from 10.3 billion to no more than 20,000 hunter-gatherers.

A global battle on the Net and in the material world ensues between McClennon, Lustig's team and other agencies and governments who seek to appropriate gravity laser technology. McClennon's genocidal misuse of the gravity laser beams, besides killing several million people, activates ever more electric currents in Earth's geological strata. She finally encounters her most formidable opponent, the Nobel Prize-winning biologist Jennifer Wolling. Wolling's work on competition and cooperation in ecological systems from a single organism to the whole planet has inspired the world-wide 'Church of Gaia', an organization that has transformed James Lovelock's Gaia Hypothesis into religious worship. McClennon and Wolling, two radically different types of environmentalists, encounter each other in an epic virtual fight at the climax of the novel. When McClennon directly attacks Wolling's computer station with a gravity laser beam, she succeeds in killing the biologist, but at the same time catalyses a fusion between Wolling's own consciousness, a digital model of human cognition she was building, and the electric currents that the gravity lasers have activated in Earth's core. As Earth and Net interlace, they generate an innovative type of artificial intelligence that is both material and digital, chthonic and electronic. McClennon is killed shortly afterwards in one of the disasters that her own gravity lasers have triggered, but the new AI, an electronic Gaia of sorts whose way of thinking resembles Wolling's, begins to shift humankind to a more sustainable way of life. Mineral extraction is moved from Earth to asteroids, the exploitation of the oceans is terminated, and displaced human populations are moved into areas left empty by McClennon's genocidal attacks. Brin's allegory here is not particularly subtle: the new planetary AI, even though it does not intervene in everyday political affairs, signals the emergence of a global ecological consciousness out of a multitude of human minds and societies.

Although *Earth* begins with a rather dystopian portrayal of ecological and social affairs in the mid-twenty-first century, the ending is nothing less than a utopian imagination of a future global governance that ensures sustainability. Yet the means by which this utopian condition is achieved do not escape from sci-fi clichés of violence and injustice. McClennon's genocide, much as it may be condemned in the novel as the act of a fanatic who has lost her empathy and humanity in her devotion to an overarching cause, creates the conditions for the final betterment of the planet, 'ameliorating the population pressures on the planet's ecology long enough for humanity to get its act together under granny Gaia's guidance', as one acerbic critic of the novel has commented.[1] The question of what human price for ecological utopia the novel offers as acceptable is exacerbated by the fact that the Gaian AI exterminates a handful of the worst offenders against sustainability – providing careful documentation but no due judicial process.

That the figure who allegorizes global environmental governance is a Gaia-type woman, in addition, raises concerns that were earlier raised against Lovelock's own 'sex-typing' of the planet.[2] Yet, before accusing Brin of sexist cliché, it is worth considering his own emphasis on the crucial importance of metaphor in the novel. The merger between Earth and Net is described as a 'new singularity of metaphors',[3] and Wolling reflects that 'all theories are only metaphors, at best helpful models of the world'.[4] The planetary AI, even more directly, considers why, as a composite of all humans, it should present itself to humanity as anything anthropomorphic or person-like in the first place:

> *If I consist of many, why do I persist in perceiving a central* me *at all! What is this consciousness that even now, as I think these thoughts, contemplates its own existence? ... Is that why I must imagine a unitary self? To give the storm a center? An 'eye' to revolve around? [....]*

1 Patrick D. Murphy, *Ecocritical Explorations in Literary and Cultural Studies: Fences, Boundaries, Fields* (Lanham, MD: Lexington, 2009), 108. For *Earth*'s engagement with demographic growth, see my analysis in *Sense of Place and Sense of Planet: The Environmental Imagination of the Global* (New York: Oxford University Press, 2008), 81–5.
2 Patrick D. Murphy, 'Sex-Typing the Planet', *Environmental Ethics* 10/2 (1988), 155–68.
3 David Brin, *Earth* (New York: Bantam, 1990), 554–5.
4 Brin, *Earth*, 467.

Epic Cli-Fi

Or is it a way to rationalize a semblance of consistency? To present a coherent face to the outside world?[5]

Similarly, in his 'Afterword', Brin emphasizes that 'after all the philosophy and speculations are finished, we're still left with just words, metaphors. They are our tools for understanding the world, but it's always well to remember they have only a nodding acquaintance with reality'.[6] The anthropomorphization and gendering of the environmentalist AI in *Earth*, then, should not be taken too literally, but rather as an allegory for the emergence of a globally shared environmental governance.

Brin's emphasis on metaphor also enables a deeper understanding of *Earth* as climate fiction. As one of the first sci-fi works to include the inevitability of climate change in its vision of the future, after the Australian novelist George Turner's *The Sea and Summer* (1987),[7] it seems odd that the major threat to Earth's existence in the plot would not come from the realistic environmental risk scenarios the novel so vividly describes, but the fantastic risk scenario of a black hole inside the planet. This shift from ecology to physics as the core of the plot, if not the novel's discourse as a whole (more about this dissociation below), allows Brin to engage with a variety of environmental crises while maintaining an overarching sense of urgency. The depletion of the ozone layer, species extinction, pollution, overpopulation and excessive resource extraction all feature prominently in the novel along with climate change, but it is the black-hole plot that allegorically draws all of them together into a threat with which a large but limited cast of characters can meaningfully engage.

Other dimensions of *Earth*'s narrative architecture also seek to balance the heterogeneity of the world's human subjects with the globality of the threats they face. The novel's twelve epic chapters are split up into subsections, each of which is focalized through one of a large set of characters who engage with the crises they encounter in a wide range of ways. In addition, the different plot strands are interspersed with bits and pieces of global discourse: for example, quotations from electronic books, online chat groups, news, letters and legal

5 Brin, *Earth*, 469, original italics.
6 Brin, *Earth*, 604.
7 See Ford, this volume.

texts; lists of jobs that have disappeared and those that have newly emerged; statistics regarding population age and voting power. Each of these fragments hints at a narrative: 'drinking tapwater' has become an obsolete activity, while new professions include 'household toxin inspector, prenuptial genetic counselor, meme adjustment specialist'.[8] In teaching *Earth*, this narrative mosaic offers rich opportunities for students to research current facts and reconstruct the transformations that Brin implies will have occurred by 2038. Together, these jigsaw puzzle pieces hint at a three-dimensional futuristic universe that includes a broad spectrum of histories and cultures.

Brin's model for this technique is John Brunner's sci-fi novel *Stand on Zanzibar* (1968). Brunner's novel similarly interspersed its narrative chapters with news items, advertisements, book and television quotations under such rubrics as 'Context', 'Tracking with Close-ups', and 'The Happening World', so as to convey a sense of planet Earth's heterogeneity as well as its totality. Brunner, in turn, explicitly derived his narrative strategy from John Dos Passos's technique in *Manhattan Transfer* (1925) and the *USA Trilogy*. Somewhat similar uses of fragmented bits of discourse from the urban scenes surrounding protagonists occur in James Joyce's *Ulysses* (1922), Virginia Woolf's *Mrs Dalloway* (1925), and Alfred Döblin's *Berlin Alexanderplatz* (1927). Brunner pioneered the translation of these narrative structures of the high-modernist urban novel to sci-fi and the portrayal of the entire planet. Brin adopts this model in *Earth* with a far more explicit focus on the global ecological crises, climate change included, that will face humankind by the middle of the twenty-first century.

To make this profusion of detail from around the global coherent and readable, Brin alludes to epic and myth, as some high-modernist novelists such as Joyce also did. Brin refers to the divinities of different cultures, to the monsters mythological heroes needed to tame or fight, and features a descent into the underworld by two of the protagonists in the manner of the *Odyssey* or the *Aeneid*. But it is really planet Earth that provides the principal epic structure, as each of the novel's twelve chapters is subdivided into sections named after parts of the planet. Each of these geological or atmospheric 'spheres' is

8 Brin, *Earth*, 381.

associated with particular sets of characters: 'core' with Lustig and his team, 'crust' with three young men in search of a livelihood, 'lithosphere' with the engineer Logan Eng, 'exosphere' with the spaceship pilot Teresa Tikhana. 'Noosphere' sections feature the events that lead up to Wolling's metamorphosis into the Gaian AI, in an allusion to the French theologian Pierre Teilhard de Chardin, who coined the term to refer to the collective human consciousness he believed would arise from technological connectedness.[9] The architecture of the novel, in this way, brings all the different plot strands and their multitudes of characters together in one overarching model of the planet, at the same time that it connects the physical planet with the virtual realm of communication, media and digital technologies.

Indeed, planet Earth itself is, to some extent, the novel's protagonist, and one way to read the plot is as Earth's own *Bildungsroman*. Brief italicized passages that precede each of the novel's chapters recount Earth's history from its origins four billion years ago to the twenty-first century. Some of these passages summarize scientific knowledge of planet formation, geology and biology, but especially the later sections increasingly portray Earth as a cosmological or geological person of sorts, a living being who acquires a global consciousness with the emergence of the Gaian AI. Through this structure, Brin puts the fast-evolving, short-term events in the novel's plot into the geological time scales that are today associated with the concept of the Anthropocene.

The Bengali novelist and essayist Amitav Ghosh argued in *The Great Derangement: Climate Change and the Unthinkable* that the realist novel, unlike epic, cannot accommodate the Anthropocene because of its focus on the human rather than the nonhuman, on the individual or national rather than the geological scale of affairs, and on the ordinary course of events rather than the extraordinary changes and disasters that climate change will bring.[10] Sci-fi, which can be understood as a continuation of epic into the age of the novel, faces none of these obstacles, as a genre focused on planets, large-scale change, and the rise and fall of societies and species. Yet Ghosh argues that

9 See Pierre Teilhard de Chardin, 'Une interprétation plausible de l'Histoire Humaine: La formation de la "Noosphère", *Revue des questions scientifiques* 118 (1947), 7–37.

10 Amitav Ghosh, *The Great Derangement: Climate Change and the Unthinkable* (Chicago: University of Chicago Press, 2016), 15–84.

'the Anthropocene resists science fiction' because sci-fi stories are set in worlds other than our own.[11] David Brin's *Earth* proves this claim wrong: his fusion of the physical with the virtual planet, and his combination of a planetary *Bildungsroman* with the discursive fragmentations of the high-modernist urban novel offers a blueprint for narratives intent on highlighting how climate change both divides and unites humankind.

Epic Cli-Fi

11 Ghosh, *The Great Derangement*, 76.

Bradon Smith

David Mitchell's *The Bone Clocks* (2014)

David Mitchell's 2014 novel *The Bone Clocks* spans a single lifetime, from 1984 to 2043, beginning with the teenager Holly running away from home and ending with her in old age.[1] Although the narrative takes in a plethora of other characters, voices, locations and events, Holly remains the thread that binds the narrative together. The plot is complex – too complex to summarize here – but consists of two 'worlds': the real world focusing on the relationships and tribulations of a variety of characters, who occasionally interact with or are acted upon by the characters of a second fantastical world in which two factions of immortal beings are engaged in an epic battle.

The book builds on thematic interests established in Mitchell's previous novels. Indeed, his novels are interconnected, with characters from one often playing cameos in others: Mitchell sees his novels as all part of one universe, or as chapters 'in a larger volume I'll keep working on'.[2] Previous preoccupations with temporality and with the eternal recurrence of events (prominent themes in *Ghostwritten* and *Cloud Atlas*, in particular)[3] recur as themes in *The Bone Clocks*. As in the earlier novels, characters transmigrate across centuries, and events can seem locked into spirals. This eternal recurrence includes the rise and fall of civilizations: in an image that draws on the common post-apocalyptic aesthetic of nature reclaiming urban space, one century-spanning character thinks that 'there are days when New York strikes me as a conjuring trick. All great cities do and must revert to jungle, tundra or tidal flats, if you

1 David Mitchell, *The Bone Clocks* (London: Sceptre, 2014).
2 Mitchell, *The Bone Clocks*, 620.
3 David Mitchell, *Ghostwritten* (London: Hodder and Stoughton, 1999); *Cloud Atlas* (London: Sceptre, 2004).

wait long enough'.[4] This image of the urban reverting to nature has a long his-
tory, but perhaps finds its epitome in Alan Weisman's non-fiction work *The
World Without Us*, which imagines and describes the return of nature in the
absence of human life on earth; it is a book which Mitchell has listed as among
his favourites.[5] At the other end of the scale, this circularity and return apply
equally to books as to cities: '"Books'll be back", Esther-in-Unalaq predicts.
"Wait till the power grids start failing in the late 2030s and the datavats get
erased. It's not far away. The future looks a lot like the past."'[6]

As in Mitchell's other novels, another thematic preoccupation of *The Bone
Clocks* is the nature of power and how the strong prey upon the weak; in this
novel, it is connected to the desire for survival, but also to immortality. Hugo
Lamb preys upon his gullible friends and acquaintances, but is in turn lured by
the immortality of the Anchorites: a 'form of power that allows one to defer
death in perpetuity'. The Anchorites prey upon mortals for the same reason;
even Crispin Hershey's cruel prank on Richard Cheeseman that goes badly
wrong is a show of power – and an abuse of trust – in revenge for tarnishing
his literary reputation, Hershey's own immortality.

This will to power is closely associated in the novel with the idea of resource
scarcity; the two phenomena can be seen to unite the different worlds and nar-
ratives. So the Anchorites, who harvest the souls of innocents to achieve a kind
of immortality, find their analogue not only in the militiamen who steal solar
panels from Holly and her neighbour in 2043 ('Number one is to survive'),[7]
but also in the invasion of Iraq to secure its oil resources, and perhaps even
in the bitter but petty rivalries in which Crispin Hershey engages – over the
more banal resource of media attention and book sales.

Climate change surfaces as a key theme of *The Bone Clocks* only in its final
chapter, set in 2043 on the south-west coast of Ireland. The world has under-
gone a period called the Endarkenment, in which a combination of peak oil

4 Mitchell, *The Bone Clocks*, 498.
5 Alan Weisman, *The World Without Us* (London: Virgin Books, 2008). David Mitchell,
 David Mitchell's 6 Favorite Books, <http://theweek.com/articles/493271/david-mitchells-
 6-favorite-books> (25 June 2010) accessed 11 April 2018.
6 Mitchell, *The Bone Clocks*, 493.
7 Mitchell, *The Bone Clocks*, 588.

and continuing climate change have brought about the collapse of electricity grids and societal structures, and the rise of militia gangs and religious fanaticism. In a list that stresses the interconnected nature of issues of climate change, biodiversity loss, energy, pollution and health, Holly describes a

> grief for the regions we deadlanded, the ice caps we melted, the Gulf Stream we redirected, the rivers we drained, the coast we flooded, the lakes we choked with crap, the seas we killed, the species we drove to extinction, the pollinators we wiped out, the oil we squandered, the drugs we rendered impotent, the comforting liars we voted into office – all so we didn't have to change our cosy lifestyles. [...] [W]e summoned it [the Endarkenment] with every tank of oil we burnt through.[8]

However, if climate change only takes on a central role in this final chapter, Mitchell leaves a trail of breadcrumbs from the very start of the book. The first chapter is titled 'A Hot Spell: 1984' and takes place on three hot days at the end of June, prefiguring the rising temperatures of a changing climate. An overheard conversation in this first chapter concerns the ongoing miners' strikes and the state of the energy industry: 'We can't keep dying industries alive for ever' one argues, to which the reply comes 'when the mine goes, the town dies. Wales and the north ain't the south, [...] and energy ain't just another industry. Energy's security. The North Sea oil-fields won't last for ever, and then what?'[9] In a later chapter, in which the narrator is Ed Brubeck, a war journalist based in Iraq, energy security surfaces again: 'the invasion of Iraq was about one thing and one thing only: oil', opines a guest at a wedding, to which Brubeck replies, 'If you want a country's oil, you just buy it'.[10]

These references are there in every chapter, signalling the seemingly inevitable course on which the world is set, towards the post-collapse society of the final chapter, a kind of environmental equivalent to the 'Script' which obliquely encodes the events in the war of the Atemporals. This is an important feature of the novel's approach to climate change, indicating the scale of the problem and the difficulties involved in changing course from our current high-carbon lifestyles, but also suggesting that the future collapse of society is already in

8 Mitchell, *The Bone Clocks*, 549.
9 Mitchell, *The Bone Clocks*, 35.
10 Mitchell, *The Bone Clocks*, 245.

some sense 'baked in', as indeed are the future climate changes that will result from our historic (and current) carbon emissions.

When it comes to the penultimate chapter set in 2025, Mitchell provides a potted history of the previous four decades, bringing up to date a character who has been in a form of hibernation since 1984. Conspicuously, the first sentence describes the major environmental trends: 'Oil's running out, [...] Earth's population is eight billion, mass extinctions of flora and fauna are commonplace, climate change is foreclosing the Holocene Era'.[11] Covering, as it does, the period from 1984 to 2043, *The Bone Clock*'s engagement with climate change traces our recent past and present, and projects the consequences of our high-carbon Western lifestyle into the near future. It becomes difficult not to see the other chapters through the lens of what the world will become. In this way, the intercontinental travel which takes Crispin Hershey to book festivals around the world in the years 2015 to 2020 becomes synecdochic for the casual luxury of our 'petromodernity'. Or, as one of the militia says to Holly in 2043, 'Your power stations, your cars, your creature comforts. Well you lived too long. The bill's due'.[12]

David Mitchell's novels have become known for their pluralism of form and narrative voice. They tend to employ multiple interwoven narratives, often showcasing strikingly different genres across their different chapters. *The Bone Clocks* continues this tendency, with six chapters each with a different narrator (if we understand 15-year-old Holly and 74-year-old Holly as different narrators). The first chapter can be seen as a form of picaresque, with the naïve Holly taking to the road; the second has aspects of a *Bildungsroman*, as Hugo Lamb describes his coming of age and eventual indoctrination into the society of the Anchorites; the fifth chapter is most consistently in the fantasy realm; and the sixth is futuristic dystopian fiction.

As often with Mitchell's novels there is self-reference and even self-mockery. Writer and novelist characters are common in his books, and they are often not sympathetic: Crispin Hershey takes this role here. Hershey recalls a story he wrote about 'a gang of feral youths who roam the near-future, siphoning

11 Mitchell, *The Bone Clocks*, 491.
12 Mitchell, *The Bone Clocks*, 571.

oil-tanks of lardy earth mothers',[13] a reference both to a story which Mitchell himself wrote ('The Siphoners')[14] and to the final chapter of the novel still to come: the fictional events come to pass in the 'real' world of *The Bone Clocks*. Obviously, the final chapter is already written, but this reference again suggests the inevitability of the dystopian future within the diegesis of the novel.

The final chapter represents an interesting formal feature of its own, since within the larger narrative arc that the novel has described it is not strictly necessary: the war between the Atemporals has been won, in the epic battle described in the penultimate chapter. The last chapter is an epilogue, almost an anti-climax. Holly's role in the long-running war has ended, but the book continues. As Mitchell has said in interview, if this was Hollywood, the film would end at this point, but in a novel, he can show how ordinary life continues outside the grand narratives: 'People's lives don't end at climaxes [...]. The minutiae of life go on, in a banal way – which is good for most of us'.[15]

Mitchell's novel received generally positive reviews. Reviewers praised Mitchell's characterization and prose, although many found it veered too far towards fantasy: 'Mitchell's observations of people are so astute, his characterisation so complex, his dialogue so sparkling, that the plunge into the supernatural feels as if your best friend just told you she believes in fairies'.[16] Even if its 'penultimate section [...] travel[led] too far into Marvel Comicsdom', they saw in the novel an exceptional eye for detail and 'astonishing ventriloquism'.[17]

13 Mitchell, *The Bone Clocks*, 304.

14 David Mitchell, 'The Siphoners', in *I'm With the Bears: Short Stories From a Damaged Planet* (London and Brooklyn, NY: Verso, 2011), 129–41.

15 Steven Poole, 'David Mitchell: "I've Been Calling *The Bone Clocks* My Midlife Crisis Novel"', *The Guardian*, <http://www.theguardian.com/books/2014/aug/30/david-mitchell-interview-bone-clocks-midlife-crisis-novel> (30 August 2014) accessed 11 April 2018.

16 Layla Sanai, 'David Mitchell, *The Bone Clocks*, Book Review: Another Fantastic Epic', *The Independent* (7 September 2014). See also Derek Thompson, '*The Bone Clocks*: David Mitchell's Almost-Perfect Masterpiece', *The Atlantic* (2 September 2014).

17 Pico Iyer, '*The Bone Clocks*, by David Mitchell', *The New York Times* (28 August 2014). For Robert Collins, however, the novel was a 'merciless, roiling cauldron of third-rate fantasy poppycock' – Collins, 'How on Earth Did David Mitchell's Third-Rate Fantasy Make the Man Booker Longlist?', *The Spectator* (6 September 2014).

The Bone Clocks was longlisted for the Man Booker Prize in 2014 and won the World Fantasy Award in 2015. The importance of climate change and energy as themes are noted by most, but not all, reviewers – 'as the oil and gas run out, he asks, "Where is the energy coming from?" That is one of the questions powering Mitchell's new book'.[18] Some found the subject uninteresting: '[the] dystopian future is a world overshadowed by Chinese hegemony and by the fact that (yawn) the planet's ice caps have melted'.[19] Others, however, saw the 'aching', 'arrow-sharp' final chapter as among the most successful parts of the novel.[20] *The Bone Clocks* has begun to receive some scholarly attention[21] and some of this work has addressed the novel explicitly in relation to cli-fi.[22]

An approach to teaching *The Bone Clocks* that centres on climate change will probably focus primarily on the final chapter. To what extent does Mitchell's depiction of society after the collapse of modern infrastructure resemble those of other post-apocalyptic or dystopian narratives? Some of the standard tropes are present: a return to an agrarian lifestyle and bartering, the descent into violence, the rise of religious fanaticism. But in other ways, it feels closer to our present world; this is not, for example, the world of Cormac McCarthy's *The Road* (2006).[23] There has been no single apocalyptic event, but rather the continual 'slow violence' of interconnected environmental disasters, failures of infrastructure and shifts in geopolitical power. On the Sheep's Head peninsula, where the chapter is set, community still exists, and local democracy and some forms of infrastructure. A fruitful comparison could also be drawn with Mitchell's other futuristic dystopia, the central chapter of his earlier novel, *Cloud Atlas*. In this instance – set further in the future – the memory

18 Poole, 'David Mitchell'.
19 Collins, 'How on Earth'.
20 Thompson, '*The Bone Clocks*'; Iyer, '*The Bone Clocks*'.
21 Patrick O'Donnell, *A Temporary Future: The Fiction of David Mitchell* (New York: Bloomsbury Publishing, 2015).
22 Elizabeth Callaway, 'Seeing What's Right in Front of Us: *The Bone Clocks*, Climate Change, and Human Attention', *Humanities* 7 (2018); Rebecca Evans, 'Fantastic Futures?: Cli-Fi, Climate Justice, and Queer Futurity', *Resilience: A Journal of the Environmental Humanities* 4 (2017), 94–110.
23 Cormac McCarthy, *The Road* (London: Picador, 2006).

of the time of fossil-fuelled plenty has long since faded, and the descent into barbarism is further progressed.

Formally, the novel offers opportunities to discuss Mitchell's shifting narrative voice, to compare, for example, the voice of Holly the teenager in 1984 – 'I fling open my bedroom curtains, and there's the thirsty sky and the wide river full of ships and boats and stuff, but I'm already thinking of Vinny's chocolatey eyes'[24] – with Holly the grandmother and guardian of 2043 – 'We sort of live on, as long as there are people to live on in'.[25] It could also form the basis of a discussion of different prose form and genres: in combination with *Cloud Atlas*, the features of the epistolary form, the picaresque, the *Bildungsroman*, the diary form could be discussed, as well as the genres of the noir thriller and various shades of speculative fiction and sci-fi.

24 Mitchell, *The Bone Clocks*, 3.
25 Mitchell, *The Bone Clocks*, 542.

Genre Pluralism in Cli-Fi

Figure 28. The Mo'ai, monolithic human figures carved between 1250 and 1500 by the Rapa Nui people on Easter Island in eastern Polynesia, symbolise our environmental self-destruction in *The Stone Gods*. In the public domain. From Wikimedia Commons.

Louise Squire

Jeanette Winterson's *The Stone Gods (2007)*

Jeanette Winterson's *The Stone Gods*[1] makes a literary adventure of climate change whilst raising some questions for reader contemplation. Will we learn from our mistakes, or will we just keep on making the same ones over and again? Is a change of direction for humanity possible? This chapter explores *The Stone Gods* from the perspective of its imagery of death-denial, depicted as the root cause of environmental crisis. The novel reflects on a notion of death that is denied and yet which rebounds upon us, depicting humanity as caught in a time-loop of error. Humanity, in *The Stone Gods*, will do anything to stave off aging and death, even if this leads to the destruction of that which is fundamental to survival: our planetary home. The question is: how might we intervene in this seemingly eternal cycle of human folly to create a differ-ent kind of future?

The novel is comprised of three distinct yet interlinking stories, which together form reiterating patterns of character, theme and plot. Spike (aka Spikkers) and narrator Billie (aka Billy) are central to the storyline each time, their same-gender, android-human lives entangling across different manifestations, different lives and different worlds. The first story, Planet Blue, is set on Orbus and tells of a failed attempt to relocate humanity to a new planet, the pristine Planet Blue; the second, Easter Island, sweeps back to the 1700s where the island's ecocide myth is retold with the felling of the last tree; the final two-part story, comprising Post-3 War and Wreck City, envisages a future of corporate takeover, political breakdown and the start of a fourth world war.

1 Jeanette Winterson, *The Stone Gods* (London: Penguin, 2008) [2007].

The novel incorporates several of Winterson's characteristic themes, such as gender, non-duality and love. These are most evocatively portrayed in the character Spike, who, in the first and third stories is a female *Robo sapiens* – an advanced form of android. Her queer cyborgian love for Billie dissolves dualisms and unsettles questions of gender, love and human exceptionalism, opening up the storyline to the possibility of 'new narratives'.[2] *Robo sapiens* are evolving, Spike tells Billie; as her death is imminent, Spike develops a beating heart. This unsettling of dualisms feeds into the novel's environmental commentary. The 'intervention' Spike proposes to disrupt repeating error is 'love', a theme also played out by Spikkers who, in story two, befriends ship's mate Billy, stranded on Easter Island. While Billy reflects cynically on human folly, Spikkers celebrates Billy's love for him in a bid to release the islanders from the monopolies of power that are the cause of environmental destruction.

Other themes in the novel include repetition,[3] especially the tendency to repeat our mistakes, and 'the retrograde myth of progress'.[4] Repetition seems the more striking, since it is integrated as structural device and plot feature and accentuated by the novel's 'planet' motif. Orbus appears to be a future Earth while Planet Blue, inhabited by dinosaurs, appears as a past Earth. This suggests that humanity will keep repeating its ecocidal behaviours. Orbus, in the first story, is expected to become uninhabitable within fifty years due to extreme climate change. Tales are told, on the mission to Planet Blue, about strange planets, burned out and abandoned by past, or perhaps future, iterations of humanity, further emphasizing the idea of repeating behaviours. While the mission's aim is to render Planet Blue habitable by destroying its dinosaurs, instead it triggers an ice age as the asteroid deflected to enact the destruction misfires. In the third story, a future Orbus is now a radioactive wasteland

2 New narratives are those which 'no longer re-enact the same self-destructive cycles'. Hope Jennings, '"A repeating world": Redeeming the Past and Future In the Utopian Dystopia of Jeanette Winterson's *The Stone Gods*', *Interdisciplinary Humanities* (2010), 132–46; here 133.

3 Jennings, 'A repeating world'.

4 Adeline Johns-Putra, 'The unsustainable aesthetics of sustainability: the sense of an ending in Jeanette Winterson's *The Stone Gods*', in Adeline Johns-Putra, John Parham and Louise Squire, eds, *Literature and Sustainability: Concept, Text and Culture* (Manchester: Manchester University Press, 2017), 177–94; here 188.

where anarchy rules. Despite these imageries of repeating destruction, the narrative is poetically inlaid with the possibility for intervention, continuing for most of the novel.

The flawed mission to Planet Blue can also be read as one of the novel's parables of the myth of progress. 'Progress', which arose in the nineteenth century, sought to free civilization from such processes of nature as disease, hunger and death. *The Stone Gods* plays out a fantasy of human immortality through the citizens on Orbus, who genetically 'fix' their age to safeguard their youth and beauty. This depicts progress as an expression of death-denial, which pervaded twentieth-century Western thought, and as a denial of the natural order. The myth of progress, in the novel, is that the freedom it envisages rebounds as self-destruction.

The idea that Western humanity has somehow denied death links with a further theme in the novel, that of its reverse: death-facing.[5] This theme revolves around the idea that (Western) humanity must now learn to face death if it is to overcome repeating patterns of destruction. Instead of plundering the natural world in a quest to live forever, humans should accept their mortal state and allow the natural world to flourish once more. This theme of death-facing has a subtle presence in the narrative and is linked to the novel's environmental focus via the theme of love. Each of the novel's stories ends with a death. At the end of the first and second stories it is Spike/Spikkers who dies. On both occasions, she dies willingly, freely releasing her material body to become part of the external world; each time she leaves behind her lover, Billie/Billy, who must come to terms with this loss. In contrast, the third story depicts Billie's death and a sating of her inner longing as she returns home to her mother's love. While for Spike, death is a kind of 'recycling'[6] and an opening to new possibilities, Billie returns in death to a past loss, denying death's role in the regeneration of life.

5 This theme appears in a range of environmental crisis fiction. See Louise Squire, "'I am not afraid to die": Contemporary Environmental Crisis Fiction and the Post-Theory Era', in Peter Barry and William Welstead, eds, *Extending Ecocriticism: Crisis, Collaboration and Challenges in the Environmental Humanities* (Manchester: Manchester University Press, 2017), 14–29.

6 Winterson, *The Stone Gods*, 37.

Accordingly, *The Stone Gods* delivers the verdict that humanity is so embroiled in profit and pleasure, so forgetful of our own mortal state, that we perpetually fail to harness the possibilities for change. Although envisaging the chance to avert climate change, the novel deals mainly with our failure to do so. Its message is conveyed with a narrative mix of satire and humour, embellished with frequent, often overtly authorial commentaries on the human condition. For example, in story three, Billie remarks: 'the future of the planet is uncertain. Human beings aren't just in a mess, we are a mess. We have made every mistake, justified ourselves, and made the same mistakes again and again'.[7] The novel is not wholly pessimistic, since it pairs its reservations with the possibility of hope, envisaging a 'yes', conveyed mainly through Spike, who observes: 'There must have been a moment when the universe itself said yes, when life was the imperative'.[8] Spike's 'intervention' of 'love' is also a kind of 'yes'. 'Yes' and 'love' are linked to the themes of a quantum universe and the idea of stories that 'lie open at the border',[9] inviting the reader to consider possibilities for change.

While the novel can be read as pushing home this 'yes', it is negated in the last instance. The distinction between Spike's/Spikkers' death in the first and second stories and Billie's in the third shifts the narrative mood, in the closing pages, from open to closed. Continuing to narrate beyond her death, Billie denies material death in favour of a transcendent self-perpetuation. This performs a reiteration of the novel's immortality imagery, returning us to a notion of repeating error. The impulses of 'love' and 'yes' conveyed by Spike are offered to Billie, but in her response to death she denies them. Thus, the novel invites the reader to envisage an impulse for hope that would counter our destructive tendencies, but demonstrates instead an insularity out of which such change fails to materialize. As such it retains both promise and a pessimism towards climate change, mourning the loss of the pristine world (Planet Blue), and mourning a kernel of potential in humanity upon which we may yet fail to act.

7 Winterson, *The Stone Gods*, 216.
8 Winterson, *The Stone Gods*, 213.
9 Winterson, *The Stone Gods*, 106.

The novel can be defined as a sci-fi and literary hybrid. It is stylistically postmodern and juxtaposes ecological concerns with an interrogation of the difficulties of representation, often explicitly placed. As Billie, grappling with her abandonment by her mother, reflects: 'inside the story told is the story that cannot be told. Every word written is a net to catch the word that has escaped'.[10] Representation is a predictable difficulty for environmental fiction, since 'environment' signifies a range of 'real' phenomena (species loss, pollution, climate change), whereas a story is always a story. Death, as the novel indicates, is also unrepresentable; thus, Billie reflects: 'The mind will not believe in death, perhaps because, as far as the mind is concerned, death never happens'.[11] In poetic terms, the novel is playful and open, employing devices of circularity in narrative, plot and characterization. These formal qualities replicate its call for an intervention that opens to possibility – a link noted by Adeline Johns-Putra, who reads the novel as predicated on the unsustainability of literary form.[12] Despite the novel's stylistic openness, its ending, returning us to closure, demonstrates the representational difficulties climate change poses for literary prose.

The Stone Gods has been largely well-received as a climate change novel. Popular commentary remarks on its viability as a work of sci-fi and on its didacticism, while celebrating its stylistic achievements. Critical attention is drawn to its poetics and its socio-political and ecological commentaries, and to the ways these two aspects interrelate. Susana Onega associates its 'overflowing margins' and 'rejection of spatio-temporal limits' with a Levinasian turn to other.[13] She relates the space opened up to Ouspensky's 'doctrine of possibilities', the potential to choose a new course of action, via which old forms of repetition literally 'disappear'.[14] Onega's commentary highlights *The Stone Gods'* main literary contribution to the body of climate change fiction, which

10 Winterson, *The Stone Gods*, 153.

11 Winterson, *The Stone Gods*, 97.

12 Johns-Putra, 'The unsustainable aesthetics of sustainability', 178–80.

13 Susana Onega, 'The Trauma Paradigm and the Ethics of Affect in Jeanette Winterson's *The Stone Gods*', *DQR Studies in Literature* 48/1 (2011) 265–98; here 273.

14 Onega, 'The Trauma Paradigm', 279.

is its harnessing of its own formal qualities as a means to devise and embellish the message it seeks to convey.

As a teaching resource, *The Stone Gods* is an accessible read and would reward a number of approaches. As a climate change novel, it offers the opportunity to explore human subjectivity and the question of change or transformation. Playing heavily on satire, it also makes room for readings that consider the role of the socio-political world in environmental degradation. Its attacks on capitalism and on the monopolies of governance and corporate power might be usefully considered in a Marxist or a Foucauldian approach. Unfastening the conventions of the sci-fi genre, one of the novel's fortes is its use of queer poetics and narrative stylistics in collaboration with its key ideas. It would therefore be a useful reading for courses focused on narrative, poetics, gender studies or ecofeminism. It also nudges at the edges of postmodern writing, moving into the contemporary territory of posthumanism and post-theory. As such it would provide an interesting case study for contemporary theory modules. It would also be an excellent core reading on courses studying the development and form of the novel due to its demonstration of the challenges for the novel at a time of environmental crisis. *The Stone Gods* packs a good deal into its smallish frame and as such it also offers scope and flexibility to a range of students at different levels.

The Stone Gods is an enjoyable read and throws some conundrums for the reader. There is room for critique as the novel takes plenty of risks; however, its fresh approach provides the opportunity to shift gear and consider climate change from multiple literary perspectives.

Iva Polak

Alexis Wright's *The Swan Book* (2013)

The Swan Book is the third novel by critically acclaimed Indigenous Australian author, Alexis Wright.[1] Her previous two novels, *Plains of Promise* (1997) and the internationally famous *Carpentaria* (2006), reveal that the author's preference lies in incorporating multiple realities into a meandering story in order to engage with Australia's troublesome socio-historical and environmental issues. *The Swan Book* follows the same blueprint but, unlike the first two novels, it is clearly projected into the future, beyond 2050, ominously showing what Australia might look like as it approaches its tricentennial celebration, with scores of global refugees who wander around the country ravaged by climate change, in search of the remaining unpolluted plots of land (Figures 29–31). In this respect, the novel functions as a commentary on the social and environmental injustice in Australia and gels with strategic practices of climate fiction.

The storyline revolves around an Aboriginal girl, Oblivia, who survives a gang-rape by petrol-sniffing Aboriginal boys. Abandoned by her community, she falls into a sacred eucalyptus tree, where she taps into the 'ancient memory' of the land. When she is discovered by an old white woman, she can no longer speak. Her peaceful life with the old lady who brings her up, black swans and other displaced people by the swamp is disrupted when she gets abducted by the country's first Aboriginal president, Warren Finch, to become his 'promised wife'. She will embark on a journey across the country, and end up in a sham marriage and locked in the tower in a ruined city, while Finch will be celebrated as the first Aboriginal president of the republic of Australia. The swans evicted from the swamp will eventually find

1 Alexis Wright, *The Swan Book* (Artarmon, NSW: Giramondo, 2013).

her in the tower, while the sudden death of the president will enable her to escape.

This simple 'what' of the story, which, at first glance, evokes the European tradition of swan maiden folktales, can be interpreted in myriad ways. Since Australia-specific issues such as the Intervention, the History Wars, the Stolen Generations, Australia's policy towards refugees, Aboriginal loss of land, problems with land councils, mining and Australia's ecological paradox are not explained by any of the novel's narrators and/or characters, any decoding of the text will depend on the reader's knowledge of Wright's world. As a result, the text can be read as a global, local and/or intimate story, which makes it accessible to both an Australian and a global readership. It can be seen as a story about the survival of displaced marginalized peoples of various ethnic and cultural backgrounds, in a world afflicted by climate change and global nuclear warfare; or as a story about Indigenous Australians and their displacement caused by Australia's mining policy and climate change; or as a story about a traumatized Indigenous girl who lives by a polluted lake reinventing stories about black swans in the Top End while she remembers and narrates her abduction from the swamp, her life in her gilded 'presidential' cage in the city, and her way back home to the swamp. For lovers of literature in general, the novel can also be a story about an Indigenous Scheherazade who knows that the only possibility of survival lies in continuous storytelling, because culture exists as long as there are tellers and stories to tell. It seems that this multiplicity of readings may have been Wright's intent, since she says that 'there are a lot of things impacting on the story because it's set in the future; it's looking at issues like climate change, people becoming stateless and homeless. [...] It's not a simple thing like going out into the backyard and seeing a hornet's nest – it's describing the hornet's nest of the world'.[2]

With its multifarious topics and the labyrinthine nature of its textual structure, the novel has been approached through different interpretative paradigms. Analysis has focused on the figure of the 'abused Aboriginal child'

2 Alexis Wright and Arnold Zable, 'The Future of Swans', *Overland* 213 (2013), 27–30; here 28.

and the narratives of harm;[3] with the book being interpreted as revealing post-traumatic experience and retraumatizing policies;[4] as reflecting multidimensional and contemporary identities from the Gulf Country;[5] as conveying the politics of fabulation;[6] as a story about the land, custodianship and recognition;[7] as a political, economic and climatic dystopia;[8] as an unsettling magical realist narrative;[9] as speculative fiction or a multi-realist work about climate change;[10] and as a work of trans-realist fiction marked by bitter truthtelling.[11] Trying to capture its structural complexities, Katherine Mulcrone refers to *The Swan Book* as encompassing 'gestures towards *bildungsroman* and survivor literature, combined with a healthy dose of swan-related fairy tales, myths and cross-cultural literary allusions bound up in a futuristic meditation

3 Honni van Rijswijk, 'Towards a Literary Jurisprudence of Harm: Rewriting the Aboriginal Child in Law's Imaginary of Violence', *Canadian Journal of Women and the Law* 27/2 (2015), 311–35.

4 Meera Atkinson, *The Poetics of Transgenerational Trauma* (New York and London: Bloomsbury, 2017), 147–80.

5 Richard J. Martin, Philip Mead and David Trigger, 'The Politics of Indigeneity, Identity and Representation in Literature from North Australia's Gulf Country', *Social Identities* 20/4–5 (2014), 330–45.

6 Linda Daley, 'Fabulation: Toward Untimely and Inhuman Life in Alexis Wright's *The Swan Book*', *Australian Feminist Studies* 31/89 (2016), 305–18.

7 Nicholas Birns, *Contemporary Australian Literature: A World Not Yet Dead* (Sydney: Sydney University Press, 2015), 151–5.

8 Cornelis Martin Renes, 'Book Review: Alexis Wright. *The Swan Book*', *The Journal of the European Association for Studies of Australia* 5/1 (2014), <http://easa-australianstudies. net/node/367> accessed 20 November 2017.

9 Ben Holgate, 'Unsettling Narratives: Re-Evaluating Magical Realism as Postcolonial Discourse Through Alexis Wright's *Carpentaria* and *The Swan Book*', *Journal of Postcolonial Writing* 51/6 (2015), 634–47.

10 Jessica White, 'Fluid Worlds: Reflecting Climate Change in *The Swan Book* and *The Sunlit Zone*', *Southerly* 74/1 (2014), 142–63; Emily Potter, 'Teaching Climate Change at the End of Nature: Post-Colonial Australia, Indigenous Realism and Alexis Wright's *The Swan Book*', in Stephen Siperstein, Shane Hall, and Stephanie LeMenager, eds, *Teaching Climate Change in the Humanities* (Abingdon: Routledge, 2016), 225–32.

11 Iva Polak, *Futuristic Worlds in Australian Aboriginal Fiction* (Oxford: Peter Lang, 2017), 189–233.

Figures 29–31. The Breakaways (South Australia), the country of Antakirinja Matuntjara Yankunytjatjara people © Iva Polak (2014).

on our responsibilities toward the land and its first peoples'.[12]

No matter what interpretative grid we choose to apply, the focal point of the story remains the same: it is the contaminated outback which bears the scars of Australia's ecological imperialism, 'exemplified in the environmentally discriminatory treatment of socially marginalized or economically disadvantaged peoples'.[13] Since Wright's characters attempt to survive in it against all odds, *The Swan Book* is a model example of cli-fi, which, among other things, debates climate change and human agency. Moreover, this novel adds Indigenous voices to the genre, since it tells a story from the perspective of those who have been on the receiving end of Australia's capitalist stick. Through Oblivia's thoughts and comments by other narrators, the novel echoes a different epistemological starting point, one embedded in 'indigenous scientific literacies', telling us that 'we survive not by conquering the world but by recognizing ourselves as part of it'.[14]

The encounter which motivated Wright to raise the issue of climate change in a novelistic form is signalled by the title and the suggestive front cover of the first edition, which featured black swans. As early as 2003, Indigenous peoples told her about the sighting of black swans in the Central Desert, far away from their native coastal regions. Displaced from their natural habitat by man-made pollution, the swans even migrated to Wright's native country in the Gulf of Carpentaria, where they are not normally found, and the Indigenous Australians have no stories about them. This very empirical situation begged for answers, which Wright offered in *The Swan Book* some ten years

12 Katherine Mulcrone, 'Wright's Cygnet-ure Achievement Eludes Conclusions', *Antipodes* 28/2 (December 2014), 518–19; here 518.

13 Graham Huggan and Helen Tiffin, *Postcolonial Ecocriticism: Literature, Animals, Environment*. (London and New York: Routledge, 2010), 4.

14 Grace L. Dillon, 'Indigenous Scientific Literacies in Nalo Hopkinson's Ceremonial Worlds', *Journal of the Fantastic in the Arts* 18/1 (2007), 23–40; here 38.

later. As she claims, 'We had taken them out of their habitat through environmental damage that has been mostly man-made, and the [black] swans moved. They have to go somewhere. Where do they go and what stories do they have? How do you make stories for them in a new place?'[15] Aware of the ecological damage caused by profit-driven industry in Australia, Wright engages with the current climate debate by exposing the fallacies of long-term gesture politics which result in the loss of land and culture. However, instead of telling a story through the binary of the displaced and the displacers, she opts for a more complex portrayal, commenting on the alienation of humanity from its own origins and the consequences of its failure to act. Her sardonic narrators mince no words in condemning those who come from the land but sell it off, as well as the outsiders who devastate the land for profit: all cultures are shown capable of becoming a-cultural if they cease to be *grounded*. Aboriginality cannot be the country's saving grace for Wright.

Her message is clear: if the black swans have been forced to leave their native country, if Indigenous Australians have become displaced, and if other people in the world must abandon their homes due to climate change, the same can happen to anyone. The only way out is 'Indigenous scientific literacies [which] represent practices used by Indigenous peoples over thousands of years to reenergize the natural environment while improving the interconnected relationships among all persons (animal, human, spirit, and even machine)'.[16] To access those literacies, like Oblivia, we need to conceptualize the land as the source of belonging and not the source of profit. This is why her voice anchors the novel in 'a new realm of "ecodiegesis" that gives a voice

15 Wright and Zable, 'The Future of Swans', 30.
16 Grace L. Dillon, 'Imagining Indigenous Futurisms', in Grace L. Dillon, ed., *Walking the Clouds: An Anthology of Indigenous Science Fiction* (Tucson: University of Arizona Press, 2012), 1–12; here 7.

to the planet itself'.[17] Otherwise, the narrator's prophecy in the opening pages, where 'mother nature' is 'the Mother Catastrophe of flood, fire, drought and blizzard', 'the four seasons which she threw around the world whenever she liked',[18] will come true.

This stimulating novel needs to be read and taught for many reasons. It will be of interest to those who enjoy reading climate fiction, Anthropocene fiction, sci-fi and postcolonial fiction, but equally to those working in utopian studies, gender studies, memory studies, trauma studies and spatial studies. It may also interest those who like engaging with demanding postmodernist works from all corners of the world, which are marked by intertextuality and heteroglossia, complex novelistic chronotopes where the notion of space and time collapse, and unreliable narrators – in the case of *The Swan Book*, the abjected child narrator Oblivia and the virus in her head – whose nomadic narratives lure the reader into a futuristic Chinese-box world.

Finally, like other highly dialogical and provocative cli-fi novels that also subvert the straightjacket of the genre, such as Jeanette Winterson's *The Stone Gods* (2007) and David Mitchell's *The Bone Clocks* (2014), *The Swan Book* should be of interest to those who take pleasure in reading and examining works whose challenging content cuts no corners and is poignant in its immediacy. Because no matter how complex the textual tissue of *The Swan Book* may be, its message is clear and concerns all of us: it exposes the fate of *homo futurus*, who has given up the placedness of culture for the placelessness of capital. The novel's disconcerting narrative is an elegiac epic of humankind undergoing irreversible epistemological change.

17 Tobias Boes and Kate Marshall, 'Writing the Anthropocene: An Introduction', *Minnesota Review* 83 (2014) 60–72; here 66.
18 Wright, *The Swan Book*, 6.

Bibliography

Baucom, Ian, '"Moving Centers": Climate Change, Critical Method, and the Historical Novel', *Modern Language Quarterly* 76/2 (2015), 137–57.

Bergthaller, Hannes, 'Housebreaking the Human Animal: Humanism and the Problem of Sustainability in Margaret Atwood's *Oryx and Crake* and *The Year of the Flood*', *English Studies* 91/7 (2010), 728–43.

Bracke, Astrid, *Climate Crisis and the 21st-Century British Novel* (London and New York: Bloomsbury, 2018).

Bristow, Tom, and Thomas H. Ford, eds, *A Cultural History of Climate Change* (London and New York: Earthscan, 2016).

Buell, Frederick, 'Global Warming as Literary Narrative', *Philological Quarterly* 93/3 (2014), 261–94.

Canavan, Gerry, and Kim Stanley Robinson, eds, *Green Planets: Ecology and Science Fiction* (Middletown, CT: Wesleyan University Press, 2014).

Chakrabarty, Dipesh, 'The Climate of History: Four Theses', *Critical Inquiry* 35/2 (2009), 197–222.

——, 'Postcolonial Studies and the Challenge of Climate Change', *New Literary History* 43/1 (2012), 1–18.

Clark, Pilita, 'Global Literary Circles Warm to Climate Fiction', *Financial Times* (31 May 2013).

Clark, Timothy, *Ecocriticism on the Edge: The Anthropocene as a Threshold Concept* (London and New York: Bloomsbury, 2015).

Cohen, Tom, ed., *Telemorphosis: Theory in the Era of Climate Change* (Ann Arbor, MI: Open Humanities Press, 2012).

Cubitt, Sean, *EcoMedia* (Amsterdam and New York: Rodopi, 2005).

Dürbeck, Gabriele, 'Ambivalent Characters and Fragmented Poetics in Anthropocene Literature: Max Frisch and Ilija Trojanow', *Minnesota Review* 83 (2014), 112–21.

——, 'Climate Change Fiction and Ecothrillers in Contemporary German-Speaking Literature', in Gabriele Dürbeck, Urte Stobbe, Hubert Zapf and Evi Zemanek, eds, *Ecological Thought in German Literature and Culture* (Lanham, MD: Lexington, 2017), 331–45.

Evancie, Angela, 'So Hot Right Now: Has Climate Change Created a New Literary Genre?', *NPR Books* (20 April 2013).

Forrest, Bethan, 'Cli-Fi: Climate Change Fiction as Literature's New Frontier?', *Huffington Post* (23 July 2015).

Gaard, Greta, 'Global Warming Narratives: A Feminist Ecocritical Perspective', in Serpil Oppermann, Ufuk Özdag, Nevin Özkan and Scott Slovic, eds, *The Future of Ecocriticism. New Horizons* (Newcastle: Cambridge Scholars, 2011), 43–64.

—— , 'From Cli-Fi to Critical Ecofeminism: Narratives of Climate Change and Climate Justice', in Mary Phillips and Nick Rumens, eds, *Contemporary Perspectives on Ecofeminism* (New York: Routledge, 2015), 169–92.

Garrard, Greg, 'The Unbearable Lightness of Green: Air Travel, Climate Change and Literature', *Green Letters* 17/2 (2013), 175–88.

Ghosh, Amitav, *The Great Derangement: Climate Change and the Unthinkable* (Chicago and London: University of Chicago Press, 2016).

Glass, Rodge, 'Global Warning: The Rise of "Cli-Fi"', *Guardian* (31 May 2013).

Goodbody, Axel, 'Melting Ice and the Paradoxes of Zeno: Didactic Impulses and Aesthetic Distanciation in German Climate Change Fiction', *Ecozon@* 4/2 (2013), 92–102.

—— , 'Telling the Story of Climate Change: The German Novel in the Anthropocene', in Caroline Schaumann and Heather I. Sullivan, eds, *German Ecocriticism in the Anthropocene* (New York: Palgrave Macmillan, 2017), 293–314.

Heise, Ursula K., *Sense of Place and Sense of Planet: The Environmental Imagination of the Global* (Oxford: Oxford University Press, 2008).

Holthaus, Eric, 'Hollywood is Finally Taking on Climate Change: It Should Go Even Further', *Slate* (9 August 2016).

Johns-Putra, Adeline, 'Climate Change in Literature and Literary Studies: From Cli-fi, Climate Change Theater and Ecopoetry to Ecocriticism and Climate Change Criticism', *Wiley Interdisciplinary Reviews: Climate Change* 7/2 (2016), 266–82.

—— , *Climate Change and the Contemporary Novel* (Cambridge: Cambridge University Press, forthcoming 2018).

—— , ed., *Climate and Literature* (Cambridge: Cambridge University Press, forthcoming 2019).

Kainulainen, Maggie, 'Saying Climate Change: Ethics of the Sublime and the Problem of Representation', *Symplōke* 21/1–2 (2013), 109–23.

Kaplan, E. Ann, *Climate Trauma: Foreseeing the Future in Dystopian Fiction and Film* (New Brunswick, NJ: Rutgers University Press, 2016).

Leilam, Susanne, and Julia Leyda, 'Cli-Fi in American Studies: A Research Bibliography', *American Studies Journal* 62/1 (2017).

Mayer, Sylvia and Alexa Weik von Mossner, eds, *The Anticipation of Catastrophe. Environmental Risk in North American Literature and Culture* (Heidelberg: Winter, 2014).

Mehnert, Antonia, *Climate Change Fictions: Representations of Global Warming in American Literature* (Basingstoke: Palgrave Macmillan, 2016).

Milkoreit, Manjana, 'The Promise of Climate Fiction: Imagination, Storytelling and the Politics of the Future', in Paul Wapner and Hilal Elver, eds, *Reimagining Climate Change* (London and New York: Earthscan, 2016), 171–91.

Morton, Timothy, *Hyperobjects: Philosophy and Ecology after the End of the World* (Minneapolis: University of Minnesota Press, 2013).

Murphy, Patrick D., 'The Procession of Identity and Ecology in Contemporary Literature', *SubStance* 41/1, 127 (2012), 77–99.

——, *Persuasive Aesthetic Ecocritical Praxis: Climate Change, Subsistence, and Questionable Futures* (Lanham, MD: Lexington, 2015).

Nikoleris, Alexandra, Johannes Stripple and Paul Tenngart, 'Narrating Climate Futures: Shared Socioeconomic pathways and Literary Fiction', *Climatic Change* 143 (2017), 307–19.

Rigby, Kate, *Dancing with Disaster: Environmental Histories, Narratives, and Ethics for Perilous Times* (Charlottesville: University of Virginia Press, 2015).

Schmeink, Lars, *Biopunk Dystopias: Genetic Engineering, Society and Science Fiction* (Liverpool: Liverpool University Press, 2016).

Skrimshire, Stefan, *Future Ethics: Climate Change and Apocalyptic Imagination* (London and New York: Continuum, 2010).

Smith, Philip, and Nicolas Howe, *Climate Change as Social Drama: Global Warming in the Public Sphere* (Cambridge: Cambridge University Press, 2015).

Solnick, Sam, 'Reverse Transcribing Climate Change', *The Oxford Literary Review* 34/2 (2012), 278–94.

——, 'Why the Cultural Response to Climate Change Makes for a Heated Debate', *The Independent* (10 June 2014).

Streeby, Shelley, *Imagining the Future of Climate Change: World-Making through Science Fiction and Activism* (Berkeley: University of California Press, 2018).

Svoboda, Michael, 'Cli-Fi on the Screen(s): Patterns in the Representations of Climate Change in Fictional Films', *Wiley Interdisciplinary Reviews: Climate Change* 7/1 (2016), 43–64.

Trexler, Adam, *Anthropocene Fictions: The Novel in a Time of Climate Change* (Charlottesville: University of Virginia Press, 2015).

—— and Adeline Johns-Putra, 'Climate Change in Literature and Literary Criticism', *Wiley Interdisciplinary Reviews: Climate Change* 2/2 (2011), 185–200.

Tuhus-Dubrow, Rebecca, 'Cli-Fi: Birth of a Genre', *Dissent*, 60/3 (2013), 58–61.

Watkins, Susan, 'Future Shock: Rewriting the Apocalypse in Contemporary Women's Fiction', *LIT: Literature Interpretation Theory*, 23/2 (2012), 119–37.

Weik von Mossner, Alexa, *Affective Ecologies. Empathy, Emotion and Environmental Narrative* (Columbus: Ohio State University Press, 2017).

Notes on Contributors

LIEVEN AMEEL is Collegium Researcher at the Turku Institute for Advanced Studies, with an affiliation in comparative literature. Research interests include city literature, urban futures and narratives in urban planning. He is the co-editor of a new Palgrave book series in Literary Urban Studies.

MARK ANDERSON is Associate Professor of Latin American Literatures and Cultures at the University of Georgia. He is author of *Disaster Writing: The Cultural Politics of Disaster in Latin America* (University of Virginia, 2011) and co-editor with Zélia Bora of *Ecological Crisis and Cultural Representation in Latin America* (Lexington Books, 2016).

HANNES BERGTHALLER is a professor at the Department of Foreign Languages and Literature of National Chung-Hsing University, Taiwan. His research focuses on the literature and cultural history of US environmentalism, ecocritical theory and social systems theory. He is currently working on a book about the Anthropocene (together with Eva Horn).

KIU-WAI CHU is a postdoctoral fellow in the Australia-China Institute for Arts and Culture, Western Sydney University. His research focuses on contemporary cinema and art in Asia, Ecocriticism and environmental humanities. His work has appeared in *Transnational Ecocinema, Ecomedia: Key Issues, Journal of Chinese Cinemas, Oxford Bibliographies* and elsewhere.

JIM CLARKE is Senior Lecturer in English and Journalism at Coventry University. He is the author of *The Aesthetics of Anthony Burgess* (Palgrave, 2017) and *Science Fiction and Catholicism* (Gylphi Press, forthcoming). He has written eco-critically about works by J. R. R. Tolkien and J. G. Ballard.

STEF CRAPS is Associate Professor of English Literature at Ghent University. His research interests range across contemporary global Anglophone literature, memory and trauma studies, postcolonial theory and the environmental

humanities. He has recently guest-edited a special issue of *Studies in the Novel* on climate change fiction (with Rick Crownshaw).

SINA FARZIN is Assistant Professor for Social Theory at the University of Hamburg. She is a member of the Fiction Meets Science network, a collaborative research group investigating cultural representations of science. Her research interests include social theory, sociology of literature, utopias/dystopias.

THOMAS H. FORD is Lecturer in English at the University of Melbourne. *A Cultural History of Climate Change*, co-edited with Tom Bristow, appeared with Routledge in 2016; *Wordsworth and the Poetics of Air: Atmospheric Romanticism in a Time of Climate Change* was published by Cambridge University Press in 2018.

GREG GARRARD is Associate Dean of Research in the Faculty of Creative and Critical Studies, UBC Okanagan. He is the author of *Ecocriticism* (Routledge, 2004, 2011, 2nd edn) and numerous essays on eco-pedagogy, animal studies and environmental criticism. He is the editor of *The Oxford Handbook of Ecocriticism* (Oxford University Press, 2014), and series co-editor of *Environmental Cultures* from Bloomsbury Academic.

TERRY GIFFORD is Visiting Research Fellow in Environmental Humanities at Bath Spa University and Profesor Honorifico at the University of Alicante. Author of eight collections of poetry and author/editor of seven books on Ted Hughes, his research interests also include pastoral theory, John Muir, Charles Frazier, new nature writing and ecopoetics.

AXEL GOODBODY is Emeritus Professor of German and European Culture at the University of Bath. He has published widely on literary representations of nature and environment, and ecocritical theory. Current projects include editing a collection of essays on energy narratives together with Bradon Smith and co-authoring a transnational study of climate change scepticism.

URSULA K. HEISE is the Marcia H. Howard Chair in Literary Studies at the Department of English and the Institute of the Environment and Sustainability at UCLA, and a co-founder of UCLA's Lab for Environmental Narrative Strategies (LENS). Her most recent book, *Imagining Extinction: The Cultural*

Meanings of Endangered Species (University of Chicago Press, 2016), won the 2017 book prize of the British Society for Literature and Science.

REINHARD HENNIG is Associate Professor of Nordic literature at the University of Agder, Norway. He holds a PhD in Scandinavian studies from the University of Bonn, Germany, and is co-founder and co-ordinator of the *Ecocritical Network for Scandinavian Studies* (ENSCAN).

ADELINE JOHNS-PUTRA is Reader in English Literature at the University of Surrey. Her main research interest is climate change and literature. She was Chair of the Association for the Study of Literature and the Environment, UK and Ireland from 2011 to 2015. Current projects include writing a mono-graph, *Climate Change and the Contemporary Novel*, and editing the volume *Climate and Literature*. She is a member of the editorial board of *Green Letters: Studies in Ecocriticism*.

RICHARD KERRIDGE leads the MA in Creative Writing at Bath Spa University. He has published prize-winning essays, and the book *Cold Blood* (2014). He is a leading authority on British ecocriticism, and the author of ecocritical essays on topics ranging from Shakespeare and Thomas Hardy to present-day fiction, poetry, nature writing and film.

SYLVIA MAYER is Chair of American Studies at the University of Bayreuth, Germany. Her major fields of research are Ecocriticism and African American Studies. Her publications include monographs on Toni Morrison's novels and on the environmental ethics of New England regionalist writing. Currently, her work focuses on environmental risk narratives and climate change fiction.

ANTONIA MEHNERT is an independent scholar who currently works in envi-ronmental education and communication. Her book *Climate Change Fictions* began life as a doctoral thesis written at the Rachel Carson Center and the American Studies Department of the University of Munich. Her research interests include ecocriticism, climate change, Chicana/o studies, and the postcolonial Caribbean.

CHRIS PAK is an independent researcher and author of *Terraforming: Ecopolitical Transformations and Environmentalism in Science Fiction* (2016). Previous projects include the Leverhulme-funded '"People", "Products", "Pests"

and "Pets": The Discursive Representation of Animals' (Lancaster University, 2013–16) and the Volkswagen Foundation-funded 'Modelling Between Digital and Humanities: Thinking in Practice' (King's Digital Lab, King's College London, 2017–18).

M. ISABEL PÉREZ-RAMOS, PhD, is an environmental humanities scholar whose research focuses on literary representations of environmental injustices. She has co-edited the 2017 winter volume of the academic journal *Resilience* and has an article forthcoming in *MELUS*. She is a member of the research group GIECO, Instituto Franklin.

DANA PHILLIPS is Professor of English at Towson University and Research Associate at Rhodes University in South Africa. He is the author of *The Truth of Ecology: Nature, Culture, and Literature in America* (Oxford University Press, 2003, 2007) and of articles and book chapters on various topics in the environmental humanities.

IVA POLAK is an associate professor in the Department of English, University of Zagreb, Croatia, where she teaches Australian studies, literary and film fantasy, and dystopian fiction. Her most recent publication is *Futuristic Worlds in Australian Aboriginal Fiction* (Peter Lang, 2017). Her current projects concern humour studies, and contemporary trends in SF and fantasy.

BRADON SMITH is a senior research associate at the University of Bristol with research interests in the Environmental and Energy Humanities. He is co-editing, with Axel Goodbody, a special issue of the journal *Resilience* on *Stories of Energy* and working on a monograph, *The Energy of Imagined Futures*.

LOUISE SQUIRE researches in the environmental humanities and contemporary literature. She is currently completing a monograph based on her doctoral work. She is co-editor, with Adeline Johns-Putra and John Parham, of *Literature and Sustainability: Concept, Text and Culture* (2017), and has published articles, including in *The Oxford Literary Review* (2012).

ADAM TREXLER is an independent researcher living in Portland, Oregon. He is the author of *Anthropocene Fictions*, the first book-length study of climate

change and literature, as well as a number of articles on the subject. He is currently exploring material and dematerialized forms of currency.

ALEXA WEIK VON MOSSNER is Associate Professor of American Studies at the University of Klagenfurt in Austria. She is the author of *Cosmopolitan Minds: Literature, Emotion, and the Transnational Imagination* (University of Texas Press, 2014) and *Affective Ecologies: Empathy, Emotion, and Environmental Narrative* (Ohio State University Press, 2017).

DAVID WHITLEY has taught film, poetry and children's literature at Cambridge University for over twenty years. He is particularly interested in the way the arts offer different forms of understanding and engagement with the natural world. His most recent book is *The Idea of Nature in Disney Animation* (2012).

Index

activism 4, 5, 38, 59, 97–102, 144, 181, 183,
 185
allegory 13, 161, 196, 198
allusion 16, 23, 25, 70, 200, 219
 see also intertextuality
Anthropocene, the 8, 10, 12, 15, 22, 27, 29,
 31, 32, 38, 39, 40, 48, 71, 87, 91, 101,
 116, 200, 201, 222
anthropomorphism 14, 197, 198
anxiety 5, 7, 83, 119, 121, 126, 156, 162
 see also trauma
apocalypse 5, 6, 10, 12, 13, 17, 21, 25, 35, 50,
 52, 57, 62, 66, 71, 74, 80, 81, 83, 84,
 86, 87, 91, 92, 94, 95, 105, 115, 116,
 117, 120, 123, 124, 133–8, 139, 144,
 148, 149, 150, 152, 153, 158, 164, 169,
 203, 208
 see also disaster narrative
authoritarian government
 see dictatorship

Bildungsroman 12, 116, 200, 201, 206, 209,
 219
biopolitics 36, 44, 45, 48, 122
biopunk 13, 55–60

capitalism 36, 37, 38, 39, 77, 92, 94, 100, 103,
 122, 216, 220
carbon dioxide 3, 22, 39, 56, 129, 182,
 187–92, 205, 206
 see also greenhouse effect
class 35, 39, 43, 44, 48, 73, 74, 77, 98,
 111–16, 188
colonialism 16, 23, 39, 48, 58, 95, 222

comedy 30, 32, 49, 67, 105, 107, 126,
 159–64, 176, 178
conspiracy 17, 139, 140, 143
crime fiction 12, 64, 165–70

democracy 37, 38, 142, 166, 208
denialism 32, 84, 88, 101, 102, 113, 119, 120,
 139–45, 183, 190, 211, 213
 see also scepticism
desertification 5, 175
detective fiction
 see crime fiction
deterritorialization 62, 65, 111, 114
dictatorship 35, 36, 37, 38, 192
didacticism 15, 115, 181, 184, 215
disaster narrative 8, 11, 12, 16, 22, 25, 26, 57,
 62, 70, 84, 85, 91, 94, 101, 118, 120,
 126, 133, 135, 139, 147, 148, 149, 151,
 1568, 166, 167, 187, 188, 190, 195, 196,
 200, 208
 see also apocalypse
documentary 10, 123–9, 137, 192
dystopia 2, 13, 17, 35, 37, 38, 39, 45, 46, 57,
 58, 59, 62, 74, 75, 84, 91, 92, 114,
 124, 135, 166, 167, 169, 183, 185, 187,
 188, 190, 191, 192, 197, 206, 207, 208,
 219

ecocriticism 14, 59, 62, 87, 109
ecotopia 13
environmental humanities
 see humanities, environmental
environmental justice
 see justice, environmental

environmental refugeeism
 see refugeeism, environmental
epic 6, 64, 115, 162, 163, 195–201, 203, 207,
 222

family drama 43, 44, 51, 81, 82, 84, 85, 86,
 94, 111, 125, 134, 148, 149, 170, 187,
 188, 190, 191
fantasy 4, 16, 49, 58, 83, 178, 180, 183, 206,
 207, 208, 213
feminism 16, 95, 142, 216
 see also gender
flood 5, 12, 16, 21, 23, 25, 26, 63, 75, 82, 83,
 91, 93, 94, 100, 104, 105, 106, 108,
 114, 115, 117, 120, 123, 141, 153, 155,
 157, 165, 168, 175, 191, 205, 222
fragmentation 10, 11, 31, 35, 64, 70, 195,
 199, 201
framing (or frame) narrative 4, 7, 10, 12, 13,
 16, 29, 38, 39, 43, 45, 46, 47, 66, 76,
 77, 93, 94, 95, 101, 117, 124, 126, 143,
 182, 192, 216
future generations 10, 15, 54, 93, 95, 115,
 124, 125, 155, 182, 186, 187–92

gender 4, 7, 14, 16, 59, 60, 92, 93, 116, 178,
 195, 198, 211, 212, 216, 222
genetic engineering 5, 49, 51, 54, 55, 56, 60,
 93, 103, 213
genre 1, 4, 12, 13, 16, 17, 21, 43, 46, 47, 48,
 49, 64, 78, 85, 116, 133, 138, 139, 144,
 149, 150, 151, 157, 158, 160, 169, 170,
 176, 178, 183, 188, 200, 206, 209,
 216, 220, 222
geo-engineering 73, 80, 103, 104, 141
geopolitics 39
global cooling
 see Ice Age
globalism 36, 38, 65, 77, 101, 114, 197,
 198
greenhouse effect 2, 3, 45, 47, 97, 101, 150,
 163, 182
 see also carbon dioxide

heteroglossisa 222
 see also multi-perspectivity and
 polyphony
horror 4, 35, 85
humanities, environmental 60
hurricane 21, 83, 100, 103, 106, 109, 117, 118,
 119, 120, 147

Ice Age 15, 45, 92, 134, 173, 174, 176, 212
ice melt, polar 50, 68, 154, 175, 205, 208
intertextuality 36, 116, 222
 see also allusion
IPCC 5, 16, 134, 141
irony 4, 30, 36, 45, 58, 63, 92, 94, 115, 119,
 125, 153, 163, 164

justice, environmental 4, 14, 60, 73, 74,
 79–80, 95, 116, 126, 182, 187, 192, 217

last man narrative 13
localism 36, 38, 46, 83, 101, 111–14, 151, 157,
 218

magical realism 183, 219
Marxism 16, 95, 109, 216
melodrama 134, 136–8, 162, 175, 176, 178
metafiction 46–8, 183,
modernism 10, 17, 29, 195, 199–201
montage 10–11, 31, 70, 94
multi-perspectivity 44–5, 58, 195, 203, 206,
 209
 see also heteroglossia and polyphony
myth 16, 70, 109, 115, 199, 211, 219

neoliberalism 36, 38–9, 166

pastoral 12, 62, 64, 71, 115–16
picaresque 64, 206, 209
polyphony 44
 see also heteroglossia and
 multi-perspectivity
post-apocalypse 13, 35, 49–54, 74, 80, 84,
 87, 91, 120, 123, 153, 158, 203, 208

postcolonialism 16, 48, 95, 222
posthumanism 10, 39–40, 55–6, 58, 60, 216
postmodernism 10, 22, 211–16, 222

queer theory 16, 56, 95, 212, 216

realism 14, 17, 22, 24, 107, 159–63, 183, 192,
 198, 200, 219
refugeeism, environmental 5, 60, 70,
 112–13, 114, 120, 166, 183, 217
religion 16, 45, 49, 56–7, 70, 73, 106–7,
 111–12, 115, 143, 147, 149, 153–4, 168,
 196, 205, 208
risk, risk society 61–6, 73, 111, 114–16,
 117–22, 123, 129, 135, 198
romance 11, 64, 92, 176, 178, 183

satire 13, 17, 35–7, 49, 68, 97, 101, 117, 153,
 157, 166, 214, 216
scepticism 113, 139–45
science 3, 5, 9, 13, 22, 25, 28–32, 48, 55–60,
 68, 71, 72, 80, 88, 94, 103–9, 111–16,
 124, 133–8, 139, 141–5, 148, 161,
 162–3, 185, 195–6, 200, 220–1

science and technology studies 109, 145
sci-fi 1, 3–4, 13, 15, 16, 21–2, 25–6, 35,
 43, 45, 46–8, 49, 59, 64, 91, 104,
 107, 109
storm 5, 21, 51, 81–3, 85–6, 100–1, 117–20,
 134, 141, 147, 150, 170, 187, 192
storyworld 7, 13, 15, 168, 170
sublime 116
symbolism 11, 13, 16, 79, 93, 98, 106–7, 155,
 161, 168, 175, 210

terraforming 26
thriller 4, 12, 13, 16, 17, 70, 85, 86, 139, 143,
 147–52, 160, 209
tragedy 64, 67–8, 100, 163–4
trauma 8, 87, 218, 219, 222
 see also anxiety

uncanny 23–4, 46
unreliable narrators 16, 92, 160, 222
utopia 35, 105–7, 109, 157, 191, 197, 222

young adult fiction 4, 15, 17, 183, 185,
 187–8, 191–2